THE RENAISSANCE AND MANNERISM
IN NORTHERN EUROPE AND SPAIN

THE HARBRACE HISTORY OF ART

ALASTAIR SMART

THE RENAISSANCE AND MANNERISM IN NORTHERN EUROPE AND SPAIN

with 178 illustrations

HARCOURT BRACE JOVANOVICH, INC.

For Julian

Photographic acknowledgments

The publishers are indebted to the museums and collectors who provided photographs of works in their possession, and also to the following individuals and institutions who supplied photographs or allowed them to be reproduced.

Copyright A.C.L. Brussels *16, 17, 19, 29, 32, 34, 89, 91, 96, 98, 102*; Alinari *31, 80, 95, 164*; Lala Aufsberg *56*; Maurice Babey *44, 46*; Joachim Blauel *14*; Bulloz *26, 99*; Peter Cannon-Brookes *134*; Domsakristeiverwaltung, Cologne *46*; R. B. Fleming *2, 111, 113*; Frequin Photos *4, 108*; Gad Borel-Boissonnas, Geneva *45*; the authorities of St Bavon, Ghent *11, 16, 17*; Giraudon *5, 7, 12, 47, 59, 61, 66, 119, 120, 121, 122, 146, 147, 149, 151*; Gabriele Hauck *39*; Martin Hürlimann *51, 118* (from *Grünewald*, Atlantis Verlag, Zurich and Freiburg i. Br., and Thames and Hudson, London); A. F. Kersting *159*; Dr Carl Lamb *139*; Layland Ross, Nottingham *105*; National Monuments Record, London *160*; Royal Academy of Arts, London *83, 101, 175*; Bildarchiv Foto Marburg *6, 23, 38, 42, 52, 53, 135, 144*; Mas *25, 68, 69, 71, 72, 75, 78, 79, 84, 85, 86, 106, 161, 162, 163, 165, 167, 168, 169, 172, 178*; Germanisches Nationalmuseum, Nuremberg *140*; Archives Photographiques, Paris *60*; Chiolini & C., Pavia *145*; Jean Roubier *57, 148*; Scala *11, 40, 41, 73, 112, 136*; Helga Schmidt-Glassner *54, 133*; Katholisches Pfarramt, Tiefenbronn *44*; Eileen Tweedy *127*; Meyer, Vienna *77*; John Webb (Brompton Studio) *152*.

ISBN o–15 576596–5 Paperbound
ISBN o–15 176826–9 Hardbound
Library of Congress Catalog Card Number : 70–165326

Printed in Switzerland
Bound in Germany

CONTENTS

NOTE

Measurements are given in inches (over four feet, in feet and inches to the nearest inch), with centimetres in brackets. Height precedes width.

CHAPTER ONE

Introductory

The term 'Renaissance', which derives ultimately from Vasari's concept of the rebirth (or *rinascita*) of the arts in Italy during the 15th and 16th centuries, following upon the prophetic innovations of such earlier masters as Nicola Pisano and Giotto, has often been applied in a loose sense to that remarkable flowering of the northern artistic genius around 1400 which we associate in particular with the sculpture of Claus Sluter and the new style of painting perfected by Jan van Eyck. Yet the ideal that inspired the Italian Renaissance – the revival and emulation of the culture of antiquity – was not to exert any profound influence upon painting and sculpture outside Italy until the 16th century. Before that time northern artists had been receptive to the realistic tendencies in the Gothic world of Giotto and the Lorenzetti, but their vision was moulded essentially by medieval traditions, and the development of the new style in northern Europe must properly be seen as the consummation of the Late Gothic spirit. Echoing the title of his celebrated study of the period, *The Waning of the Middle Ages,* the great Dutch historian Johan Huizinga justly insisted that neither the art of Sluter nor that of van Eyck is to be called Renaissance: 'Both in form and in idea it is a product of the waning Middle Ages. If certain historians of art have discovered Renaissance elements in it, it is because they have confounded, very wrongly, realism and Renaissance.' Unquestionably the *renovatio* of the arts in northern Europe during the 15th century raises an important problem of terminology, and to this we shall return presently.

By the years around 1500, on the other hand, the glamour of the Italian achievement had become too strong to be resisted, and throughout the 16th century the desire of northern European artists and their Spanish

7

contemporaries to assimilate Italian principles is increasingly evident. As Panofsky has emphasized, 'the works produced by Albrecht Dürer at the turn of the 15th century mark the beginning of the Renaissance style in the North. At the end of an era more thoroughly estranged from classical art than any other, a German artist rediscovered it both for himself and his countrymen.' It was Dürer who stimulated the same process in Netherlandish art of the period; and it is significant that Jan van Scorel, one of the most conscientious of the Netherlandish 'Italianizers', should have visited Dürer in Nuremberg in 1519 before going to Italy, where he succeeded Raphael as Inspector of the Belvedere. In Rome Scorel was deeply affected by the art of Raphael and Michelangelo, and his painting of *Adam and Eve* in New York (*Ill. 3*), which is directly based upon a print by Marcantonio Raimondi (*Ill. 2*) after a Raphael drawing now at Oxford, is fully representative of the new tendencies of the age. It was in much the same spirit that Quinten Massys, the Antwerp master, borrowed the design of his Poznan *Madonna* (*Ill. 97*) from a well-known composition by Leonardo da Vinci, and that Gossaert,

1 MARTEN VAN HEEMSKERCK (1498–1574) *Self-portrait with the Colosseum in the background, 1553. Oil on panel, 16⅝ × 21¼ " (44.2 × 54). Reproduced by permission of the Syndics of the Fitzwilliam Museum, Cambridge*

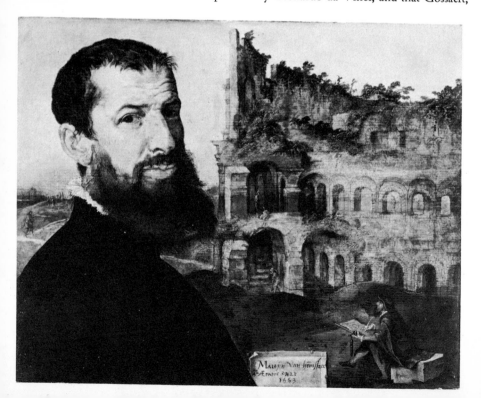

whose origins lay entirely in the older Eyckian tradition, looked for inspiration both to Leonardo and to Dürer himself (see Ills. 92, 93).

By the early 16th century it was the rule for northern artists to visit Italy, and they went there not only to absorb the lessons of the High Renaissance masters but also to study the ancient monuments. The artist who did most to make available in northern Europe a detailed knowledge of Roman antiquities was Scorel's pupil Marten van Heemskerck (Ill. 1), who spent several years in Rome drawing its ancient architectural remains and its masterpieces of classical sculpture. It is not surprising to find Carel van Mander – the 'Vasari of the North', whose Schilder-Boek of 1604 is our principal source of general information about Netherlandish painting, – describing Rome as 'the capital of Pictura's Schools'. Van Mander had studied in Rome as a young man in 1575, and on his return to the Low Countries had established an academy at Haarlem, along with Cornelis van Haarlem and the painter-engraver Hendrick Goltzius, with the aim of instructing northern artists in Italian Renaissance principles.

2 (below left) MARCANTONIO RAIMONDI *(c. 1480–1527/34) The Fall of Man. Engraving, 9⅜ × 6⅞" (24 × 17.5). British Museum, London*

3 JAN VAN SCOREL (1495–1562) Adam and Eve. Tempera and oil on panel, 18½ × 13¾" (47 × 34.9). The Metropolitan Museum of Art, New York, Gift of Mrs Stanford White, 1910

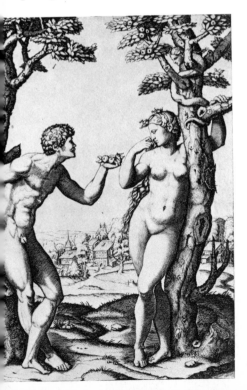

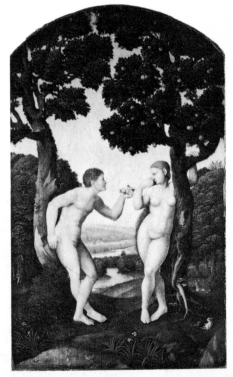

The spread of humanism to northern Europe played its own part in directing attention to Italy and to its Roman past. One of the early founders of humanism in Germany, Conrad Celtis, had given this advice to the writers and scholars of his time: 'Emulate, noble man, the ancient nobility of Rome, which, after taking over the empire of the Greeks, assimilated all their wisdom and eloquence. . . . In the same way you . . . should cast off repulsive barbarism and seek to acquire Roman culture.' And it is not without significance that we are able to see many of the great scholars of the period through the sympathetic eyes of such masters as Dürer, Massys and Holbein (*Ills. 100, 101*), the three principal creators of the humanist portrait in northern Europe.

At this point, however, another factor enters in, that brings home to us the ultimate independence of the northern genius; for as we study the likenesses of such men as Erasmus and More we know that we stand upon the threshold of the Reformation, that distinctively northern development for which their writings had prepared the way. The work of the many artists who embraced the Protestant cause highlights that 'hyperborean outlook', as Panofsky has termed it, which, in his own words, expresses itself in 'an independent individualism in artistic, intellectual and spiritual matters' and in 'a kind of quietism or introspectiveness based on an insurmountable feeling that the soul is not really at home in the body' – an aspect of the northern genius that seems to be summed up in Grünewald's great altarpiece at Colmar (*Ills. 119–122*).

The 16th century, then, gave birth to a style that, while preserving in its varied manifestations a distinctive character which separates it from contemporary or earlier developments in Italy, can be meaningfully categorized as Northern Renaissance. And indeed the whole of Europe beyond the Alps, and not least Catholic Spain and France, was to respond to the new ideals of which Italy was the fountainhead. In the 16th century the Renaissance became universal. But just as Grünewald could never be mistaken for anything but a product of the German School, so such masters as Clouet and Pilon in France or Alonso Berruguete and Luis Morales in Spain make us aware of the immensely varied nature of the whole vast pattern of development, as we pass from French elegance to Spanish mysticism. On the whole,

however, this pattern is constant in one vital respect, in so far as the process, whether gradual or sudden, constitutes a reaction against still potent Gothic traditions.

The long survival of these traditions poses, as we have seen, the question whether the stylistic currents of the 15th century outside Italy can be appropriately brought within the term 'Renaissance'. The problem is complicated by the undeniable fact that the founders of the Netherlandish School themselves made important contributions to the development of late 15th- and 16th-century painting in Italy – notably in portraiture and landscape and, above all, in their perfection of the oil-technique, without which the art of Leonardo or Titian would have been unthinkable. Nevertheless the spiritual differences, clarified so admirably by Huizinga, cannot be ignored, and the parallels with the literature and music of the period, drawn by Huizinga and developed further by Panofsky, offer us a unified picture of a culture at once medieval in character and 'progressive' in its impulse to come to terms with the beauty of the natural world.

The affinities between the detailed imagery of van Eyck and that of the poet Alain Chartier – one of whose descriptions of nature concludes with the statement, 'It looked like a painting, So many various colours there were' – are among the most striking of such parallels. In Huizinga's words, 'Thought takes the form of visual images'. Above all, perhaps, this new delight in nature expressed itself in an awakening to the beauty of light, and it is interesting to find that several works by van Eyck are inscribed with the text from *The Wisdom of Solomon* (describing Wisdom itself): 'For she is fairer than the sun'. Yet this vizualizing tendency of mind, founded as it was on pure observation, must be sharply distinguished from the rational approach of the Italians: the difference can be seen most clearly in the contrast between the Florentines' method of basing the spatial organization of their pictures upon a system of mathematical perspective and the apparently empirical approach to this problem of such painters as the Master of Flémalle and Jan van Eyck. In this as well as in other respects van Eyck and his contemporary Masaccio belong to quite separate worlds.

Although he did not himself coin the term, the 15th-century musicologist Johannes Tinctoris saw in the work of the English composer John Dunstable the creation of

an *ars nova*, or 'new art', which was developed by Guillaume Dufay and Gilles Binchois, both of them prominent figures at the court of Burgundy (where Binchois held the post of chaplain to Philip the Good). There is good reason to accept Panofsky's view that van Eyck's little half-length of a young man in the National Gallery in London (*Ill. 18*), mysteriously inscribed *Tymotheos* (the name of a celebrated musician of antiquity) and *Leal Souvenir*, is a portrait of Binchois. It is equally tempting to apply, with Panofsky, the term *ars nova* to the progressive tendencies that emerge from the International Style, or International Gothic, seen already at an advanced stage in the art of the Master of Flémalle and consummated in that of Jan van Eyck. For we may view this general process of stylistic development both as a manifestation of the 'waning Middle Ages' and as one of the most exciting explorations of the potentialities of painting in the history of European art; and we shall see that the development of northern European sculpture follows a parallel course.

We shall trace the origins of this development in the masters of the International Gothic, a well-defined artistic current that, although a product of the French and Burgundian courts, where it first made its appearance in the latter years of the 14th century, spread quickly to other centres, from Germany to Italy, becoming indeed a kind of *lingua franca* in Europe as a whole. Its chief characteristic is its combination of aristocratic elegance and rich decorativeness with an inquisitive naturalism that fixes attention upon the details of visual experience, whether in the depiction of landscape and animal forms or in the evocation of the luxurious trappings and adornments of courtly life.

The Forerunners: the court of Burgundy and the International Style

The stirring of a new artistic impulse which culminated in the realistic style of Jan van Eyck can be detected in a number of works produced in the latter part of the 14th century in France and Burgundy. This was the period in which the new State of Burgundy, with its capital at Dijon, was beginning to challenge the ascendancy of France, then embroiled in the disastrous Hundred Years' War with England. The Duchy of Burgundy originally comprised a relatively small area of eastern France, centred upon Dijon and Beaune. In 1363, when these lands reverted to the French Crown on the death of the last Capetian Duke, they were made over by Jean le Bon of France to his youngest son Philip, known as 'the Bold'. During the course of the next hundred years, by means of alliances and political marriages – such as Philip's own marriage to Marguerite of Flanders – the Duchy acquired extensive territories in the north, including Lorraine, Alsace, and a great part of the Low Countries.

At this time the Flemish port of Bruges was the principal trading centre of northern Europe, and the Netherlands enjoyed unrivalled prosperity. It was a prosperity founded chiefly upon the wool trade and the great weaving industries of Flanders. Once these territories had been absorbed into the Burgundian state, the Duchy tended to ally itself with England against French interests, for the weaving industry depended upon imports of wool from England; and, as we shall see, English art in the Tudor period was to be directly affected by these commercial and political links with the Low Countries. What more immediately concerns us is the fact that by the middle years of the 15th century most of the cities that are so closely associated with the founders of the Netherlandish School, such as Bruges, Ghent and Tournai, lay within the boundaries of the Duchy:

indeed Philip the Bold's grandson, Philip the Good, was eventually to transfer his capital to Bruges, where he employed Jan van Eyck as his court painter.

The rise of the Burgundian 'empire' under Philip the Bold and the accession to the French throne in 1364 of his eldest brother Charles V, known as 'the Wise', ushered in one of the great ages of patronage. Charles V, Philip the Bold and another brother, the cultured Jean, duc de Berry, all employed great masters at their courts. That universal genius André Beauneveu, whom Froissart described in his *Chronicles* as an artist without peer among his contemporaries, erected the imposing tomb of Charles V in the abbey church of St Denis, and was later to be employed by Jean de Berry as a sculptor, an illuminator and a designer of stained glass windows.

The new life and conviction of Beauneveu's sculpture, anticipating the revolutionary art of Claus Sluter, the major sculptor active in the years around 1400, are matched in painting by a similar development towards realism of presentation and intimacy of feeling. Among the painters employed by Charles V, we must single out Jean Bondol, the head of a large workshop in Paris although he himself came from Bruges. In the famous *Hague Bible,* which he illuminated for Charles V in 1371, Bondol portrayed the king not as the panoplied monarch but as the studious scholar (*Ill. 4*): wearing the cap and gown of a Master of Arts of Paris University, the king is seated in an attitude of simple and grave attentiveness as he receives the completed Bible from a courtier. The mastery of pictorial space exhibited in this little dedication miniature must owe much to Italian traditions deriving from the innovations of Giotto and the Lorenzetti, and similar influences account for many of the stylistic qualities of another famous work of the period, the *Parement de Narbonne* in the Louvre, an altar-hanging (*parement*) painted in *grisaille* on silk at some time before the year 1380.

Not long after the death in 1380 of Charles V, a new phase of artistic activity opened with the foundation by his brother Philip the Bold of a great Carthusian monastery at Champmol, near his capital of Dijon. The Chartreuse of Champmol (now a hospital) is celebrated for the works executed there by the Netherlandish sculptor Claus Sluter, whom we shall consider presently; but other artists worked for the Chartreuse before and

4 JEAN BONDOL (active 1368–81) *Dedication miniature from the Hague Bible, 1371. Rijksmuseum Meermanno-Westreenianum, The Hague*

5 MELCHIOR BROEDERLAM (active 1381–c. 1409) *The Presentation in the Temple and the Flight into Egypt, exterior of right wing of the Champmol altar, 1394–9. Panel, 5' 6" × 4' 1" (167 × 125). Musée des Beaux-Arts, Dijon*

after him, including the Flemish sculptor Jacques de Baerze, the painters Melchior Broederlam (from Ypres), Jean Malouel (from Guelders), Henri Bellechose (from Brabant) and probably the Master of Flémalle (usually identified with Robert Campin of Tournai; see Chapter Three). It will be apparent from this list that already many of the leading artists of the time had their origins in the Low Countries, even if they still acquired their training in Paris – as Malouel certainly did, for his *Trinity,* in the Louvre, represents at its most tender the graceful style fashionable around 1400 at the French court.

Among the works commissioned for the Chartreuse before the arrival of Sluter special importance must be attached to a carved altarpiece by Jacques de Baerze, the two wings of which bear on the outside paintings by Broederlam (*Ill. 5*). When the shutters are open the altarpiece shows three scenes carved in high relief, below intricate canopy work containing a profusion of Gothic detail, together with figures of prophets and angels. This type of altarpiece is evidently of German origin. We know that Jacques de Baerze had completed his work on the altarpiece by 1391, and that the wings (sent to Broederlam at Ypres) were paid for in 1394 and finally installed five years later.

The Dijon altar wings demonstrate that Broederlam

6 JACQUES DE BAERZE (late 14th C.) *Interior of the Champmol altar, 1390–91. Polychromed wood, 5′ 6″ × 4′ 1″ (167 × 125). Musée des Beaux-Arts, Dijon*

17

was among the first to develop what we call the Inter-
national Style, or International Gothic. The delicate
grace prevalent in his figures and in much of the detail is
typically French; but his adventurous management of
space and perspective provides a further illustration of the
decisive role played by Italian influences upon northern
art in this period. Elements in the scene of the Presentation
on the right wing (*Ill. 5*) are reminiscent of the work of
the Lorenzetti: yet Broederlam's treatment of perspective
is less consistent than that of his Italian predecessors – as
is evident from the drawing of the lantern surmounting
the domed building on the left. His originality lay in his
feeling for landscape and in his interpretation of light,
qualities that come to the fore in the scene of the Flight
into Egypt (*Ill. 5*). Here we are led step by step into the
spatial world of a true landscape-painter whose powers
of observation foreshadow those of van Eyck. Moreover
the sturdy St Joseph, whose rough appearance must
surely have been taken straight out of life, anticipates in
a remarkable manner the peasants and labourers of
Bruegel (*Ills. 76, 77*), or, before Bruegel's time, the famous
shepherds of the *Portinari Altarpiece* (*Ill. 32*).

The art of Claus Sluter had its origins in the same world
of International Gothic, but his great works for Champ-
mol must have seemed from the beginning to stand alone
in their majestic grandeur, and in modern criticism
Sluter has been likened to such key figures in the history
of Italian Renaissance sculpture as Donatello and Jacopo
della Quercia: his impact upon the 15th century was
certainly not less than theirs, and affected the course of
northern European sculpture and painting in equal
measure, whether in France, the Low Countries or
Germany. Sluter executed four great works for Champ-
mol. They are the splendid portal, completed in 1397;
the gigantic Calvary, placed over a well-head in the
monastery cloisters (now usually referred to as the *Well
of Moses*, from the fact that the main part to have survived
is the base of the monument, surrounded by figures of
Moses and other prophets), begun in 1395 and finished
by 1403; the continuation of work on the tomb of Philip
the Bold, which had been left unfinished by Jean de
Marville and which after Sluter's death in the winter of
1405–6 was to be completed by his nephew Claus de
Werve; and a *Pietà* for the chapter-house, of which a
copy is preserved at Frankfurt.

To understand what van Eyck may have learnt from
Sluter we have only to compare the donor statues from
the portal at Champmol (*Ill. 7*) with such figures as van
Eyck's Jodoc Vyt and his wife, on the *Ghent Altarpiece*
(*Ill. 16*), or his still more memorable character-study of
Canon van der Paele (*Ill. 19*). The way was now open
for realistic portraiture – already emergent in Bondol's
dedication miniature (*Ill. 4*) – to be given new life by the
panel painter as he faced the task of creating an illusion of
the three-dimensional world comparable in its con-
viction of reality with polychromed sculpture; a process
that was to give birth to the modern portrait.

The affinities between the two arts are less apparent
now because of the general loss of the brilliant colouring
and gilding that originally adorned the sculpture of the
period; but this final stage in the completion of a work of
sculpture formed a normal part of a painter's duties, so
that painters and sculptors were always in close contact
with each other. No less distinguished a master than Jean
Malouel was one of the artists entrusted with the colouring
of the statues on the *Well of Moses*. A fondness for

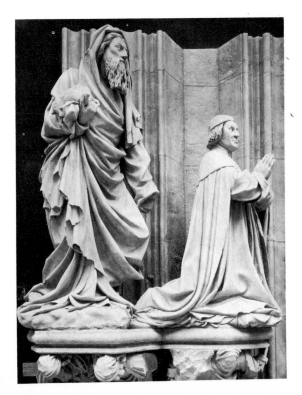

7 CLAUS SLUTER (active *c*. 1380–
1406) *St John the Baptist and Philip
the Bold, from the portal of the
Chartreuse de Champmol, 1391–7.
Stone, about life-size. Musée des
Beaux-Arts, Dijon*

19

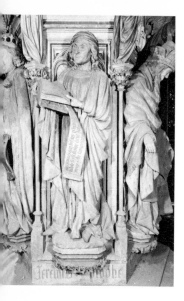

8 CLAUS SLUTER (active *c.* 1380–
1406) *Jeremiah, detail of the Calvary
or Well of Moses, 1395–1403.
Stone, originally polychromed, about
life-size. Chartreuse de Champmol,
Dijon*

glittering decorativeness was typical of the age, and found expression as much in the vivid spectacles afforded by court pageants and Church festivals as in International Gothic manuscript illumination and in the elaborate gems of the period, in which the craft of the jeweller joined hands with that of the goldsmith.

The original effect of the *Well of Moses* must have been that of a dramatic *tableau vivant*. At its apex was a representation of the crucified Christ, with the Virgin, St John the Evangelist and St Mary Magdalen at the foot of the Cross. (Of the Calvary group only the head of Christ, with part of the torso, is preserved.) The association of the Calvary with a well alludes to the Johannine image of Christ as the source of 'water springing up unto eternal life'. The six prophets below were intended to complement the solemn theme of the salvation wrought by Christ's sacrificial death, to which the Latin texts inscribed on their scrolls are all related. The scroll of Jeremiah (*Ill. 8*), for example, cites a famous passage in Lamentations which was interpreted from early Christian times as being prophetic of Christ's crucifixion: 'Is it nothing to you, all ye that pass by? Behold, and see if there be any sorrow like unto my sorrow, which is done unto me.' The tragic countenances and grave gestures of these figures express the same mood of grief too heavy to be borne: to Huizinga the *Well of Moses* seemed 'a threnody of six voices rising up to the Cross'.

The monumental *gravitas* of Sluter's masterpiece, which is common also to the *Pietà* and to the tomb of Philip the Bold, can be seen both as the climactic expression in sculpture of the Late Gothic spirit and as the embodiment of a new ideal, much as Nanni di Banco's *Santi Quattro Coronati* at Orsanmichele in Florence marks the dividing-line between Italian Gothic sculpture and the early phase of the Florentine Renaissance. And just as the Orsanmichele figures anticipate the art of both Donatello and Masaccio, so Sluter's work at Dijon stands at the head of the realistic movement in northern European sculpture that stretches from Nicolaus Gerhaerts (*Ill. 51*) to Germain Pilon (*Ill. 151*), as well as making its impact upon such painters as van Eyck, the Master of Flémalle, Rogier van der Weyden and Konrad Witz.

In view of Sluter's historical importance, and especially in view of his intrinsic greatness as an artist, it is tragic that neither the Dijon Calvary nor the tomb of Philip the

Bold can now be seen in its entirety. One of the famous *pleurants,* or weepers, from the ducal tomb is now among the medieval treasures of the Cleveland Museum.

The losses in architecture are no less severe in this period. The duc de Berry, for example, although best known today as the begetter of a celebrated group of books of hours, and above all of the *Très Riches Heures* illuminated by the brothers Limbourg, was famous in his own lifetime as one of the great builders of the age: yet little now survives of the magnificent residences that he erected or remodelled in various parts of his domains or of the churches that he endowed.

The most important of these edifices were the palace at Bourges, the adjoining Sainte-Chapelle, and the château of Mehun-sur-Yèvre outside the city. Of the palace only the main hall now stands, but its general appearance, like that of the Sainte-Chapelle, is known from drawings. Views of some of the duc de Berry's châteaux, such as those at Mehun, Lusignan and Dourdan, figure in a

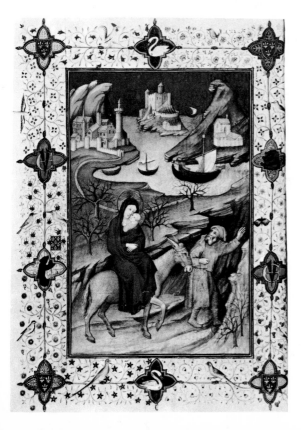

9 JACQUEMART DE HESDIN (d. c. 1410) *The Flight into Egypt, miniature from the Brussels Hours; after 1385, documented by 1402. 10¾ × 7¼″ (27.5 × 18.5). Bibliothèque Royale Albert I, Brussels*

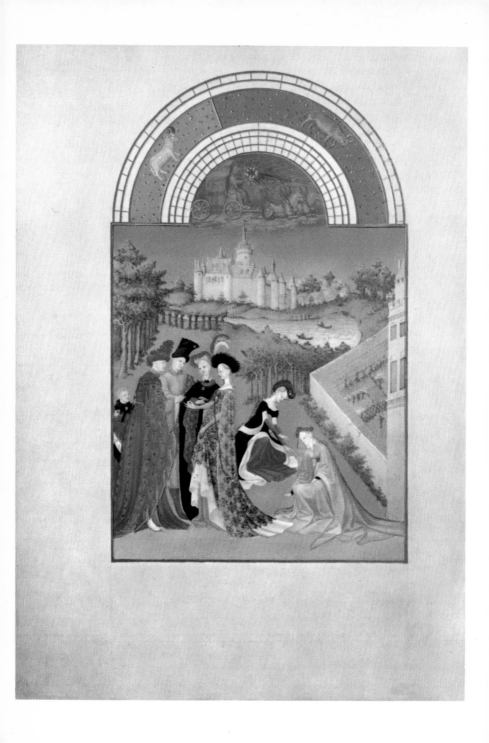

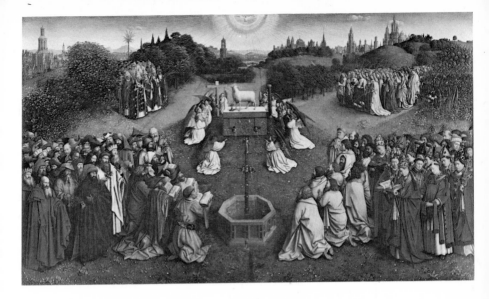

number of the landscape backgrounds in the *Très Riches Heures* (*Ill. 10*). All these buildings were designed in the Gothic style, and they show a predilection for refined and yet elaborate detail. They were the repositories of major works of painting and sculpture, many of them by the much sought-after André Beauneveu. Beauneveu's most important work in sculpture, among those that have survived, is the tomb of Charles V in St Denis; he also designed windows for the Sainte-Chapelle, and illuminated a psalter for the Duke containing a sculpturally conceived series of prophets and apostles.

Another great artist patronized by the duc de Berry, Jacquemart de Hesdin, introduced a revolutionary innovation into the art of manuscript illumination, for in the so-called *Brussels Hours* of 1400 he allowed the miniatures to fill the entire page, independently of the accompanying text, so giving them something of the value of paintings on panel. It is interesting to compare Jacquemart's interpretation of the Flight into Egypt (*Ill. 9*) with the slightly earlier panel painted by Broederlam for the Champmol altar (*Ill. 5*). There is a new freedom; the artist has escaped from some of the conventions and limitations of manuscript illumination, and achieved an unprecedented naturalism. The page ceases to be merely a flat, decorated surface; the depths of the picture-space open out; and we become aware of a novel search for purely pictorial harmonies. It is equally clear

11 JAN (1385/90–1441) and HUBERT? VAN EYCK Adoration of the Holy Lamb, central panel of the Ghent Altarpiece, c. 1426–32/4. Oil on panel, 4' 5"×7' 9" (135 × 236). St Bavon, Ghent

10 (opposite) THE BROTHERS LIMBOURG (early 15th C.) April, calendar miniature from the Très Riches Heures du Duc de Berry, 1413–16. 8½ × 5½" (21.6 × 13.9). Musée Condé, Chantilly

that Jacquemart de Hesdin, who probably visited Italy, no longer felt any need to repeat Italian landscape conventions in the old way, but preferred to observe nature anew for himself. This new naturalism was to be developed in the early years of the 15th century by the so-called Boucicaut Master (named after a book of hours commissioned by the Marshal of France, Jean le Maigre, known as Boucicaut) and above all by the brothers Limbourg – Pol (or Paul), Herman and Jehanequin (or John).

The Limbourgs probably came from Limbricht (originally Lymborch) in the Netherlands, and received their training under a goldsmith in Paris. Pol and Jehanequin are known to have worked for Philip the Bold from 1402, but by 1411 all three were in the service of Jean de Berry, succeeding Jacquemart de Hesdin in office and enjoying exceptional privileges at the ducal court. There is an element of eclecticism in their art, in the sense that they brought together within the terms of the International Style the traditions established by Broederlam, the Boucicaut Master and Jacquemart, reinforced by a renewal of that Italian influence which had been one of Jacquemart's most potent sources of inspiration. Their masterpiece, the *Très Riches Heures du Duc de Berry* (which was left unfinished on the Duke's death in 1416 and completed some seventy years later by Jean Colombe), is remarkable for its calendar cycle, comprising twelve scenes each illustrating a particular month. In several of these we are admitted to the entertainments and customs of the aristocracy: *January*, for instance, shows us a splendid banquet given by the Duke; *April* the betrothal of a high-born couple, perhaps Charles d'Orléans and the Duke's granddaughter Bonne (*Ill. 10*); and *August* a hawking-party setting out, with fair companions in amorous attendance. In such scenes the painters, dwelling upon the elegance of the courtly figures and upon the sumptuousness of their attire, have woven miniature tapestries of graceful shapes and delicately varied colours which give the compositions a highly ornamental character. Here, we may conclude, breathes the essential spirit of International Gothic.

Yet the art of the Limbourg brothers had another aspect. Other scenes in the *Très Riches Heures* cycle show us the daily occupations of the peasantry, and in this they anticipate the frank scrutiny of Pieter Bruegel well over

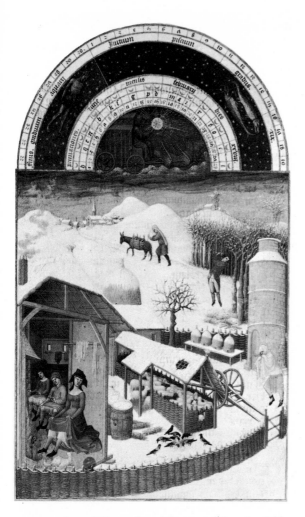

a century later. We see farm-labourers tilling the fields, mowing the hay and gathering in the harvest; others are engaged in sheep-shearing or in the tending of pigs; but perhaps the most remarkable scene of all, and one that most forcibly brings Bruegel to mind, is *February* (*Ill. 12*) – a spacious snowscape stretching into the distance, where labourers are still at work in the cold, while within a simple farmhouse in the foreground two peasants warm themselves by a fire in attitudes more practical than modest, as the mistress of the house discreetly averts her eyes.

12 THE BROTHERS LIMBOURG (early 15th C.) *February, calendar miniature from the Très Riches Heures du Duc de Berry, 1413–16. 8½ × 5½″ (21.6 × 13.9). Musée Condé, Chantilly*

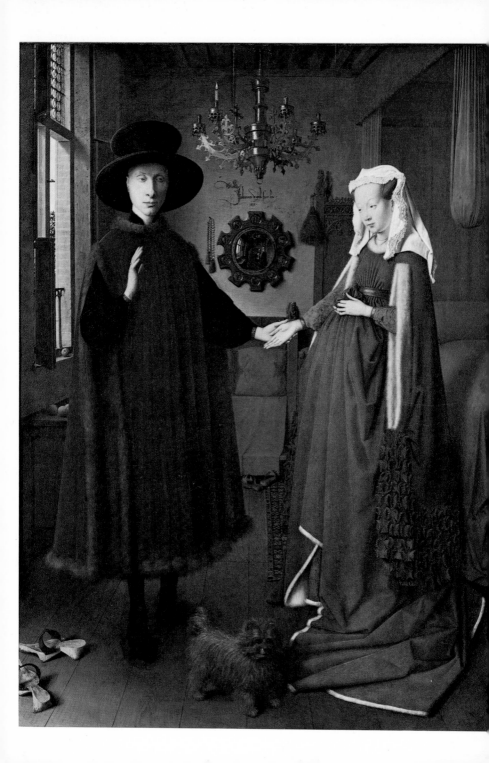

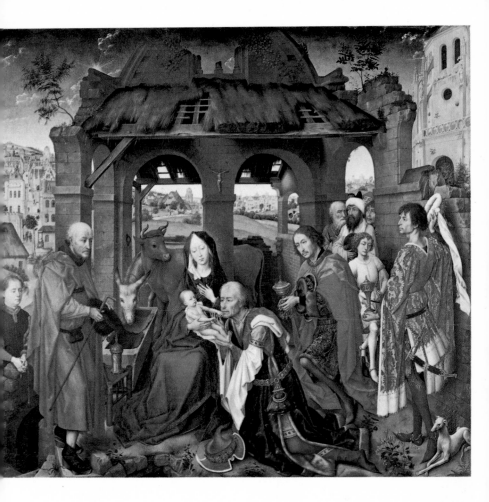

The brothers Limbourg can therefore be seen both as the heirs to traditions deriving from the courtly style of International Gothic, which finds its own consummation in their delicately sensitive art, and as forerunners of a new manner which was to turn away from the purely ornamental graces of International Gothic in its exploration of nature and in its deeper concern for humanity. It is their astonishing powers of observation, whether in their marvellous landscapes or in their sympathetic portrayal of the common man, that remain their most memorable qualities, and relate them to the great school of Netherlandish painting founded by Jan van Eyck, the Master of Flémalle and Rogier van der Weyden.

14 ROGIER VAN DER WEYDEN (1399/1400–1464) *Adoration of the Magi, central panel of the St Columba Altarpiece, c. 1462. Oil on panel, 4' 6"×5' (138×153). Alte Pinakothek, Munich*

13 (opposite) JAN VAN EYCK (1385/90–1441) *Supposed portrait of Giovanni Arnolfini and his wife Giovanna Cenami, 1434. Oil on panel, 32¼×23½" (81.8×59.7). Courtesy the Trustees of the National Gallery, London*

The Netherlands, I: Jan van Eyck, the Master of Flémalle and Rogier van der Weyden

The early writers, from Bartolomeo Fazio and Giovanni Santi in the 15th century, to Giorgio Vasari and Carel van Mander in the age that followed, all placed Jan van Eyck at the head of the Netherlandish School, of which he was regarded as the founder. Only one other name was considered worthy of mention in the same breath – that of Rogier van der Weyden (or in its French or Walloon form, Roger de la Pasture), who was then wrongly believed to have been van Eyck's pupil. To the modern historian the origins of Netherlandish painting appear far more complex and problematic, and it has even been argued that its true founder was not van Eyck at all but the 'Master of Flémalle' (so called from an erroneous tradition that a number of panels now at Frankfurt came from an abbey or castle at Flémalle in the Netherlands), an artist usually identified with Robert Campin of Tournai and accepted by most authorities as the teacher of Rogier van der Weyden. What seems quite clear is that van der Weyden's style, although indebted in part to that of van Eyck, had its origins in different traditions.

There are other problems besides. A radical school of criticism maintains that all the works grouped together under the name of the Master of Flémalle are, in reality, early works by van der Weyden. And the problem of Jan van Eyck's own origins is complicated by two factors – the doubts that have been raised about his presumed authorship of some miniatures in a book of hours at one time in the possession of the duc de Berry (now known as the *Turin Hours*), and the larger question-mark that hangs over the very existence of his legendary elder brother Hubert van Eyck.

With the details of these controversies we cannot be concerned here; and in any case it is probably wise to

keep such questions open, since new evidence can always upset conclusions that are unsupported by adequate documentation. It is, however, important to state some of the known facts, and we shall consider these in relation to each painter.

Jan van Eyck is first recorded in 1422, when he was in the service of John of Bavaria, Count of Holland; in 1425 he became court painter to Philip the Good, living first at Lille and then at Bruges, where he was to die in 1441.

The mystery of 'Hubert van Eyck' has been debated with the utmost vigour. It is directly related to the author-ship of the greatest and most renowned of all the master-pieces of early Netherlandish painting, the huge altarpiece of the *Holy Lamb* executed for the church of St John – now the cathedral of St Bavon – in Ghent (*Ills. 11, 16, 17*). On the authority of a Latin quatrain inscribed on the outer shutters, which remained undiscovered until the 19th century, most modern scholars accept the *Ghent Altarpiece* as a work begun by 'Hubert van Eyck', left un-finished at his death, and completed in 1432 by Jan. Others, however, have doubted the authenticity of this inscription, and it has been suggested that political motives may have been at work. No 15th-century writer seems to have been aware of the existence of Hubert, Jan van Eyck being given the credit for the painting of the entire altarpiece. Yet the Latin quatrain goes out of its way to explain that Hubert was a greater master than Jan. Was Hubert, who reputedly lived and died at Ghent, invented to give the city a glory of its own rivalling that of Bruges, celebrated for the works executed there by Jan van Eyck?

Those who argue for the real existence of Hubert van Eyck, the elder brother of Jan, point to documentary references between 1424 and 1426 to a 'Master Luberecht' who was paid by the Ghent magistrates for designs for an altarpiece, as well as to a 'Master Ubrechts' and to a 'Master Hubrechte the painter'. A further document of 1426 refers to the heirs of 'Lubrecht van Eycke', although this Lubrecht is not specifically described as a painter. The document mentioning 'Master Hubrechte the painter', which is also dated 1426, is of particular interest, since we learn from it that the artist had in his studio a statue and other parts of an altarpiece; but if this was the still incomplete altarpiece of the *Holy Lamb,*

which according to the Latin quatrain Jan van Eyck is supposed to have finished, we still do not know why it was finally set up as a painted altar without sculpture.

The orthography of the quatrain is not easy to decipher, but the most acceptable reading of it in its present state is perhaps the following:

*Pictor Hubertus eyck, maior quo nemo repertus
Incepit. pondus. que Johannes arte secundus
[Frater] perletus Judoci Vijd prece fretus
Versu sexta mai. vos collocat acta tueri.*

('The painter Hubert Eyck, than whom none was greater, began this work, which his brother Jan, who was second to him in art, completed at the behest of Jodoc Vyt, and which he invites you by this verse to contemplate on 6 May 1432.') The date 1432 is supplied by a chronogram in the last line. However, a recent examination and philological analysis of the quatrain seems to demonstrate that it has been tampered with, and that in its original form it read:

*Picturae expertus, maior quo nemo repertus,
Pulchri fecundus, cui Apelles arte secundus,
Johannes laetus, Judoci Vijd prece fretus,
Versu hexametri vos pellicit haecce tueri.*

('Jan [van Eyck], a man skilled in painting, with a prolific genius for the beautiful, than whom none was greater and to whom even Apelles was inferior in art, invites you in hexameter verse, at the behest of Jodoc Vyt, to contemplate this work.') This is less barbaric Latin; but what is more important is that the quatrain as reconstructed excludes all reference to Hubert van Eyck, saying instead, not that Jan was inferior to Hubert, but that Apelles himself – the classical Greek painter whose realism was legendary – was second in art to Jan. Furthermore the chronogram in the last line now gives the date 1434 rather than 1432 for the completion of the altarpiece. (See A. Ampe, 'De metamorfozen van het authentieke JanvanEyckkwatrijn op het Lam Gods: een nieuwe filologische studie', in *Jaarboek van het Koninklijk Museum voor Schone Kunsten, Antwerpen,* 1969, pp. 7ff.)

It has often been maintained that some parts of the *Ghent Altarpiece* show a less 'advanced' style and a more 'poetic' vision than others; but even if this is so the question still remains whether we are entitled to infer the presence of two distinct hands or whether it is simply a case of a

stylistic evolution within a single personality. The central panel, the *Adoration of the Lamb (Ill. 11)*, belongs in general to the first of these stylistic categories. Unfortunately there exist no signed or documented works by the putative 'Hubert van Eyck' with which comparisons can be made; but an interesting group of paintings, which includes two panels in the Metropolitan Museum in New York (the *Crucifixion* and the *Last Judgment*), a panel in Berlin (also a *Crucifixion*), and the lovely *Three Maries at the Sepulchre* in the Boymans-van Beuningen Museum at Rotterdam, and which can be related stylistically to the less 'progressive' parts of the *Ghent Altarpiece,* has been ascribed by various authorities to 'Hubert', along with some of the miniatures in the *Turin Hours*.

The most widely accepted view, accordingly, is that the *Holy Lamb* panel and certain other portions of the altarpiece were begun and largely completed by Hubert van Eyck before his presumed death in 1426, and that the down-to-earth realism of the *Adam* and *Eve* and the donor portraits (*Ill. 16*), which is consistent with Jan van Eyck's known style in the early 1430s, gives us the vital clue to the nature and scope of Jan's personal share in the execution of the work as a whole. Fortunately Jan van Eyck signed and dated a considerable number of his paintings – among them the *Tymotheos (Ill. 18)* of 1432, the *Man in a Red Turban* of the year after, and the *Giovanni Arnolfini and his Wife (Ill. 13)* of 1434 (all in the National Gallery, London). It is arguable that the portrait of Jodoc Vyt on the *Ghent Altarpiece* shows a greater maturity and assurance than the *Tymotheos,* bringing it closer to the *Man in a Red Turban* and to the *Arnolfini Portrait,* and that the mastery of space and perspective demonstrated by Jan van Eyck in the latter picture represents the consummation of the spatial explorations that are reflected most obviously in the *Ghent Altarpiece* in the *Annunciation* on the outer shutters, immediately above the donor portraits.

A strikingly similar approach to perspectival problems can be seen in the miniature of the *Birth of the Baptist (Ill. 15)* in the *Turin Hours*, and it is not impossible that Jan van Eyck worked as a manuscript illuminator at some stage in his career. The *Turin Hours* are usually, although not universally, dated before 1417, and their historical importance lies in their apparent reflection of an 'Eyckian' style at what may be a very early stage in its development – perhaps about a decade and a half before

the completion of the *Ghent Altarpiece*. It is in the *Turin Hours* that the stylistic origins of Hubert van Eyck have also been sought. Nevertheless some doubt surrounds the date of the miniatures: Charles de Tolnay, for example, assigns them to the fourth or fifth decade of the century and ascribes them to a skilful disciple of Jan van Eyck. We know, however, that Jan van Eyck was already an established master by the year 1422, and on stylistic grounds two panels of special importance – the *Virgin in a Church* at Berlin and the Washington *Annunciation* – can be placed somewhere within his early period: but even these works take us into the 1420s, and only if we were to assume that Jan was definitely the author of the Turin miniatures could we glimpse anything of his development before 1420, and then doubtfully.

Nor can we be certain about the precise nature of Jan

15 ?JAN VAN EYCK (1385/90–1441) *The Birth of the Baptist, miniature from the Turin Hours, c. 1435? 11 × 7½″ (28 × 19). Museo Civico, Turin*

van Eyck's contribution to that technical revolution which led later writers to give him the credit for the invention of oil-painting. What matters is that he brought the new technique to a marvellous perfection. Oil-painting was known long before the 15th century, but it had proved to be an extremely intractable medium: no suitable diluent had been discovered, so that refinement of brushwork was made difficult, and the thick oil then in use had the effect of darkening the colours.

The technical revolution introduced by the Flemish masters was made possible by the discovery of turpentine, which they mixed with refined oil, applying the colours in thin glazes of the utmost delicacy. The artist approached his task with careful deliberation. First, the panel was prepared with a smooth coat of gesso, and this white surface accounts in great measure for the radiant luminosity of early Flemish paintings; over this the design would be drawn, and then modelled up in detail in a brownish monochrome; finally, the colours would be applied, often in a succession of thin glazes, so that the underlying pigments subtly modified the transparent films of colour superimposed upon them. Before he began painting, the artist would have made a finished drawing on paper, like the superb study by Jan van Eyck for the presumed portrait of Cardinal Albergati at Dresden. Yet despite the care with which the painter made his preparations he sometimes changed his mind about a particular passage as his work proceeded: one example is provided by the *Arnolfini Portrait* (*Ill. 13*), for infra-red photography has disclosed that van Eyck made radical alterations to Arnolfini's hands and to other parts of the composition.

It was the *Ghent Altarpiece* that revealed the full potentialities of the new Eyckian technique. Its unveiling in 1432 or 1434 may be described as the most historic moment in the development of northern painting before the age of Rubens and Rembrandt. The shutters of the altarpiece, when closed, comprise eight panels – four arched panels at the top and four rectangular panels below (*Ill. 16*). The upper panels are divided in order to provide a sequence of three lunettes containing figures of prophets and sibyls, and to define a large oblong field beneath them, on which there is represented – as a continuous composition painted on all four panels – the central scene of the *Annunciation*. The four panels in the

lowest register, each framed by a traceried archway, contain, at the centre, monochrome figures of St John the Baptist and St John the Evangelist, simulating statuary not yet polychromed, and, at the outside, the donor portraits of Jodoc Vyt and his wife, reverently kneeling in prayer and facing inwards.

No doubt the perfection of the whole harmonious scheme would have astonished the citizens of Ghent when they first beheld this miracle of painting: the two portraits must have seemed like living presences of flesh and blood; and there had never been an interpretation of sacred legend to compare in its conviction of reality with van Eyck's luminous *Annunciation*. The entire central area of the *Annunciation* is given over to triumphant illusionism, and the light-filled interior opens out upon a prospect of some Flemish town such as Bruges or Ghent itself. In his treatment of the interior van Eyck may well have been influenced by the *Merode Altarpiece* (*Ill. 22*), but a comparison between the two works demonstrates that van Eyck was the first to master the problem of spatial representation, an achievement that was to have a profound effect upon the Master of Flémalle's later style. In the Ghent *Annunciation*, it will be noticed, the light falls from a point behind the spectator, and so intense is the artist's realism of purpose that the lattice-like framings of the polyptych are imagined as throwing shadows upon the floor of the Virgin's room: light has begun to play a new role in painting.

When the shutters of the altarpiece are opened – as they would have been on feast-days and other special occasions – the overall unity of the whole, notwithstanding the cavillings of modern criticism, is no less impressive (*Ill. 17*). Beneath an imposing reinterpretation of the traditional *deësis* (a representation of the Godhead, with the Virgin and the Baptist on either side), there is spread before our eyes the celestial meadow-land of the New Jerusalem. In the central panel, beyond the Fountain of Life, angels kneel in adoration around the altar of the Lamb, four of them holding in their hands the Instruments of the Passion; above, the Dove symbolic of the Third Person of the Trinity sheds a golden radiance from the heavens. The central scene is continued in the four lateral panels. Above these, in the upper register, the *deësis* group is flanked by musician-angels, while the narrow panels at the extremities contain life-size figures

16 (opposite) JAN (1384/90–1441) and HUBERT? VAN EYCK *Altarpiece of the Holy Lamb (Ghent Altarpiece), c. 1426–32/4: shutters closed. Oil on panel, 11′ 6″ × 7′ 9″ (350 × 236). St Bavon, Ghent*

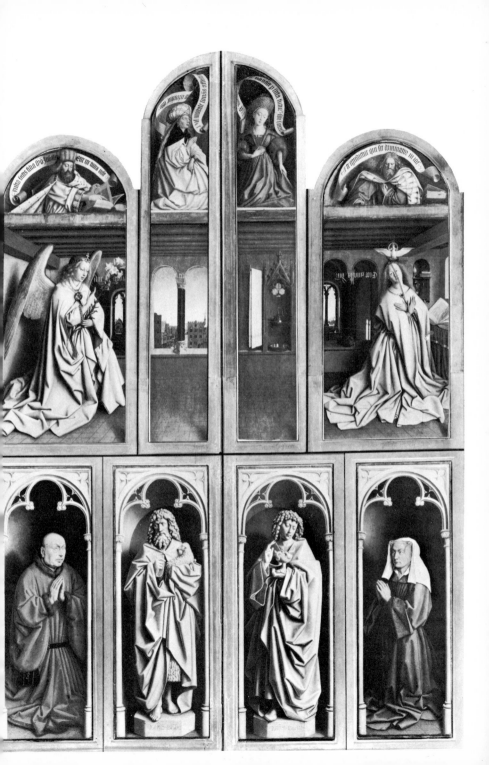

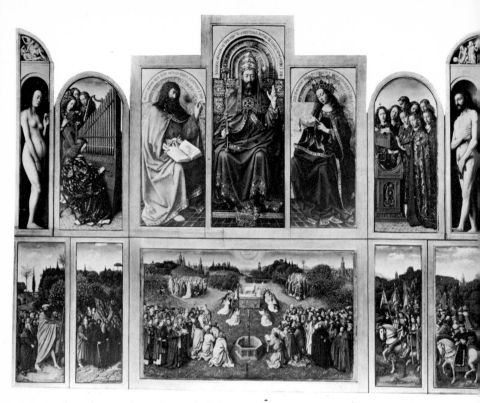

17 JAN (1385/90–1441) and HUBERT? VAN EYCK *Altarpiece of the Holy Lamb (Ghent Altarpiece),* c. 1426–32/4: shutters open. Oil on panel, 11′ 6″ × 14′ 5″ (350 × 439.5). St Bavon, Ghent

of Adam and Eve, surmounted by small-scale representations in *grisaille* of Abel's sacrifice and the murder of Abel, reflections of the 'Original Sin' inherited from Adam which made necessary the redemptive sacrifice of Christ.

The principal theme, which the subsidiary images all reinforce, derives chiefly from the passage in the Book of Revelation (7:9 ff) read as the Epistle for All Saints' Day:

I saw, and behold, a great multitude, which no man could number, out of every nation, and of all tribes and peoples and tongues, standing before the throne and before the Lamb, arrayed in white robes, and palms in their hands; and they cry with a great voice, saying, Salvation unto our God which sitteth on the throne, and unto the Lamb.

This 'great multitude' presses in towards the altar and the Fountain of Life from either side – to the right of the fountain, a group containing the apostles and martyrs; to its left, prophets, patriarchs and sages, among them the white-robed Virgil, whose fourth *Eclogue* was seen

as a prophecy of Christ's coming; further back, beyond the altar, confessors and holy virgins; in the shutter panels, the 'Just Judges' (represented by a copy, the original having been stolen in 1934); next, the 'Knights of Christ', including St George; finally, on the right side, the holy hermits and then the holy pilgrims, led by the giant St Christopher.

The beauty of the *Ghent Altarpiece* is like the beauty of jewels scattered over some richly woven vestment: the eye is caught by a multitude of finely wrought details before it grasps the harmony of the whole. This harmony is not of our times, but belongs to the late-medieval world of the 15th century; and some of the anomalies that have been detected in the organization of the altarpiece would seem to be figments of modern sensibility. It has been pointed out, for example, in respect of the interior panels, that the figures of Adam and Eve are seen from below, whereas all the other figures and scenes are represented from above. The discrepancy in scale between the upper and lower registers has also been noted.

The first of these difficulties may have a simple theological explanation. The figures of Adam and Eve do not belong to the heavenly vision experienced by St John the Divine which is the principal subject of the altarpiece: they are subsidiary symbols of unredeemed humanity, and they stand in their own space, within dark niches unilluminated by the radiance of Paradise. Placed in the upper register, they are skilfully represented in perspective, as though seen from below; and a similar treatment was given to the two prophets – Zacharias and Micah – on the outer sides of the shutters (as is especially clear from the large book which Zacharias is perusing). All the other interior panels belong to a different spatial world, the world of St John's visionary experience, when on being bidden by a divine voice to 'come up hither' he ascended to the heavens in the spirit.

As to the second problem, it is difficult to see how matters could possibly have been arranged in such a way as to accord the 'multitude which no man could number' a scale similar to that of the majestic *deësis*; nor could the panel of the *Adoration of the Lamb* (*Ill. 11*) have been given a much greater height without diminishing proportionately that effect of an almost boundless panorama which is so appropriate to the sublime theme of the lower register, and which links together its component parts.

The *Ghent Altarpiece* displays all the riches of van Eyck's genius, and his later achievements can be seen as developments and extensions, as it were, of its various qualities – from its sheer technical mastery to the calm authority of its spiritual content, which goes hand in hand with a novel realism and objectivity. When we compare him with his contemporary Rogier van der Weyden, who was more concerned with the expression of interior feeling, it is perhaps van Eyck's marvellous eye that impresses us most; and it was likewise the astonishing clarity of his vision that made him one of the greatest of all portrait-painters and that would have especially recommended him to his patron Philip the Good.

On several occasions van Eyck's duties as the Duke's painter and *varlet de chambre* took him abroad, and when in 1428 he accompanied the diplomatic mission sent to Lisbon for the purpose of negotiating Philip's marriage to Isabella of Portugal, it must have been chiefly in his capacity as a portrait-painter, for the Duke was desirous of obtaining a likeness of his prospective bride. During this visit van Eyck seems also to have travelled in Spain: his presence was to have important consequences for the history of Spanish painting.

At the Burgundian court itself, van Eyck received every mark of honour and respect: the Duke addressed him on one occasion as 'our excellent painter and friend', and even acted as sponsor at the baptism of one of his children. Jan van Eyck was evidently a man of wide culture: one Italian writer, Bartolomeo Fazio, says in his *De Viris Illustribus* (published about 1455) that van Eyck was proficient in geometry, geography and chemistry, and that he was acquainted with the writings of Pliny; and it is of some interest that the famous motto inscribed on the frame of the London *Man in a Turban* – 'Als ich kan' ('As I can') – is written in Greek letters.

All van Eyck's pictures convey a sense of solemn wonder, of a grave acceptance of the miracle of existence; and this feeling is nowhere more in evidence than in the *Arnolfini Portrait* (*Ill. 13*), a work whose tiny scale belies the impressiveness, even the monumentality, of its conception. To some extent, of course, this is a religious picture: various details, such as the candle, symbolic of the Light of the World, the discarded slippers, suggesting reverence, the carved statuette of St Margaret, patroness of child-bearing women, and the scenes of the Passion in

the medallions decorating the circular mirror, remind us
that the imagery of medieval art often conceals allusions
that may escape the modern eye. The couple portrayed in
the picture are almost certainly Giovanni Arnolfini, a
merchant from Lucca who conducted his business at
Bruges, and his wife Giovanna Cenami: Arnolfini's
gesture suggests the enactment of a solemn vow, and this,
together with the other symbolic references in the painting,
led Panofsky to infer that what is shown is a marriage-
ceremony performed in front of witnesses according to
rites in use before the Council of Trent. According to

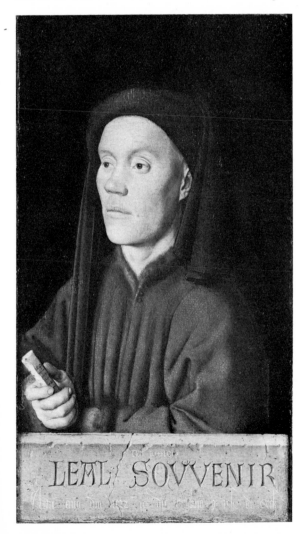

18 JAN VAN EYCK (1385/90–
1441) *Tymotheos, or Leal Souvenir,
supposed portrait of Binchois, 1432.
Oil on panel, 13⅛ × 7½″ (33.4 ×
19). Courtesy the Trustees of the
National Gallery, London*

this hypothesis, the room is a nuptial chamber, and the witnesses are the two men reflected in the mirror, one of them being van Eyck himself: added point would thus be given to the painter's elaborate signature – the most beautiful, surely, in the whole history of art – directly above the mirror: *'Johannes de eyck fuit hic'* ('Jan van Eyck was here').

The *Arnolfini Portrait* represents the final triumph of Eyckian realism. The convex looking-glass upon the wall of the room distorts the reality it reflects, but this distortion only draws attention to the faithfulness of van Eyck's art, the true mirror of the visible world. The picture is at once a harmonious composition and a vivid evocation of two personalities: ' who could forget Arnolfini's cold and pallid countenance? Historically, it is important in other ways. With the *Arnolfini Portrait,* painting enters new habitations: a door is thrown open upon the intimacy of the domestic scene, and the art of Vermeer has been anticipated by two centuries. Unless Fazio's allusion to van Eyck's knowledge of geometry is taken to imply also his acquaintance with Italian perspectival theory, it would seem that van Eyck was able to solve empirically – through sheer observation – spatial problems that had defeated earlier masters. A further advance can be seen in his handling of light. The light from the window falls full upon Arnolfini's face but becomes gradually more diffused as it penetrates the room; it touches the chandelier with gleaming gold, but quietens to silvery grey on the wall behind. And always it acts as a modelling agent, revealing the subtle modulations of the forms over which it plays.

The *Arnolfini Portrait* introduces us to a world that is at once realistic and symbolic; and it is therefore a relatively short step from this deeply religious picture to such great altarpieces as the *Rolin Madonna* in the Louvre, commissioned by the Duke of Burgundy's powerful and worldly Chancellor Nicolas Rolin, and the *Madonna of Canon van der Paele* at Bruges, painted in 1436. In the Bruges picture *(Ill. 19)* the Virgin is enthroned within the apse of a Romanesque church, giving on to an ambulatory beyond. In the 15th century what we now call Romanesque architecture was confused with Byzantine, and was associated in people's minds with the Holy Land: thereby it became, in painting, a symbol of the New Jerusalem. The setting of the Bruges picture,

accordingly, is not Earth but Heaven, however deceptive the realism of the presentation may be.

The *Madonna of Canon van der Paele* was commissioned for the church of St Donatian in Bruges. The donor, Canon van der Paele, kneels on the right in a white surplice, holding in his hands a prayer-book and a pair of spectacles. He looks up at St Donatian (on the left), to whom he is being presented by St George, his patron saint. The portraiture here is so powerful that it almost distracts attention from the central figures of the Virgin and Child. Yet the Virgin herself is one of van Eyck's most impressive conceptions: despite all the marvellous detail the figure is seen in broad terms, and the ample folds of the draperies, which have arranged themselves in patterns of complex beauty, contribute to the sense of majesty. The capitals of the columns are decorated with carvings of Old Testament scenes prefiguring the Redemption, and the figures of Adam and Eve and of Cain and Abel appear on the Virgin's throne: the minute realism of these details must have enhanced their symbolic significance for van Eyck's contemporaries. The painter himself might well have repeated here the

19 JAN VAN EYCK (1385/90–1441) *Madonna of Canon van der Paele, 1436. Oil on panel, 4´ × 5´ 2˝ (122 × 157). Musée Communal, Bruges*

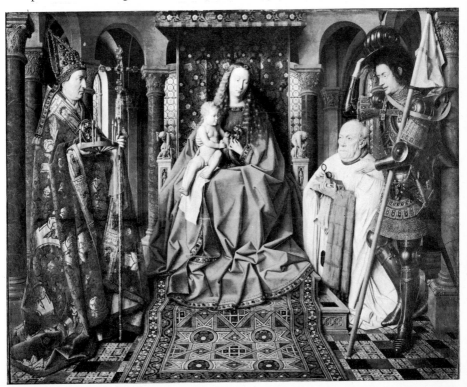

motto that he inscribed on the *Arnolfini* panel, 'Jan van Eyck was here'; for a close inspection of St George's armour reveals a detail of fascinating interest – the reflection of the head and shoulders of a man, who must be the artist himself, and who presumably wished to associate himself with the Canon's act of devotion.

After van Eyck's death in 1441 his reputation was to grow rather than to diminish as the century advanced. Yet although his influence was widespread he had few direct followers in the Netherlands. Even Petrus Christus, who has traditionally been regarded as his pupil, may have received his training elsewhere: but as the leading painter in Bruges after van Eyck's death Christus fell heir to the Eyckian tradition, and some of his pictures are copies or variants of compositions by the older master. As a portrait-painter he learnt much from van Eyck, as can be seen from the *Edward Grimstone* of 1446, a work that illustrates Christus's concern with perspective and effects of light. Another aspect of Christus's art is reflected in the picture known as *St Eligius and the Lovers* in New York (*Ill. 20*), in which the saint, in the guise of a gold-smith, appears to be shown in the act of selling a ring to a betrothed couple. The composition, however awkward, is notable for its informality. In this sense Christus anticipates not only Quinten Massys but the 17th-century exponents of *genre* subjects, and Teniers in particular; and he already shows here a comparable interest in still-life objects, which he renders in micro-scopic detail. The mirror may well derive directly from the *Arnolfini Portrait*.

Among the works that have been ascribed to Petrus Christus we may finally consider the small *St Jerome in his Study* at Detroit, which bears the date 1442. It is extremely probable that this panel was begun by Jan van Eyck and completed after his death by Christus, and that it is to be identified with a painting of this subject known to have been in the collection of the Medici. In that case the Detroit picture must have inspired Ghirlandaio's celebrated fresco of *St Jerome* at Ognissanti in Florence, and would have been known also to Botticelli, whose *St Augustine* in the same church was painted as a pendant to Ghirlandaio's fresco. Both frescoes show an appreciation of the virtues of the new Eyckian realism, which during the second half of the 15th century was to make a decisive impact upon Italian

Eyckian tradition as well as being the strongest formative influence upon the development of Rogier van der Weyden; for Campin was active as early as 1406, and by 1427, the date of the commencement of the apprenticeship of 'Rogelet', he would already have been about fifty years old. It is no wonder that Charles de Tolnay declared the Master of Flémalle to be the true founder of Flemish painting.

21 MASTER OF FLÉMALLE (?ROBERT CAMPIN, 1378/9–1444) Nativity, ?1420s. Oil on panel, 32½ × 27½″ (82.4 × 69.7). Musée des Beaux-Arts, Dijon

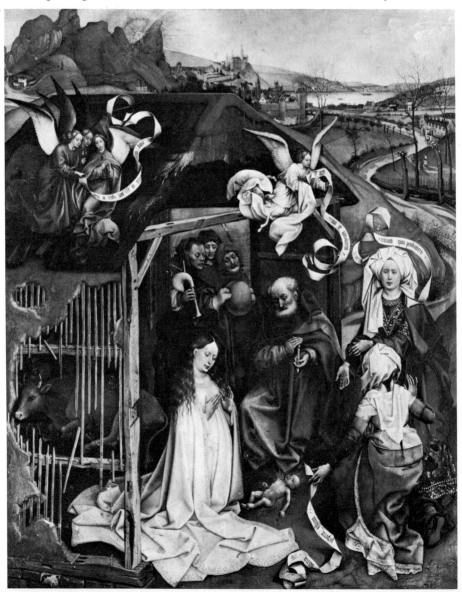

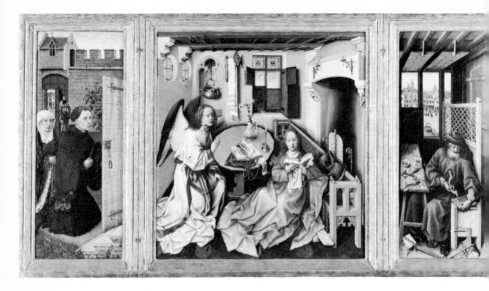

22 MASTER OF FLÉMALLE
(?ROBERT CAMPIN, 1378/9–1444)
Merode Altarpiece, c. 1425–8. Oil
on panel, 25¼ × 49¾″ (64.1 ×
126). The Metropolitan Museum of
Art, New York, The Cloisters
Collection, Purchase, 1957

The essential problem would be solved if one signed or documented painting by Campin had survived; but none exists. We do know, however, that in 1428, under the terms of the will of one Jean de Bus, Robert Campin was commissioned to colour a beautiful *Annunciation* group by Jehan Delemer for Ste Marie Madeleine at Tournai (*Ill. 23*); and there is much in these figures, from the spatial treatment to the pictorial rhythms of the draperies, to remind us of the Master of Flémalle's *Merode Altarpiece* in New York (*Ill. 22*), suggesting the possible influence of the painter upon the sculptor. Again, if Campin was Rogier's master, we should expect the work of the two painters to show a fairly close stylistic relationship, and undoubtedly the pictures that are generally ascribed to the Master of Flémalle do have much in common with the style of van der Weyden.

The most important of these works are the *Entombment* in the collection of Count Seilern, the Madrid *Betrothal of the Virgin,* the *Merode Altarpiece* (formerly in the possession of the Merode family), and the *Nativity* at Dijon. We have only to compare the *Entombment* (*Ill. 24*) with van der Weyden's great *Descent from the Cross* in the Prado (*Ill. 25*) to be struck by remarkable affinities between the two compositions – above all in the frieze-like arrangement of the figures, in the facial types and in

the intensity of the emotional content. No less suggestive is the evident dependence of a *Nativity* executed for the abbey of St Vaast, near Arras, by Jacques Daret, the fellow apprentice of 'Rogelet' under Campin, upon the Dijon *Nativity* (*Ill. 21*) ascribed to the Master of Flémalle. In short, the identification of the Master of Flémalle with Campin and of 'Rogelet' with van der Weyden seems plausible enough.

In the 15th century the Master of Flémalle's most famous work was probably the Dijon *Nativity* (*Ill. 21*), which was discovered near Dijon and may well have been painted for the Chartreuse de Champmol. It is perhaps to be dated in the 1420s. The homely realism of the setting and above all the treatment of the distant landscape reveal its painter as an innovator worthy of comparison with van Eyck himself: there are few passages in Netherlandish painting of the first half of the century quite as remarkable as this glimpse of green countryside, with its pollarded trees and country road, across which there fall the long shadows of early morning.

In the *Merode Altarpiece* (*Ill. 22*), evidently commissioned by a member of the Ingelbrechts family of Malines, the Master of Flémalle turned his attention to the intimate representation of an interior, replete with *genre* details. We may note how carefully the three panels of the triptych are harmonized. On the left shutter, the donor and his wife, who are beautifully characterized, kneel together in a little courtyard and look in upon the sacred event through a half-open doorway; on the right shutter, St Joseph plies his trade as a carpenter: he has been making mousetraps – an allusion, as Meyer Shapiro has shown, to St Augustine's description of St Joseph as 'the mousetrap of the Devil', his role in marrying Mary being not only to dignify her state but also to deceive or trap the Devil, whose suspicious nature will be baffled when he is told that a married girl is a mother and yet still a virgin; caught off guard, the Devil will be blinded to the truth of the Incarnation.

Yet the elaborate allegory has been made the excuse for an exercise in the illusionistic evocation of the objective world. The artist fixes his eye upon every tool and furnishing in St Joseph's workshop with all the intensity of a still-life painter. The window opens on to a fascinating view of a little square, where a number of citizens go about their business; further back, a narrow street leads

23 JEHAN DELEMER (early 15th C.) *Angel of the Annunciation, 1428. Stone, life-size; polychromed by* ROBERT CAMPIN *(1378/9–1444). Ste Marie Madeleine, Tournai*

off towards a magnificent cathedral. This appears to be the first example in Flemish painting of those views through an open window which we particularly associate with van Eyck, Bouts and Memling. The glimpse that we are here given of burgher life is wholly in tune with the spirit of the altarpiece, which may be said to exalt the virtues of domesticity and family life in contemporary society: St Joseph is presented to us as the responsible head of his household, and the neat comfort of the Virgin's parlour mirrors the same ideal of domestic order and harmony.

Superlative though the qualities of this altarpiece are, the central panel demonstrates the artist's difficulty in relating one figure to another and in creating a convincing space for them. It was in fact Jan van Eyck who showed the Master of Flémalle the way to a more successful treatment of space and perspective, as we can see from the two shutters that have survived from the much later *Werl Altarpiece* in the Prado, painted in 1438 for the learned Heinrich of Werl, an eminent Franciscan. The two shutters represent St John the Baptist and the donor and St Barbara, and it is apparent from the donor panel that the Master of Flémalle had studied the *Arnolfini Portrait* – an inference suggested in the first place by the presence of a circular mirror like the one hanging in Arnolfini's room, and confirmed by a new assurance in the management of perspective which can scarcely have

24 MASTER OF FLÉMALLE (?ROBERT CAMPIN, 1378/9–1444) *The Entombment. Oil on panel, centre panel 23⅝ × 19¼" (60 × 48.9), each wing 23⅝ × 8⅞" (60 × 22.5). Collection Count Antoine Seilern*

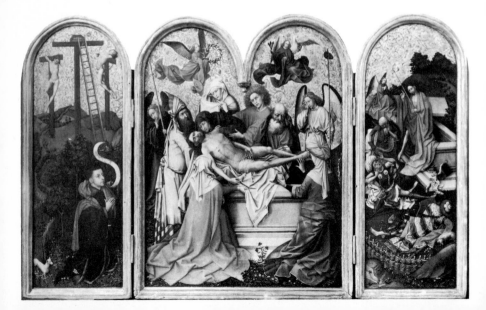

any other source. Despite such contacts, the art of the Master of Flémalle belongs to a spiritual world somewhat remote from that of van Eyck, which by comparison seems almost coldly analytical; but the emotional intensity of his vision reappears in the work of his presumed pupil van der Weyden.

Not a great deal is known for certain about the life of Rogier van der Weyden, but it is established that by 1435 he had become official painter to the city of Brussels, where he was to die in 1464. Fazio tells us that Rogier visited Rome in 1450, the year of the Jubilee. There is one painting by him that might be taken as confirmation of Fazio's testimony: this is the famous *Entombment* in the Uffizi, a work that at one time belonged to the collection formed by the Medici at their villa at Careggi, outside Florence. The *Entombment* reflects a type of composition characteristic of Fra Angelico, and may well have been executed in Italy.

Shortly after his arrival in Brussels, van der Weyden was commissioned to decorate the town hall with some large panels illustrating the Justice of Trajan, which were unveiled in 1439. These no longer survive, and although free copies of them are preserved in a tapestry at Berne the loss of secular works of this importance is particularly severe. The *Trajan* panels included contemporary portraits, among them a striking self-portrait, and van der Weyden must early have established himself as one of the leading portrait-painters of his time. His portraits are usually grave and tender, with a wonderful simplicity about them, and his interpretations of womanhood are among the loveliest creations of the period: one thinks in particular of the characteristic portrayals of young women with folded hands in Washington, London and Berlin, all of them masterpieces of delicacy.

Rogier's reputation, however, must have been founded principally upon his religious commissions. A place of special importance in the sum of his work must be given to the *Descent from the Cross* (*Ill. 25*) originally in the church of Notre-Dame-du-Dehors at Louvain, where it was recorded by van Mander. It is around this work, in the absence of signed pictures by him, that the *corpus* of van der Weyden's paintings has been assembled. It would appear to be an early work, and it has certain elements in common with a lost *Deposition* by the Master of Flémalle which is known from a copy at Liverpool

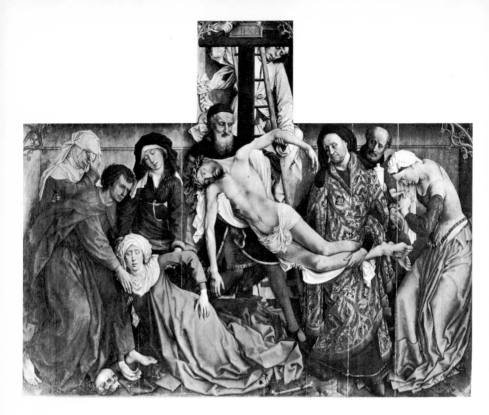

25 ROGIER VAN DER WEYDEN
(1399–1464) *Descent from the
Cross, c. 1438. Panel, 7′ 2″ × 8′ 7″
(220 × 262). Prado, Madrid*

26, 27 *(opposite)* ROGIER VAN
DER WEYDEN (1399–1464) *Last
Judgment, c. 1446–8 (?). Below: in-
terior of the altarpiece. Panel, with
some paintings transferred to canvas,
width 18′ 4″ (560), height of wings
4′ 5″ (135), height of centre 7′ 1″
(215). Above: St Sebastian, from the
outside of one shutter. Hôtel-Dieu,
Beaune*

and from a fragment at Frankfurt, as well as with the
Seilern *Entombment* (*Ill. 24*). The frieze-like arrangement
of the figures, which van der Weyden places against a
simple, gold-coloured wall – no landscape of Golgotha,
– derives ultimately from the Master of Flémalle; but
here we stand in the presence of a far higher achievement
of the creative imagination, and the altarpiece introduces
us to one of the great tragic artists of Western Europe. Not
here the rich sumptuousness of a painting by van Eyck,
but rather a more austere vision impatient of the outward
semblance, so intently is it fixed upon the interior world
of thought and feeling. 'Dignity', Fazio observed of
another painting by van der Weyden, equally tragic in
tone, 'is preserved amidst a shower of tears.'

The nobility of van der Weyden's conception of
humanity and his inventiveness as a designer are nowhere
more in evidence than in this staggering composition.
The concentrated simplicity of the design, which conceals
many subtleties, is enhanced by the absence of any
distracting features in the background; and this process

of a reduction to essentials is carried a stage further in a pair of altar shutters now at Philadelphia, representing as a unified concept Christ on the Cross and the Virgin with St John, and perhaps datable about 1445: here the figures are set against brilliant red fabrics hung over a grey wall; once again there is no attempt to represent the hill of Golgotha; and the imagery is all the more arresting on account of its vivid isolation.

The most important of van der Weyden's late works is the large altarpiece of the *Last Judgment* (*Ills. 26, 27*) commissioned by Chancellor Rolin for the chapel of the Hôtel-Dieu which he had founded at Beaune in the year 1443. The Hôtel-Dieu was dedicated to St Anthony, who is represented in *grisaille* on the outside of the shutters, along with St Sebastian, another saint associated with the care of the sick. The panels above these figures contain an *Annunciation,* also in *grisaille ;* and to the left and right, on the lower level, the ageing Chancellor and his wife kneel in prayer. When opened, the altarpiece displays the awesome event of the Last Judgment, treated as a continuous narrative which carries through all the panels. Below the traditional persons of the *deësis,* St Michael weighs the souls of the dead, while on either side the bare terrain of Earth cracks open, and the dead rise in attitudes either of trust or terror – the blessed to be led by an angel through the gateway of Paradise, the damned to be hurled into the flames of Hell. Van der Weyden's portrayal of the resurrected souls as individuals wholly responsible for their own fate is profoundly original: from the moment of their awakening to the sound of the Last Trump the blessed are assured of their salvation;

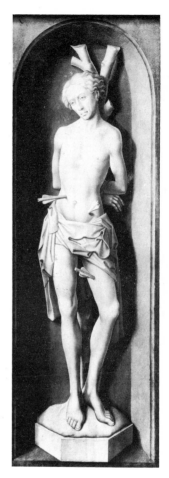

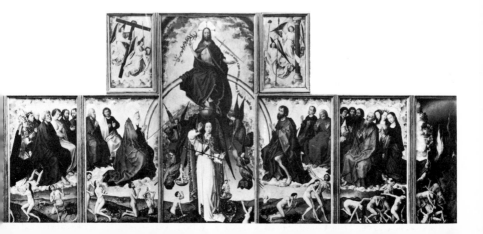

for the damned it is an awakening to the inevitable consequences of their life on earth, and, maddened by the enormity of their guilt, they rush headlong, of their own accord, into the flames.

The organization of the exterior panels of the Beaune *Last Judgment* can be described as a simplified version of the outer shutters of the *Holy Lamb* altarpiece at Ghent, and there are other general similarities between the interiors of the two works. Nevertheless the dissimilarities are more striking than the resemblances. The Eyckian style exhibits nothing of this lofty austerity, and the contrast cannot be due merely to the difference in subject matter, for the *Last Judgment* in the Metropolitan Museum in New York, which has been variously ascribed to Hubert and to Jan, is as richly loaded in its imagery as the *Ghent Altarpiece.*

Van der Weyden's figures are, moreover, at once more ideal and less static than van Eyck's: the resurrected souls of the Beaune altarpiece seem to be symbolic of a liberation that reaches beyond the literal meaning conveyed by these figures into the realm of style itself. Van der Weyden's originality in this respect is epitomized by the *grisaille* 'statue' of St Sebastian (*Ill. 26*), which it is instructive to compare with the *Adam* on the *Ghent Altarpiece* (*Ill. 16*). The rhythmic beauty of the *St Sebastian* takes us by surprise: there is a quality of the ideal in this nude that is almost Italian in its quest for perfection. Jan van Eyck is so literal, so painstaking, in his concern to set down the appearance of each form, inch by inch: van der Weyden, on the other hand, creates a figure harmonious in its proportions and instinct with graceful movement. Although the Beaune altar is usually dated in the 1440s, it has been suggested that the design of the interior reflects some knowledge of monumental fresco decoration; in which case it was possibly executed after Rogier's visit to Italy in 1450. The style of the *St Sebastian,* raising the question whether its author was acquainted with contemporary Florentine or Sienese sculpture, might also be evidence in the same direction.

Van der Weyden's final manner is well represented by the superb *St Columba Altarpiece* in Munich *(Ill. 14)*, so named because it was painted for the church of St Columba at Cologne, where it was to be studied by such German masters as Stephan Lochner and Dürer. The altarpiece must have been executed about 1462, some

two years before the artist's death. The central panel of the *Adoration of the Magi* may be described as in many ways Rogier's noblest composition. It is informed by that quality of serenity which is often found in the very last works of the greatest masters, as though, like an accession of wisdom, it were a special gift bestowed only in old age. The austere visionary of the Beaune *Last Judgment* is scarcely recognizable here, and it was the enhanced feeling for the decorative and the elegant that is reflected in the Cologne altar that seems to have especially appealed to the German painters of the 15th century. We observe also a new assurance in the mastery of the complexities of three-dimensional composition. The 'backdrop' formed by the stable, against which the characteristic frieze of figures is set, now opens out into a broad landscape, and the figures are organized more freely in space, whereas in his earlier works van der Weyden was accustomed to place a greater emphasis upon two-dimensional rhythms.

The art of Rogier van der Weyden made a deep and lasting impression upon northern European painting in the middle and later years of the 15th century: in the Low Countries he was the dominant force in the stylistic development of such masters as Bouts and Memling; in Germany there were many artists, including Lochner and Schongauer, who were indebted to him; and even in Spain his impact was ultimately greater than that of Jan van Eyck. The large number of copies or variants of his compositions that has survived testifies in itself to his enormous influence. His appeal lay not merely in the originality of his pictorial ideas but also in the profound humanity and expressiveness of his art.

The Netherlands, II: painting and sculpture after van Eyck

In the second half of the 15th century the centre of gravity in Netherlandish painting gradually shifted from Bruges to other cities, although Petrus Christus continued to work there until his death in the early 1470s and two younger Bruges painters, Hans Memling and Gerard David, were to bring the Eyckian tradition to a close on a note of gentle eclecticism.

The first cities to assume an increasing importance were Brussels, the home of Rogier van der Weyden, and nearby Louvain, where van der Weyden's great *Descent from the Cross* could be studied at Notre-Dame-du-Dehors, and where Dieric Bouts was employed as town painter. Bouts himself and his contemporary Ouwater, the teacher of Geertgen tot sint Jans, played a decisive role in the creation of a school of painting in Bouts's native Haarlem, in the northern Netherlands. This development was matched in the art of sculpture by the emergence in Utrecht of a major master in the person of Adriaen van Wesel. Then, about 1500, Antwerp became the centre of a new artistic outlook which opened the doors to High Renaissance and Mannerist influences from Italy.

Economic factors must have been partly responsible for these changes: with the growth of trade, the small port of Bruges was no longer able to accommodate the traffic in merchandise, which steadily increased as trading routes were opened to the Americas; much larger ships were now required; and Antwerp succeeded Bruges as the principal port and trading centre for northern Europe. Ghent also declined as a commercial city for similar reasons: nevertheless it was to produce one great master in Hugo van der Goes.

In this period the dominant influence was at first that of Rogier van der Weyden, and it can be inferred that Dieric Bouts had some contact with him in Brussels

before settling in Louvain, where he was active from the 1440s. There are compositions by Bouts that indicate his close study of Rogier's Louvain *Descent from the Cross* (*Ill. 25*). He seems also to have known the work of the Master of Flémalle, with whom he shares an instinct for landscape and a *penchant* for an intimate, realistic inter/ pretation of religious themes. Besides such influences, his style shows a strong connection with that of Petrus Christus, the principal channel of the Eyckian tradition. There appears, however, to be something uniquely Dutch about the strange stillness of his compositions and his gaunt and bony, almost immobile figures.

All these aspects of his art are present in the *Altar of the Last Supper* (or *The Five Mystic Meals*) at St Pierre in Louvain, a work executed between 1464 and 1468, the year of Bouts's appointment as official painter to the city. The central scene of the altarpiece shows the Institution of the Eucharist, and this is flanked by four smaller panels illustrating Old Testament meals which in patristic theology were regarded as prefigurements of the Last Supper. Bouts was advised on the iconography by two professors of theology. The treatment is sacra/ mental rather than dramatic, and indeed in this respect the subject/matter was ideally suited to Bouts's genius.

In the central panel (*Ill. 35*) the interpretation of the sacred event is remarkably matter/of/fact. Bouts brings the biblical story into the context of contemporary life: the disciples might be his own acquaintances; the servant standing in the background on the right is almost certainly a self/portrait; and the upper room at Jerusalem has become a middle/class parlour in 15th/century Louvain. The assured handling of perspective reminds us of the historical importance of the *Arnolfini Portrait,* and Bouts was no less van Eyck's heir in his devotion to the rendering of light. The *genre/*like treatment of the religious subject convinces because its uncompromising realism is elevated by that solemnity of mood which informs the whole of Bouts's art. Bouts varied his style very little, and we pass to a secular subject such as the *Justice of the Emperor Otto,* painted on two panels for the town hall in Louvain, with scarcely any awareness of the difference of theme, for the idiom is unchanged: the basic elements of his pictures remain constant – the serene lighting, the deep reds, rich blacks and dazzling whites; the stillness; and not least that restriction of facial and bodily expression which

endows the fixed glances and wooden gestures of his figures with a curious, suppressed intensity.

Bouts's fellow-countryman, the short-lived Aelbert van Ouwater, is known chiefly from one authenticated work, the *Raising of Lazarus* now in Berlin. This shows the same kind of vertical composition that Bouts developed in the *Last Supper* altar and in other pictures. The iconography is unusual, for the miracle takes place within a Romanesque church. Possibly Ouwater worked for a while with Bouts in Louvain before settling in his native Haarlem: the two painters certainly had much in common, both in their approach to pictorial composition and in their figure-style. Ouwater, however, was an innovator in his employment of light to give a richer tonality and substance to his forms.

According to van Mander, Ouwater was the master of Geertgen tot sint Jans ('little Gerard of the Brethren of St John'), another Haarlem painter. Geertgen, who died at the age of twenty-eight, was active in Haarlem in the 1480s and perhaps the early 1490s. He became a lay-brother in the monastery of the Order of St John at Haarlem, for which he painted a triptych of the *Passion of Christ*. The *Lamentation* at Vienna, one of only two scenes that survive from this altarpiece, reflects the influence not only of Ouwater and Bouts but also of Hugo van der Goes, whose work will be considered presently. But Geertgen's vision was an extremely personal one, and, as this superb composition demonstrates, he is perhaps the most tenderly expressive of all the minor masters of the period. In a tiny masterpiece in London, the *Nativity by Night* (*Ill. 28*), Geertgen explores the nature of light in so novel a manner that this picture (although possibly inspired by a lost work by van der Goes) gives him a place among the pioneers of that nascent 'tenebrism' which we meet again in such German painters of the 16th century as Grünewald and Baldung Grien. The light that here emanates from the Christ-Child, in allusion to a pious fable, is not, of course, natural light in the strict sense; but this passage was clearly based upon sensitive observation, and the glow of the shepherds' fire is suggested no less skilfully.

The northern Netherlands produced in this period not only such outstanding painters as Bouts, Ouwater and Geertgen but one sculptor of supreme genius, Adriaen van Wesel of Utrecht. Sculpture in the Low Countries

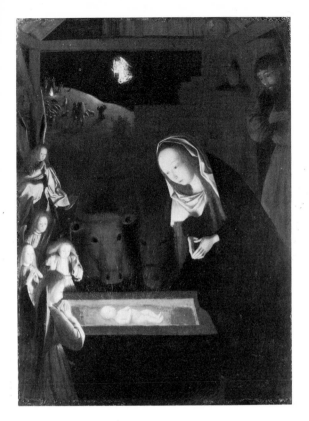

during the middle years of the century was profoundly receptive to the emotive imagery of Rogier van der Weyden, and is often markedly pictorial in character. An example is the *Mercy-Seat* (*Ill. 29*) of 1450 from a tabernacle in the church of St Pierre at Louvain: it is impossible to doubt that the unknown author of this work had studied van der Weyden's *Descent from the Cross* (*Ill. 25*) in the same city.

With Adriaen van Wesel, on the other hand, this tendency to pictorialism takes second place to a truly sculptural concern with volume and spatial organization, as in the famous group of *St Joseph with Musician Angels* (*Ill. 30*), part of an *Adoration* from van Wesel's most important work, the now dispersed *Altar of the Virgin* which he executed about 1475 for the Confraternity of Our Lady at 'sHertogenbosch, and for which

30 ADRIAEN VAN WESEL (c. 1420–c. 1500) St Joseph with Musician Angels, c. 1475. Oak, 17½ × 14¾" (44.6 × 37). Rijksmuseum, Amsterdam

Hieronymus Bosch painted the wings. The art of Adriaen van Wesel might be described as the sculptural counterpart of the expressive realism developed in painting by Hugo van der Goes in the second half of the century. The climax of this movement is represented by the great *Altar of the Passion* at Gheel (*Ill. 31*), the authorship of which is unknown. Here the large scene of the Crucifixion is conceived in terms of startling illusionism, and yet the crowded figures, with their intense expressions, cohere together in a composition of ordered simplicity. On either side of the *Crucifixion* small-scale scenes of the Passion of Christ are set into the mouldings of the frame, each of them a masterpiece of narrative and of clarity of design.

The *Altar of the Passion* probably postdates the 'sHertogenbosch altar by a decade or more. We must now retrace our steps and consider the work and influence of the greatest Netherlandish painter of the second half of the 15th century – Hugo van der Goes, an artist who holds a special fascination for our own times because he has been held up as the type of the neurotic, divided personality often associated in popular thought with creative genius. He was trained in Ghent, where he

became Master in 1467. He was sponsored on his entry into the Painters' Guild by Justus of Ghent (Joos van Wassenhove), who was subsequently to become painter to Federigo da Montefeltro of Urbino, and who is best known for his *Communion of the Apostles* (in the Palazzo Ducale at Urbino) and for a series of decorations for the Duke's study probably executed in collaboration with the Spanish painter Pedro Berruguete (see Chapter VII).

Van der Goes was active both in Ghent and in Bruges. He was born about the time of Jan van Eyck's death. Although he could not, therefore, have been van Eyck's pupil, as Carel van Mander supposed, his stylistic roots lay in the Eyckian tradition. It is equally clear that the expressiveness of van der Weyden's art elicited an immediate response from his sensitive and reflective temperament. Van der Goes became Dean of the Painters' Guild at Ghent in 1474, and it was around this time that he received from Tomaso Portinari, the agent of the Medici banking house at Bruges, what must be regarded as his most important commission.

31 UNKNOWN SCULPTOR *Altar of the Passion, c. 1480–90. Polychromed sculpture. St Dymphna, Gheel*

32 HUGO VAN DER GOES (*c.* 1440–82) *Shepherds, from the central panel of the Portinari Altarpiece, c. 1475. (See Ill. 40)*

The *Portinari Altarpiece* (*Ills. 32, 40*) was executed for the donor's family chapel in Sant'Egidio, the church attached to the hospital of Santa Maria Nuova in Florence, and when it was set up there – in 1475 or thereabouts – it came as a revelation to the Florentines; for here was a demonstration, on an impressive scale, of all that the Eyckian technique and Netherlandish realism could achieve. From this time oil-painting was to be increasingly practised in Italy; and even where the medium employed was tempera or fresco the appearance in late Quattrocento style of a new note of realism seems to reflect a general awareness that with the arrival at Sant'Egidio of this miracle of the northern genius the art of painting could never be quite the same again. One passage in the *Portinari Altarpiece* that evidently attracted special attention was van der Goes's portrayal of the three yokel shepherds (*Ill. 32*): nothing comparable with the directness of observation and the humane sympathy shown in these studies of simple working men had been seen in Italy before this time.

The design of the *Portinari Altarpiece* has a majestic simplicity. The two wings of the triptych – portraying the donor and his wife, together with their patron saints – are related to the central scene of the Nativity. The Portinari family are represented as joining in the angels' adoration of the newborn Child; and indeed their kneeling figures support the pyramidal structure of the *Nativity* scene. The backgrounds of the side panels introduce two subsidiary incidents from the Christmas story – the journey of the Holy Family to Bethlehem, with St Joseph supporting the fainting Virgin as they descend a rough mountain path; and the Journey of the Magi, one of whom is asking a peasant the way to the inn. The shutters when closed show an *Annunciation* painted in *grisaille* which is so pictorial in treatment, and so full of life and movement, that the sculptural origin of such *grisaille* scenes is wholly transcended.

The composition of the *Nativity* scene (*Ill. 40*) is spatial before it is anything else. To Florentines acquainted with the Albertian tradition the somewhat high viewpoint may well have appeared awkward, even naïve: the tendency of the Flemish masters to tilt the ground-plane slightly towards the picture-surface – which can be seen both in the *Arnolfini Portrait* (*Ill. 13*) and in Bouts's *Last Supper* at Louvain (*Ill. 35*) – was perhaps the inevitable

concomitant of an empirical approach to perspective, for the untutored eye accepts as an insistent fact of visual experience the wide angle of the immediate foreground to the line of sight, which is difficult to reconcile with the rapid foreshortening of the ground plane as it recedes into the distance. But the individual quality of van der Goes's handling of space in the Portinari *Nativity* can be explained, to a great extent, by his concern with the religious implications of his subject. The adorers are grouped in a wide circle around the Virgin and the Christ-Child: the distance that they keep is the measure of their reverence, for in the humble stable they have come into the presence of the Holy of Holies; and in fact prominence is given in the lower left corner of the picture to the same symbol of reverence that van Eyck introduced into his *Arnolfini Portrait* – a discarded clog, belonging to St Joseph. Within this numinous space the Incarnation of the Godhead as a helpless infant, lying naked and alone upon the ground, assumes a new pathos.

The flowers in the foreground, forming one of the most beautiful still-life passages in Netherlandish painting, add their own symbolic overtones – the scarlet lily, referring to the blood of the Passion; the iris, known to the ancients as the *gladiolus* or sword-lily, and alluding here to Simeon's prophecy to Mary that a sword would pass through her soul; and the purple columbine, regarded in medieval times as the flower of melancholy, and hence a symbol of the sorrows of the Virgin. So also the sheaf of wheat, suggesting the Johannine text, 'I am the bread which came down from heaven', signifies in a liturgical sense the bread which is broken in the Eucharist and which is Christ's body. All these allusions support the grave tone of the artist's interpretation of the Nativity story: the 'glad tidings of wonder and joy' are overcast by a brooding melancholy that dwells upon the ultimate purpose of Christ's coming – his redeeming sacrifice upon the Cross. Such references to Christ's Passion are by no means unprecedented in representations of the Nativity: but here the tragic implications of the Incarnation have been deepened, it would seem, by the shadows of the melancholia which was soon to deprive van der Goes of his reason. There is undoubtedly a contrast between the mood of the *Portinari Altarpiece* and the quieter serenity of the Montforte *Adoration* in Berlin, one of his early masterpieces.

In 1478 van der Goes entered the Augustinian monastery of the Roode Clooster, near Brussels, as a lay
brother. His struggles there with his mental illness have
been graphically described for us by a monk of the Order,
Gaspar Ofhuys, whose novitiate coincided with the
painter's. It is clear from Ofhuys's account that van der
Goes was suffering from a typical form of melancholia
in which the patient becomes convinced that he is
doomed to everlasting damnation; but Ofhuys himself
attempted to find an explanation for van der Goes's illness
either in natural causes, such as the excessive drinking of
wine, or in some supernatural visitation, whether it might
be devilpossession or, alternatively, an intervention of
Divine Providence with the object of humbling the pride
of one who enjoyed unrivalled fame as an artist. Ofhuys
is at pains to point out that the special privileges accorded
van der Goes by the prior, on account of his distinction,
did not go down well in the monastery; and in this context
it is interesting to learn from the perhaps envious chronicler
that 'since he was a great expert in the art of painting he
often received visitors of high rank, including the most
illustrious Archduke Maximilian', and that 'all of them
had a great desire to inspect his pictures'. Ofhuys concludes his narrative with the somewhat sanctimonious
observation that the great painter's illness eventually
taught him the virtue of true humility. Van der Goes was
to die in the monastery in 1482: in Ofhuys's simple
words, 'he lies buried in our cloister, under the open sky.'

Among the works that survive from this last period of
van der Goes's life the *Death of the Virgin* at Bruges (*Ill. 41*)
must be accounted one of the most original compositions
in the history of Netherlandish painting. The traditional
manner of representing Christ's appearance to his mother
at her death was to show him standing by her bed: here,
however, he appears in a radiant vision, accompanied
by angels. The portrayal of the apostles reveals a similar
independence of outlook: they are presented to us as men
disturbed by an inward agitation of the soul; and,
although attendant upon the Virgin, they remain
enclosed within their own melancholy thoughts, as
though seized by a sense of irrevocable loss: the emphatic
yet empty gestures of their hands seem themselves to
speak of 'the folly of being comforted'. The ambiguous
treatment of space and the restlessness of the design
contribute to a general sense of disquiet, while the petal

like brilliancy of colouring that glows from the *Portinari Altarpiece* has here given way to strange, high-pitched discords.

Van der Goes was not the only Netherlandish artist to be patronized by Tomaso Portinari. The lovely pair of portraits of Portinari and his child-wife Maria Maddalena Baroncelli, in New York, although sometimes attributed to van der Goes, is rather to be ascribed to Hans Memling, a painter of German origin who settled in Bruges, where he was to die. Although chiefly a religious painter, Memling exerted a considerable influence on Italian portraiture, and his characteristic half-lengths set against a gentle, undulating landscape clearly made a deep impression upon such masters as Giovanni Bellini and Perugino.

Memling and his younger contemporary in Bruges, Gerard David, bring the older Flemish tradition to a graceful close. David, who came from Oudewater in the northern Netherlands, and who died as late as 1523, was more receptive than Memling to Italian influence, and his altarpiece of the *Baptism of Christ* at Bruges (*Ill. 33*) is a good example of his skill in absorbing a quality of Italian monumentality into the Eyckian tradition. Since some of the wealthy Italians who were, like Portinari, resident in the Low Countries must have owned collections of pictures, it would not have been difficult for Netherlandish artists to come into direct contact in this period with Italian painting. The *Baptism* was executed in the first decade of the 16th century, and is representative of the dignified grandeur of style, even in quite small panels, that characterizes Gerard David's late work.

Memling, on the other hand, was a more conservative painter who was content, on the whole, to bring together within his placid art – as it were in a final summing-up of a dying tradition – the achievements of Jan van Eyck, Dieric Bouts and Rogier van der Weyden. Yet his lack of adventurousness and the physical languor of his figures have inclined modern critics to undervalue him. To appreciate his qualities one must go to the Memling Museum in the Hôpital de St Jean at Bruges, where many of his paintings are housed, and allow his quiet harmonies to work their spell. His *Mystical Marriage of St Catherine* (*Ill. 34*), completed in 1479 although begun four years earlier, was itself painted for the hospital, and

this is his masterpiece. The general arrangement of the central panel and the emphatic verticality of the design recall Bouts, but there are many new elements, among them a delicate and inventive sense of colour and an uncompromising insistence upon a harmonious symmetry of formal relationships. The wings are remarkable for the beauty of their landscape settings.

The same gift for landscape can be seen in the famous *Shrine of St Ursula*, a late work which Memling presented to the Hôpital de St Jean not long before his death. This consists of a series of panels telling the story of St Ursula and her eleven thousand virgins, who suffered

34 HANS MEMLING (active 1465, d. 1494) *The Mystical Marriage of St Catherine*, central panel of altarpiece, 1479. Oil on panel, whole altarpiece 10′ 1″ × 12′ 10″ (307.5 × 391.5). Memling Museum, Bruges

33 (*opposite*) GERARD DAVID (1460–1523) *The Baptism of Christ*, central panel of altarpiece, c. 1500–1508. Oil on panel, 4′ 3″ × 3′ 2″ (129.5 × 97.5) Musée Communal des Beaux-Arts, Bruges

35 DIERIC BOUTS (c. 1415–75) *Institution of the Eucharist, or Last Supper, from the Altar of the Five Mystic Meals, 1464–8. Oil on panel. St Pierre, Louvain*

martyrdom at Cologne. Memling was not a great narrative painter, but the *St Ursula* panels are memorable for their wealth of incidental detail (*Ill. 36*), from sailing ships in busy ports to distant glimpses of churches and castles, bathed in a soft, atmospheric light. The art of Memling, in this respect, must be described as more than a synthesis, for it does break new ground. Nevertheless it did not contain the seeds of future development, and his pupils were to produce only skilful pastiches of his own style. He died in 1494, while Gerard David lived on to witness the transformation of the great Eyckian and Rogerian traditions brought about by the incursion of new ideals from Italy.

36 HANS MEMLING (active 1465, d. 1494) *Detail of the Martyrdom of St Ursula's companions, panel from the Shrine of St Ursula, 1489. Each panel 16½ × 10″(42 × 25.5). Memling Museum, Bruges*

CHAPTER FIVE

Germany: painting and sculpture before the age of Dürer

37 UNKNOWN SCULPTOR *'Fair Virgin' from Krumau, South Bohemia, c. 1400. Limestone, h. 44⅛" (112). Kunsthistorisches Museum, Vienna*

Any full account of early German art must be a history of largely independent local schools, from Cologne on the Rhine to Prague, far to the east in Bohemia. The details and complexities of that history lie outside the scope of this book; but despite notable variations between one region and another a general pattern of stylistic development can be discerned.

In the 14th century German painting had owed much to the great Parisian school of illuminators, and like their French contemporaries artists working in such widely separated areas as the Lower and Upper Rhine, Austria and Bohemia were also receptive to the innovations of Giotto and the Sienese. A second wave of Italian influence – this time from northern Italy – made itself felt from about the middle of the century at Prague, then the capital of the Empire: the decorations executed by Master Theodoric at Karlstein Castle for the Emperor Charles IV strongly recall the art of Tomaso da Modena, who was himself receiving commissions from the Emperor in these years. The realism of Master Theodoric's style is paralleled in sculpture by the work of Peter Parler the Younger, whose life-like series of portrait-busts for Prague Cathedral, representing notable benefactors, are datable in the 1380s.

In the years around 1400 the pervasive current of International Gothic flowed through the German territories, affecting the arts of painting and sculpture alike, and giving rise to the so-called 'Soft Style', of which perhaps the most outstanding exponent was the Westphalian painter Konrad von Soest, documented as being active in Dortmund in the early years of the new century. The panel of the *Adoration of the Magi (Ill. 38)* from an unusually large polyptych in the Stadtkirche at

Wildungen shows how the German master was able to adapt the graces of the International Style – epitomized by the elegant Christ-Child – to his deeply contemplative vision. On the other hand, the grave countenances of the three Magi strike a note of brooding intensity that seems so typical of the German genius, having its roots in that propensity to fervid and often gloomy mysticism which characterizes the spirit of the German Middle Ages, and which is reflected especially in the teachings of Meister Eckhart of Cologne.

The impact of the International Style is no less evident in the small statues of the Virgin and Child known as 'Beautiful Madonnas' or 'Fair Virgins' (*Ill. 37*), which were produced in large numbers in Austria, Bohemia, Bavaria and elsewhere. These charming works, whether

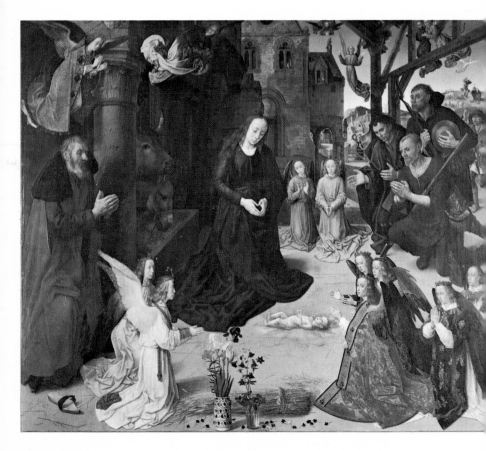

40 HUGO VAN DER GOES (c. 1440–82) *Nativity, central panel of the Portinari Altarpiece, c. 1475. Oil on panel, 8′ 3″×10′ (252×304). Uffizi, Florence*

41 (opposite) HUGO VAN DER GOES (c. 1440–82) *Death of the Virgin. Oil on panel, 4′ 11″×4′ (141×122). Musée Communal des Beaux-Arts, Bruges*

carved in stone or in wood, were exquisitely poly-chromed; but still more important is the function given to line as the vehicle of a rhythmic unity. Another favourite subject for small-scale sculpture was a type of vesper-image or (in Italian parlance) *Pietà*, in which the Virgin holds the dead Christ on her lap, as she held him in his infancy (*Ill. 39*); a touching theme that was to be revived in Italy a century later by Michelangelo. One such *Pietà* is fully documented as having been com-missioned in 1429 by an Italian patron from Egidius of Wiener Neustadt, then resident in Padua.

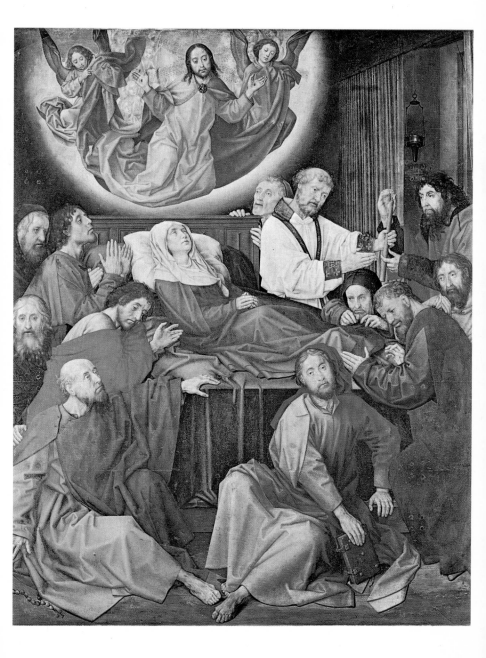

The 'Soft Style', rooted in International Gothic, could not long survive the increasing demand for a more boldly expressive art, and it was succeeded by the 'Angular Style' of such masters as Hans Multscher of Ulm, who worked chiefly as a sculptor but also as a painter, and Konrad Witz from Constance. What we witness in fact is the assimilation of the *ars nova* developed in Burgundy and the Low Countries: Multscher, for example, seems to have known the work of Claus Sluter at Dijon; and Witz was evidently indebted not only to Sluter but to Jan van Eyck and the Master of Flémalle. The art of Rogier van der Weyden was to have an equally strong impact, not least upon the great painter-engraver Martin Schongauer.

Multscher's statue of the *Man of Sorrows* (*Ill. 42*) on the west portal of Ulm Cathedral, which is datable about 1429, demonstrates the power of a style that makes no concessions to the ideals of International Gothic but concentrates upon uncompromising realism. Much the same spirit informs Multscher's work as a painter, as in the scene of Christ carrying the Cross (*Ill. 43*) from the *Wurzach Altarpiece* of 1437: the intention is primarily 'expressionistic'; the spectator is compelled, as it were, to partake in the tragic drama unfolded before him. The bowed Christ of Multscher's panel, a figure that yet dominates the well-organized design, is crushed beneath the weight not so much of the cross as of 'man's inhumanity to man', and his eyes, staring into ours, are strained with anguish. There is a strong element here of that obsession with human cruelty and brutality that marks the German mind of the Late Middle Ages, and this unforgettable image of divine humanity might be regarded as a symbol of the same oppression of the spirit.

Multscher was not the only great master to be employed at Ulm, now one of the most vital centres of artistic activity in northern Europe. The decoration of the cathedral was to be continued by other sculptors of genius, notably Jörg Syrlin the Elder. One painter of particular interest, Lukas Moser, is documented at Ulm in the early years of the century, and may have designed the stained-glass windows in the Besserer Chapel in the cathedral. His only certain painting is the *St Magdalen Altarpiece* (*Ill. 44*) in the parish church at Tiefenbronn, near Baden. This exquisite little work, painted on sheets of parchment applied to panel, was executed in 1431, and

Moser added to his signature a famous but still enigmatic inscription: 'Cry, art, cry, grieve bitterly: no one now desires thee any more' – a lament that can be interpreted either as a bitter reflection upon the uncertainties of patronage in the German territories during this period or, possibly, as a protest against the decline of the International Gothic tradition. Yet the Tiefenbronn altarpiece demonstrates that Moser had by this date absorbed some of the new principles introduced by Jan van Eyck.

43 HANS MULTSCHER (c. 1400–67) *Christ carrying the Cross, from the Wurzach Altarpiece, 1437. Panel, 4′ 10″ × 4′ 7″ (148 × 140). Staatliche Museen Preussischer Kulturbesitz, Gemäldegalerie Berlin (West)*

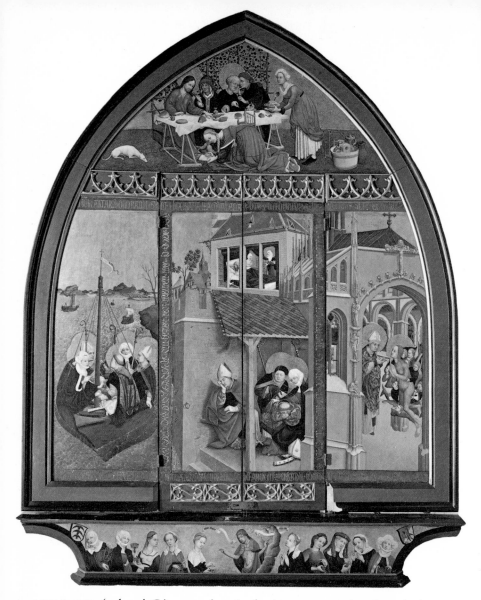

44　LUKAS MOSER (early 15th C.)
St Mary Magdalen Altarpiece, 1431:
shutters closed. Oil on panel, h. 4′ 11″
(149). Parish church, Tiefenbronn

45　*(opposite, above)* KONRAD WITZ (1400/10–44) *The Miracu-*
lous Draught of Fishes, from the St Peter Altarpiece, 1444. Tempera
on panel, 4′ 4″ × 5′ (132 × 154). Musée d'Art et d'Histoire,
Geneva

46　*(opposite, below)* STEPHAN LOCHNER (c. 1400–51)
Adoration of the Magi, centre panel of the Dombild. Tempera on oak,
7′ 10″ × 8′ 8″ (238.5 × 264.5). Cologne Cathedral

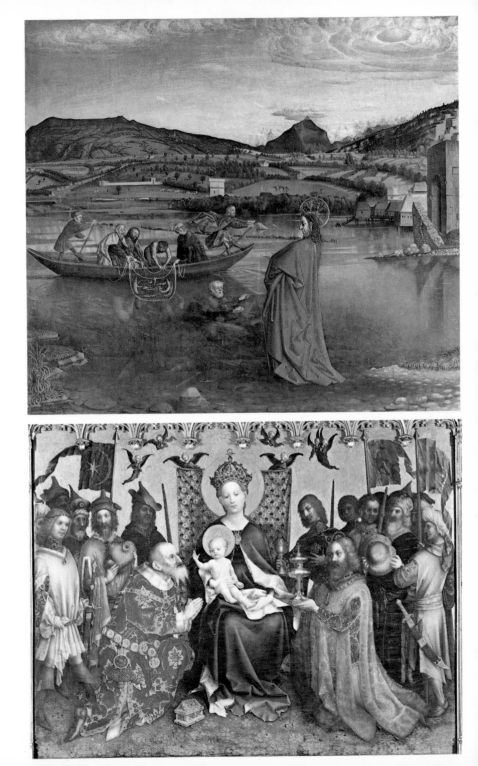

The altarpiece takes the form of a series of panels enclosing sculpture. When the panels are closed they reveal, below a lunette containing a scene of the Feast in the House of Simon the Pharisee, three further episodes in the life of Mary Magdalen, all brought together within a single panoramic view in which the application of a convincing perspectival system contributes to the total unity. The three scenes (read from left to right) show the Magdalen's voyage to Marseilles, accompanied by Martha and two bishops; her rejection at the inn; and her last communion. Much survives here of the idealized world of the International Style, and indeed Moser was a transitional figure; but the qualities of sensitive observation revealed in the four scenes – whether in the treatment of the enchanting seascape in the *Voyage to Marseilles* or in the masterly handling of complex architectural forms in the neighbouring compositions – entitle this *petit maître* of the Ulm School to a place among the pioneers of the Eyckian tradition in Germany.

Netherlandish influence becomes more and more apparent as the century advances. Konrad Witz, who worked at Basle, where he died in 1447, was the most consistently 'Eyckian' painter of the early German School, as it evident from the superb *Annunciation* at Nuremberg, with its utter rejection of the ornamental qualities of the 'Soft Style' in favour of an art of architectonic form and spatial illusionism in which light plays an important role. Witz's masterpiece is the *St Peter Altarpiece* of 1444, a work commissioned by the Bishop of Geneva, François de Mies. Of the various scenes, painted on both sides of two panels, the most celebrated is quite justly the highly original *Miraculous Draught of Fishes (Ill. 45)*, which has been hailed as the first true landscape of northern European art.

Other painters before Witz had introduced realistic landscapes into their pictures, but here the setting is an actual locality – the Lake of Geneva with Mont Blanc in the distance, – and it is observed with meticulous attention to natural appearances, from the reflections in the water and the widening ripples made by the moving boat to the cirrus clouds in the luminous sky. Yet this is not mere topography, and the almost Pre-Raphaelite detail is subordinated to the demands of the artist's fine sense of design: for example the relationship established between the nobly conceived figure of Christ and the

rock-like mountain dominating the distant shores of the lake was clearly the result of careful calculation, and may well have been intended to contain a symbolic allusion to Christ's later words to St Peter, 'Thou art Peter, and upon this rock I will build my church.' Witz's powerful sense of structural design was accompanied by a markedly sculptural feeling for form which characterizes all his figures, giving them a somewhat hard, metallic quality. The old tradition that he practised as a sculptor is a perfectly credible one; and it is of some interest also that he was closely associated in Basle with the Tübingen painter Nikolaus Rusch, who had worked at Dijon.

In comparison with the severe art of Konrad Witz the dreamy Madonnas of Stephan Lochner, who migrated from Constance to Cologne, seem all sweetness and grace. Lochner soon established himself as the leading painter of the Cologne School. He became a highly respected citizen, and was elected to the town council; he died in Cologne in 1451. The so-called *Dombild* (*Ill. 46*), executed for the town hall at Cologne but now in the cathedral, takes pride of place in his *oeuvre*. Indeed it is not to exaggerate to regard it as the counterpart in 15th-century German painting of the *Ghent Altarpiece*. It was one of the celebrated works of the period, and in the following century Dürer (as he informs us in his *Journal*) was to pay two silver pennies to have the altarpiece unlocked for him.

The *Dombild* takes the form of a traditional triptych. When closed, the shutters display an *Annunciation*. When opened, they reveal a sumptuously decorative inter-pretation of the Adoration of the Magi, the Virgin being enthroned at the centre against a gold background surmounted by a Gothic canopy. The two older kings kneel on either side, while the younger king and other attendant figures crowd around. The wings are devoted to representations of the patron saints of Cologne – St Ursula with her virgin-martyrs on the left, and St Gereon with his knights-at-arms on the right.

This masterpiece could scarcely have been conceived without the prior achievements of Jan van Eyck, and we may recall also that van der Weyden's *St Columba Altarpiece* (*Ill. 14*) was then to be seen in Cologne. Lochner's style represents a fusion of that of the Nether-landish masters with the more conservative, Late Gothic manner still current in Cologne. Lochner's 'modernity'

did not impel him to enter the world of three-dimensional space opened up by van Eyck and explored by Konrad Witz: as in his smaller pictures of the Virgin and Child, the spatial treatment of the *Dombild* remains secondary to the general, tapestry-like decorativeness of the whole, and the perspectival rendering of the Virgin's room on the *Annunciation* wings shows misunderstandings that Witz, for example, would have found incomprehensible. What Stephan Lochner learnt from van Eyck and van der Weyden can be studied rather in his subtle modelling of the figure, which he conceives as an entity in itself without taking great account of its spatial setting, and in his fine rendering of rich fabrics, for which a supreme *exemplum* already existed in the St *Columba Altarpiece* (*Ill. 14*). So also Lochner's *Last Judgment* in the Wallraf-Richartz Museum at Cologne can be related to the innovations made by van der Weyden in his great altarpiece at Beaune, even though the general conception is quite different. It is very possible that Lochner had close contacts with van der Weyden, and even that he had received some training in the Netherlands under the Master of Flémalle.

Among other Cologne painters who were indebted to van der Weyden, the charming Master of the Life of Mary – so called from his *Altar of the Virgin* at Munich – was active between 1460 and 1490. By this time, however, the work of Bouts was making an almost equal impression upon German painting, especially in the north, and the rather stiff, elongated figures of the Munich panels must derive directly from the Dutch master. The penetration of Netherlandish influence into central Germany can be illustrated by the work of Hans Pleydenwurff, who is recorded in Nuremberg from 1457 to 1472. At Colmar, on the Upper Rhine, Caspar Isenmann and the great Martin Schongauer, both of whom lived into the last decade of the century, were able to assimilate the lessons of van der Weyden without sacrificing anything of their individuality: Isenmann may be said to look forward to the 'expressionism' of Grünewald, and Schongauer to the 'high art' of Dürer.

In a letter to Vasari, the 16th-century Flemish painter Lambert Lombard gives the precious information that van der Weyden was Schongauer's master. Unfortunately the paintings that can definitely be ascribed to Schongauer are few in number, but one absolute masterpiece that is unquestionably from his hand is the

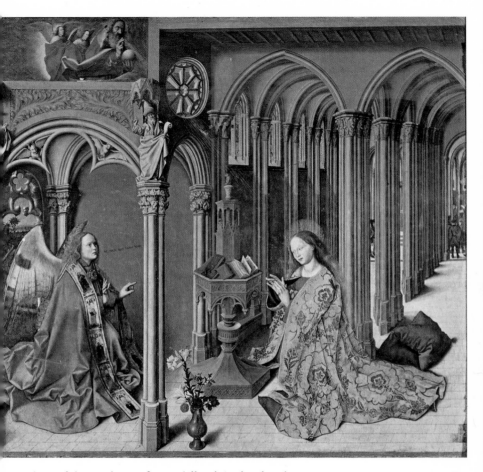

Madonna of the Rosebower of 1473 (*Ill. 49*) in the church of St Martin at Colmar. His engravings, on the other hand, are numerous, and anticipate in their inventiveness those of Dürer, who was deeply indebted to him. Schongauer was probably the pupil of the engraver known from his signature as the Master ES, who was active in the Rhineland in the middle years of the century, and who was the true pioneer of the new art of copperplate engraving in northern Europe. The style of the Master ES descends from the Rogerian tradition, and he may well have been of Netherlandish origin. A slightly later engraver from the Rhineland, the Master of the Housebook, takes his name from an illustrated book in Schloss Wolfegg, datable in the mid-1470s. Many

47 MASTER OF THE AIX AN-NUNCIATION (?JEAN CHAPUS, active *c.* 1400–50) *Annunciation, c. 1442. Oil on panel,* 5′ 1″ × 5′ 7″ *(155 × 176). Ste Marie Madeleine, Aix-en-Provence*

48 MASTER OF THE HOUSEBOOK
(active *c.* 1475–1500) *Lovers, c.*
1475. Silverpoint drawing. Kupfer-
stichkabinett, Staatliche Museen, Ber-
lin-Dahlem

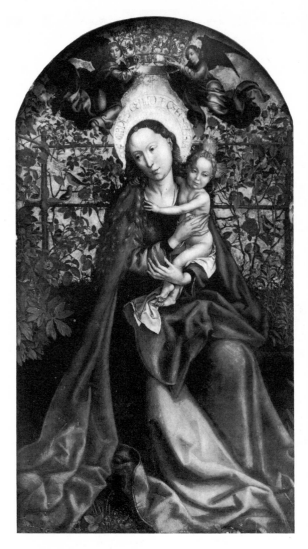

49 MARTIN SCHONGAUER (*c.*
1445/50–91) *Madonna of the Rose-*
bower, 1475. Panel, 6′ 7″×3′ 8″
(201×112). St Martin, Colmar

of the drawings and engravings of this charming artist
take their subjects from contemporary life (*Ill. 48*) and
are therefore of considerable historical and social interest,
even apart from their superlative qualities of draughtsman-
ship. Schongauer, however, far surpasses these masters
both in technical accomplishment and in imaginative
power. A superb example of his gifts as an engraver is
provided by his *Temptation of St Anthony (Ill. 50)*, a

composition of which the young Michelangelo was to make a copy.

During the middle and later years of the 15th century the Netherlandish influences that we have traced in German art from Multscher to Schongauer affected the development of sculpture in the German territories no less profoundly than that of painting or engraving. There was indeed no more effective channel for such influences than the presence in Germany during this period of the great Dutch sculptor Nicolaus Gerhaerts, who came from Leyden but whose early activity in his native country is now a blank to us. In his monument to Canon Conrad von Busnang in Strasbourg Cathedral, dated 1464, the donor is brought into intimate association with the Virgin and Child, much on the pattern of van Eyck's *Altarpiece of Canon van der Paele (Ill. 19).* Gerhaerts's realistic style reaches its climax in his putative *Self-*

50 MARTIN SCHONGAUER (*c.* 1445/50–91) *The Temptation of St Anthony, c. 1480–90. Engraving, 103⁄8 × 13" (26 × 33). British Museum, London*

81

portrait (Ill. 51), also at Strasbourg, and no work of sculpture of the 15th century is more instinct with inner life than this image of the contemplative life – informal, closely observed, and not untouched by gentle humour.

Gerhaerts's departure in the 1460s to Vienna, where he was employed by the Emperor Frederick III, further disseminated a knowledge of the new style of which he was the principal exponent, and his influence upon his German contemporaries was to be immense. One can see this, for instance, in the beautiful carvings on the choir-stalls of Ulm Cathedral (datable between 1469 and 1474), which are the work of Jörg Syrlin the Elder and assistants. The numerous busts that decorate the stalls include a remarkable figure that must surely be a portrait of the artist himself *(Ill. 52)*. Comparisons with the figure by Gerhaerts are inevitable, but Syrlin displays a more intense concern with the psychological implications of portrait-sculpture, and the style is distinctively German. Here the German contribution to the develop-ment of the 'humanist portrait' may be said to have its beginnings.

With their ebullient gaiety, Erasmus Grasser's famous *Morris Dancers* of 1480 from the town hall at Munich, free-standing figures posed in comic attitudes that give an extraordinary impression of swift movement, are particularly striking examples of the new impulse to evoke the inner life and energy of the human figure in sculptural terms. But the sloughing-off of Late Gothic traditions gave birth also to a more monumental conception of the art of sculpture, and Grasser's masterpiece is the pensive *St Peter (Ill. 53)* executed in 1492 for the high altar of the church of St Peter at Munich. Although it is much later in date, the sublime *gravitas* of this figure, together with the humane dignity of the 'portraiture', makes possible a comparison with the statues contributed by Donatello to the embellishment of Florence Cathedral and Orsan-michele.

Yet the first clear indication of the actual assimilation of Italian principles is found in the work of the Austrian woodcarver and painter Michael Pacher, who died in 1498. His origins lay in the northern tradition inspired by Gerhaerts, but about 1470 he visited Padua, where he seems to have been overwhelmed by the power of Mantegna's frescoes in the Eremitani. In his masterpiece, the high altar in the pilgrimage church of St Wolfgang,

51 NICOLAUS GERHAERTS (active 1462–73/8) *Supposed self-portrait, 1467. Sandstone. Musée de l'Oeuvre Notre-Dame, Strasbourg*

52 JÖRG SYRLIN THE ELDER
(documented from 1449) *Sup-
posed self-portrait, from the choir-
stalls of Ulm Cathedral, 1469–74.
Oak*

near Salzburg, a work commissioned in 1471 and
completed some ten years later, the effects of this revelation
are apparent both in the painted wings and in the carved
and gilt *Coronation of the Virgin* (Ill. 54), which forms the
central scene. The crowded detail of the *Coronation* and
the intricate workmanship of the traceried canopy are
characteristic enough of the northern Gothic altar; but
the ornamental features of the *St Wolfgang Altarpiece* sink
into insignificance beside the subtlety of Pacher's
manipulation of space and the grandeur of his forms,
qualities that are carried still further in the panels of the
Doctors of the Church (Ill. 55) painted in the early 1480s
for an altar in the convent at Neustift (in the Tyrol). These
panels demonstrate the fullness of Pacher's understanding
of the art of Mantegna and, not least, of the Paduan
master's adventurous use of mathematical perspective.

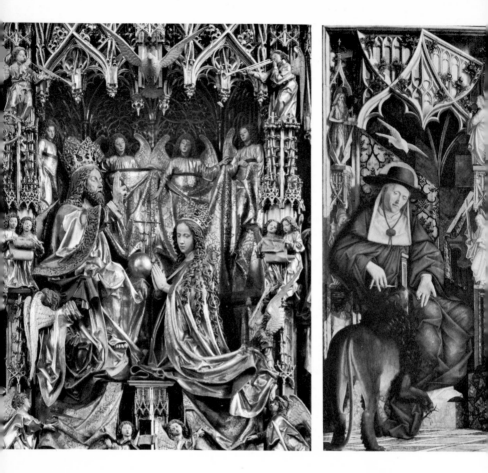

54 (above) MICHAEL PACHER (c.
1435–98) Coronation of the Virgin,
central panel of altarpiece, commis-
sioned 1471. Polychromed wood,
12′ 9″ × 10′ 4″ (390 × 316). St
Wolfgang

55 (above right) MICHAEL
PACHER (c. 1435–98) St Jerome,
early 1480s. Panel, 7′ 1″ × 3′ (216 ×
91). Alte Pinakothek, Munich

Pacher's greatest achievement, however, remains the St
Wolfgang Altarpiece, in which the new realism is placed
at the service of a presentation of sacred legend akin, in
its vividness, to the live enactment of some religious
drama.

The St Wolfgang Altarpiece is matched in its dramatic
intensity only by the huge altar of the Life of the Virgin
executed by the Nuremberg sculptor Veit Stoss for the
church of St Mary at Cracow – a colossal exposition of
Gerhaertian realism which was begun in 1477, when
Stoss settled in Cracow, and completed twelve years
later. Subsequently, Stoss was to modify the Gothicisms
fundamental to his early manner in favour of a greater

simplicity and clarity of form more closely approximating the Italian ideal, as in the beautiful figure of *Christ on the Cross (Ill. 56)* which he made for the church of St Sebald after his return to Nuremberg in 1496.

Michael Pacher and Veit Stoss stand upon the threshold of a new age. Such later sculptors as Peter Vischer the Elder and Peter Flötner, whose work will be discussed in a subsequent chapter, were to be affected still more decisively by contact with Italian High Renaissance ideas. In painting, a similar process can be discerned in the art of transitional figures like Hans Holbein the Elder and Hans Burgkmair. Moreover there was to be an increasing tendency on the part of German artists to make the journey across the Alps to study the work of their Italian contemporaries and predecessors at first hand. But the more widespread dissemination of Italian ideals throughout northern Europe was to be the achievement of Germany's greatest master, Albrecht Dürer.

56 VEIT STOSS (*c.* 1445–1533) *Christ on the Cross, from St Sebald, c. 1500. Wood. St Lorenz, Nuremberg*

France: painting and sculpture from Charles VII to Louis XII

After the battle of Agincourt in 1415, northern France had fallen under English rule, and Henry V of England, on entering Paris, had been proclaimed heir to the French throne. The story of France's resurgence under the leadership of the young Joan of Arc is now legendary. During the reign of Charles VII, who made Bourges his capital, almost all the northern territories were recon-quered, only Calais remaining in English hands at his death in 1461. These events were followed in the reign of Louis XI by a war with Burgundy, and after the battle of Nancy of 1471, which saw the defeat and death of Charles the Bold (the heir and successor of Philip the Good), France now regained her Burgundian lands. The power of the French kingdom by the closing years of the century is demonstrated by her invasion of Italy in 1494, in consequence of the revival on the part of Charles VIII of the French claim to the Kingdom of Naples, which had once been under the rule of the Angevin dynasty but was now a dependency of the Spanish house of Aragon. Further Italian campaigns were undertaken by Louis XII in 1502 and 1509.

One result of the French presence in Italy in these years was to facilitate contacts between French artists and their Italian contemporaries. To give one example, the sculptor and painter Jean Perréal accompanied both Charles VIII and Louis XII to Italy, where he met Leonardo da Vinci in Milan. Yet it was not until later in the 16th century, during and after the splendid reign of François I, that France assumed a leading role in the European cultural revival: this was the age that produced the School of Fontainebleau, the architecture of Philibert de l'Orme and Pierre Lescot, and the writings of Rabelais, Du Bellay and Ronsard, the creators of modern French as a great literary language. During the greater

part of the 15th century most of the major developments in painting outside Italy had taken place within the Burgundian territories, and the Netherlandish masters Claus Sluter and Nicolaus Gerhaerts had led the field in sculpture. Paris, for long the principal centre of manu-script illumination, had been eclipsed as the artistic capital of northern Europe first by Dijon and then by Bruges and Brussels. It should, however, be borne in mind that contemporary documents testify to a very considerable artistic activity in France during the 15th century, of which, because of the loss of numerous works, we now know relatively little at first hand.

In the early and middle years of the century French sculpture often reflects the direct influence of Sluter. After the death of Claus de Werve, who had succeeded Sluter, one of the sculptors entrusted with the completion of the tombs of Jean Sans Peur and Margaret of Bavaria in the Chartreuse de Champmol was a French artist from Avignon, Antoine le Moiturier. The contract for the tomb of Charles I of Bourbon and his wife Anne, the daughter of Jean Sans Peur, which was executed by Jacques Morel around 1450 for the abbey of St Pierre at

57 JEAN MICHEL and GEORGES DE LA SONNETTE (mid-15th C.) *The Entombment, 1451–4. Stone, almost life-size. Chapel of the former hospital, Tonnerre*

Souvigny, specified that this work should be modelled upon Sluter's monument to Philip the Bold at Dijon. Sluter's example clearly lies behind one of the master-pieces of this period, the large *Entombment* carved in stone by Jean Michel and Georges de la Sonnette for a hospital chapel at Tonnerre (*Ill. 57*). Here the altar-like sar-cophagus suggests that the vivid realism of the presentation was inspired by the artists' observation of religious dramas in which the *Corpus Christi* was associated with the liturgy of the Mass. It is interesting to compare this tenderly expressive work with what is perhaps its nearest counterpart in early French painting, the so-called *Villeneuve Pietà* in the Louvre (*Ill. 61*).

The most beautiful of all the paintings of the middle years of the century, the *Annunciation* in the church of Ste Marie Madeleine at Aix-en-Provence (*Ill. 47*), which formed the central panel of a now dispersed altarpiece, combines influences deriving from Sluter, van Eyck and probably the Master of Flémalle and Konrad Witz, within an individual style of peculiar charm. The sculptural decoration of the porch recalls similar motifs in the work of Broederlam (*Ill. 5*) and the Master of Flémalle, but Sluter must be the ultimate source, just as the painter's technique and outlook are primarily Eyckian: Jan van Eyck, in his Washington *Annunciation,* had likewise represented the event as taking place in a church, and the design of the kneeling figures of the Virgin and the Archangel may indicate a re-miniscence of the outer shutters of the *Ghent Altarpiece* (*Ill. 16*); but a still more profound indebtedness to van Eyck is revealed in the warm radiance of the light, which casts shadows into the picture-space, as in the Ghent *Annunciation,* and by the glowing colours and sonorous tonal harmonies.

The altarpiece at Aix was commissioned by a draper named Pierre Corpici under the terms of a will that he made in December 1442, but there is no record of its painter. Various theories have been proposed, of which the most plausible is that it is the work of Jean Chapus, a native of Avignon who was employed at the court of René of Anjou, titular king of Sicily. After vain attempts to claim his throne, this cultured prince had returned to his estates in Provence and Anjou, residing chiefly at Aix. His sister, Marie of Anjou, was the wife of Charles VII of France.

The Master of the Aix *Annunciation* clearly intended to contrast the Old Dispensation, symbolized by the statues of prophets surmounting the piers of the vestibule within which the Archangel kneels, with the New Dispensation of Christ, whose sacrificial death is re-enacted in the Mass being celebrated at the altar (at the far end of the nave). The demon and bat carved on the archway on the left seem to refer to the power of Satan, vanquished by Christ's Incarnation. The picture contains other disguised symbols such as are found elsewhere in the art of the period, one of the most interesting being the carved monkey on top of the Virgin's *prie-Dieu*, an apparent allusion to the evil impulses that led to Eve's temptation and the Fall of Man, and whose consequences were undone by the purity and obedience of Mary, the 'second Eve': in the Aix *Annunciation* this strange symbol of evil lies in the path of the radiance which streams from God the Father to the Virgin, a light which bears, in the likeness of a diminutive babe, the image of the Incarnate Christ.

King René was celebrated in his own time as a poet, and according to tradition he was also a painter: in the former capacity he wrote the famous *Livre du Cuer d'Amour Espris* ('Book of the Heart smitten with Love'), an allegorical poem redolent of the chivalric fantasies of the Middle Ages which describes the adventures of the knight Cuer, aided by Désir, in his efforts to win the love of the lady Doulce Mercy. As a painter, King René is said to have studied the methods of the Flemish masters and to have introduced them to Provence. The *Livre du Cuer d'Amour Espris* contains some exquisite illustrations by an unknown artist who is generally referred to as the René Master. One of the finest of them (*Ill. 58*) shows Cuer reading a magic inscription on a tablet which discloses the meaning of his last adventures: it is early dawn, and as Désir rests beside his grazing horse the rising sun still casts long shadows across the field. The subtle alchemy of the lighting may remind us of Geertgen, but the resemblances are superficial, and there is nothing in Netherlandish painting to compare with this delicate and fanciful poetry.

King René, a great patron of the arts, employed as his court painter the well-documented Nicolas Froment, whose best known altarpiece is the so-called *Buisson Ardent,* or *Burning Bush* (*Ill. 59*), a triptych commissioned

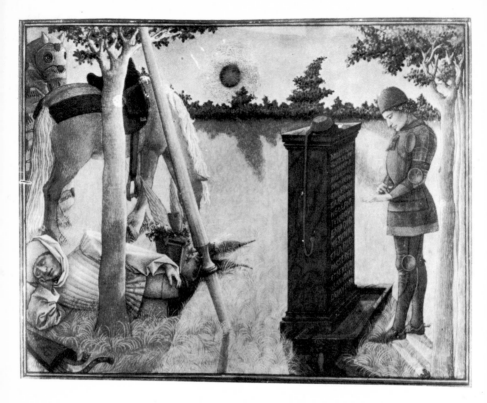

58 RENÉ MASTER (late 15th C.)
*Cuer reading the inscription on the
well, miniature from the Livre du Cuer
d'Amour Espris, 1460–70. 11⅜ × 8″
(29 × 20.1). Staatsbibliothek, Vienna*

by the King for the royal chapel in the church of the
Grands Carmes (a Carmelite foundation) at Aix and
completed in 1476. The wings of the altarpiece contain
portraits of the King and his Queen, Jeanne de Laval,
which are remarkable for a realism that makes no con-
cessions to flattery. The iconography of the central panel
is somewhat unusual, for it is not Jehovah who appears
in the burning bush to Moses, but the Virgin Mary, with
the Christ-Child in her arms. Moreover an angel, in
the attitude of Gabriel in a scene of the Annunciation, is
introduced on the left.

The explanation is to be sought in the first place in the
typological symbolism of the Middle Ages, according to
which the bush in Exodus which burned and yet was
not consumed became a symbol of the virginity of Mary,
who conceived without being consumed by the flames of
concupiscence. The Roman breviary makes explicit
reference to this analogy in a rubric for the Feast of the

Circumcision, and the passage in question is quoted in an inscription on the Aix altarpiece. The same symbolism features in one of the most popular devotional works of the Middle Ages, the *Speculum humanae salvationis,* where the story of the burning bush is related specifically to the Annunciation (hence, it would seem, the presence in Froment's picture of the Gabriel-like angel); moreover when the shutters of the altarpiece are closed what is displayed is in fact an Annunciation scene – in other words an explicit statement of the theme (or one of the themes) implicit in the main interior panel of the

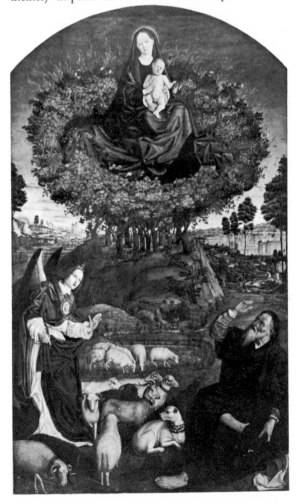

59 NICOLAS FROMENT (active 1450–90) *The Burning Bush, central panel of triptych, 1476. Oil on panel, 5′ 4″ × 3′ 10″ (162 × 118). Cathedral, Aix-en-Provence*

triptych. At the same time the thorn-bush of Exodus has been transformed into a rose-bush, the rose being another medieval symbol of virginity. Again, in a famous 14th-century poem, Guillaume de Deguilleville's *Pilgrimage of the Soul,* a vision of Mary is described in which she appears in a mystic apple-tree: in this case the apple is the symbol of Christ himself. Possibly other traditions and legends that have not hitherto been cited in explanation of Froment's composition entered in. There is a story, for example, told of a shepherd of the early 15th century who was tending his sheep near Chalons when a vision appeared to him of the Virgin in a burning bush, holding her Son in her arms; and we may wonder also whether the pastoral setting of Froment's picture, with its sheep and sheepdog, has not some connection with his royal patron's fondness for playing the shepherd on his estates in Provence.

The minutely observed landscapes found in paintings by Nicolas Froment have little in common with the lyrical vision of the René Master, but they mark a stage in the development of a naturalistic tradition which culminates, at the end of the century, in the art of the so-called Master of St Giles. Still more interesting, however, is the landscape vista that stretches across the lower edge of the well-known *Coronation of the Virgin* commissioned in 1453 from Enguerrand Charonton (or Quarton) for the Chartreuse du Val de Bénédiction at Villeneuve-lès-Avignon (*Ill. 60*). The contract required the artist to show clearly, in a symbolic representation of the Holy City, the church of St Peter's in Rome and the Castel Sant'Angelo: but Charonton went further, and introduced into his landscape some charming glimpses of local scenery – the noble profile of Mont Sainte-Victoire, the sea-girt cliffs of L'Estaque and other features of the Provençal scene that are so familiar to us from French paintings of a much later age.

60 ENGUERRAND CHARONTON (active 1447–61) *Detail of landscape from the Coronation of the Virgin, 1453–4. Tempera on panel, entire work 6′×7′ (183×213). Hospice, Villeneuve-lès-Avignon*

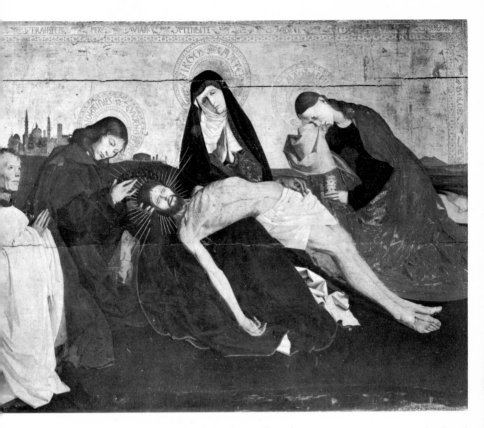

Stylistically there is a connection between this work and the famous *Villeneuve Pietà* (*Ill. 61*) of about 1460, also painted for a church in Villeneuve. The facial types resemble those of Charonton, but the picture is perhaps by a pupil. The *Villeneuve Pietà*, of all the religious paintings of the 15th century, seems the most imbued with the spirit of the popular piety of the period, with its intense realism of outlook and its deep concern to penetrate beyond the bare narratives of the Gospels to the private thoughts and emotions of the actors in the divine drama: here, we may say, art clothes itself in humility, stooping to the needs of the common man.

The art of Jean Fouquet, on the other hand, reflects the decorum and something of the worldliness of court life: but its scope is broad, and in his great series of miniatures, the *Jewish Antiquities* of about 1470, Fouquet depicts the familiar scenes of the Touraine countryside, which he

61 AVIGNON SCHOOL (mid-15th C.) *Villeneuve Pietà, c. 1460. Oil on panel, 5′ 4″ × 7′ 2″ (162 × 218). Louvre, Paris*

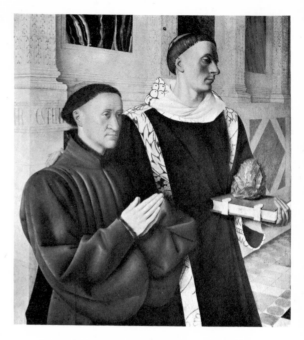

knew from boyhood, with the eye of a voracious observer of everyday life. Early in his career, in the 1440s, he was in Italy, where he is supposed to have painted a portrait of Pope Eugenius IV. In Rome, he possibly came into contact with Fra Angelico, whose luminous colouring may well have made a deep impression upon him. He would also have become familiar with Italian perspective theory: certainly his treatment of pictorial space is advanced for his time. On settling at Tours in 1448, Fouquet worked first for Charles VII and subsequently for Louis XI. He died at Tours about 1481.

Around 1451, King Charles's treasurer Etienne Chevalier commissioned Fouquet to paint the so-called *Mehun Diptych,* which is now divided – the left wing, representing the donor and his patron St Stephen, being in Berlin (*Ill. 62*), and the right wing, showing the Virgin and Child, at Antwerp. It was for the same patron that Fouquet illuminated the book of hours known as the *Hours of Etienne Chevalier.* Fouquet practised extensively as an illuminator of manuscripts: the *Grandes Chroniques de France,* of about 1458, were presumably undertaken for Charles VII himself; and an important series of

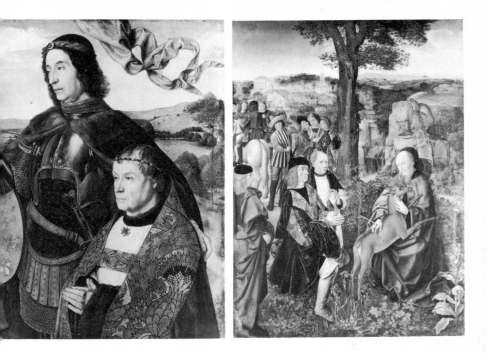

illustrations to Boccaccio was ordered by the King's secretary, Laurens Gayard; but the finest of all Fouquet's miniatures are the eleven illustrations to Josephus's *Jewish Antiquities,* commissioned about 1470 by Jacques d'Armagnac, duc de Nemours, and containing all the power and fullness of the artist's genius in its final maturity.

The quartz rock displayed by St Stephen in the donor panel of the *Mehun Diptych* (*Ill. 62*) – an allusion to the saint's martyrdom by stoning – might well be regarded, on account of its adamantine tangibility, as the symbol of Fouquet's realism. The clarity with which its form is defined in relation to the channelled space of the palatial setting (a mere corner, yet implying an echoing vastness) depends upon a rare ability to grasp the essentials of visual experience; a mastery that attains unforgettable expression in the noble head of the young saint, where the total form is analysed in terms of subtly modulated planes: the appeal of so humane and so sympathetic a 'portrait' cannot be divorced from these purely formal preoccupations, which may be said to link the art of Fouquet, across the span of four centuries, to that of Cézanne.

63 *(above left)* MASTER OF MOULINS (active *c.* 1480–99) *St Maurice with a donor. Panel, 22 × 18¾" (4′ 8″ × 4′). Museum and Art Gallery, Kelvingrove, Glasgow*

64 *(above)* MASTER OF ST GILES (active *c.* 1500) *St Giles and the Hind, c. 1500. Oil on panel, 24¼ × 18¼" (61.5 × 46.5). Courtesy the Trustees of the National Gallery, London*

The same gift for simplicity and clarity of statement characterizes the illustrations to Josephus (*Ill. 65*). In Fouquet's hands the art of manuscript illumination aspires to the grandeur of monumental fresco-painting, making the difference in scale of little account. The powerfully conceived forms, the mastery of space and light, the inventiveness and luminosity of the colour (of which a notable feature is the telling use of white), the compactness of the designs, the sheer brilliance of the technique and not least the combination of breadth of vision with minute, retinal observation – all these varied qualities demonstrate the range and the balanced nature of Fouquet's genius. Of his reputation in his own day we have some inkling from the high praise accorded him in the treatises of two Italian contemporaries, Francesco Florio and the sculptor and architect Antonio Averlino, known as Filarete.

The work of two important *anonimi,* the Master of Moulins and the Master of St Giles, brings to a close the somewhat patchy history of 15th-century French painting. The former gets his name from a triptych which the duc de Bourbon, who held his court at Moulins, not far from Lyons, commissioned for the city's collegiate church (now the cathedral), probably in the late 1490s. Several other works by this sensitive and altogether charming painter are known, a particularly splendid example being the Glasgow *St Maurice with a Donor* (*Ill. 63*), which rivals the Moulins altarpiece in the brilliance of its colouring. A comparison with Fouquet's *Etienne Chevalier* (*Ill. 62*) will make clear the greater dependence of the Master of Moulins upon purely Flemish traditions, ranging from Jan van Eyck to Hugo van der Goes, of whom he may in some sense have been the pupil.

The Master of St Giles must unquestionably have received his training in the Low Countries, perhaps in Bruges, although he was evidently active thereafter in Paris. The name by which he is known refers to two panels in London illustrating scenes from the life of St Giles. One of these, the *Mass of St Giles,* accurately renders the interior of the abbey church of St Denis, near Paris; the other reveals the artist as a no less conscientious exponent of naturalistic landscape, which he scrutinizes with all the care of a botanist (*Ill. 64*). The subject is the apology made by the king of France and a

65 (opposite) JEAN FOUQUET (*c. 1420–c.* 1481) *The Fall of Jericho, miniature from the Jewish Antiquities, c. 1470. 8⅜ × 7" (20.5 × 17.5). Bibliothèque Nationale, Paris*

bishop after an archer of the royal hunt has shot an arrow at a hind adopted by St Giles, in the process piercing the saint's protective hand. Eyckian naturalism could scarcely be carried further, and the story is told with infinite charm; but the picture stands at the end of a road, and for a work painted around 1500 it is surprisingly archaic in feeling and method. The contrast with Fouquet is absolute; for whereas Fouquet in his manuscript illuminations aspired to the grandeur of monumental painting, the Master of St Giles diligently preserved in the medium of oil-painting qualities especially appropriate to the miniaturist.

With the turn of the century, however, French painting and sculpture begin to follow a familiar pattern: as in other northern European countries, the desire to emulate the achievements of the Italian masters of the High Renaissance gradually becomes an overriding consideration, opening up new possibilities of artistic expression. Michel Colombe's *Altarpiece of St George* (*Ill. 66*), executed for the chapel of the château of Gaillon, in Normandy, introduces us to one of the channels whereby the work of the Italian masters became known in France, even in the northernmost parts of the country, in the early years of the 16th century. The château was built in the first decade of the century for Louis XII's minister Cardinal Georges d'Amboise, a fervent Italophile who brought in a number of Italian artists to decorate his new residence, including Andrea Solario,

66 MICHEL COLOMBE (c. 1430/ 35–after 1512) Altarpiece of St George, from the chapel at Gaillon, 1508–9. Marble, h. 4′ 5″ (134). Frame by Girolamo Pacchiarotti. Louvre, Paris

the accomplished follower of Leonardo and the early Venetian masters. Colombe's *St George* relief, for which the Genoese sculptor Girolamo Pacchiarotti supplied an elegantly carved frame, combines a fine understanding of Italian Renaissance sculpture with a Gallic, and essentially Gothic, grace which is entirely the artist's own. Colombe, together with Jean Perréal, also co-operated with another Italian sculptor, Girolamo da Fiesole, on the tomb of François II of Brittany in Nantes Cathedral.

Jean Perréal, who was later commissioned by Margaret of Austria to design the sepulchral monuments at Brou, executed between 1509 and 1512, was employed successively at the courts of Charles VIII, Louis XII and François I. He was to die, in extreme old age, as late as 1530, when François I had already commenced the building of that prime symbol of the new age, the great palace of Fontainebleau. The effects of Perréal's several visits to Italy and his contacts with Leonardo, who was not too proud to acknowledge that he had learnt some-thing from him, are reflected in his half-length portrait of Louis XII at Windsor (*Ill.* 67), which has a distinctly Italianate and partly Leonardesque air. This picture was doubtless taken by Perréal to England in 1514, on the occasion of his mission on behalf of the widowed French King to paint the portrait of a prospective bride, Henry VIII's sister Mary Tudor. King Louis' choice, however, fell upon Anne of Brittany, herself the widow of Charles VIII.

It was Anne of Brittany who commissioned one of the most celebrated books of hours of the period. The miniatures in the *Hours of Anne of Brittany,* which were completed in 1507, are the work of Perréal's contemporary Jean Bourdichon, who was employed as court painter to several members of the house of Valois, including Charles VIII, Louis XII and François I. He died in 1521. Although there is no documentation of any visit by Bourdichon to Italy, his art is saturated in Italian ideas and stylistic idioms. His debt to the Italians is apparent already in his one certain altarpiece, the triptych at Naples datable in the early 1490s, but its full extent becomes clearer when we examine the *Hours of Anne of Brittany*, and it is difficult to resist the conclusion that at some time Bourdichon visited at least northern Italy. His *St Sebastian* (*Ill.* 70) suggests a direct knowledge of the work of Perugino, whose London *Madonna* of 1498 was then

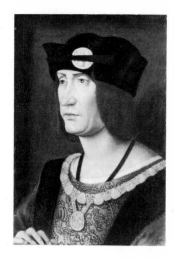

67 JEAN PERRÉAL (*c.* 1455–1530) *Louis XII, c. 1514. Oil on panel, 11 × 7" (30.4 × 22.9). Repro-duced by Gracious Permission of Her Majesty Queen Elizabeth II*

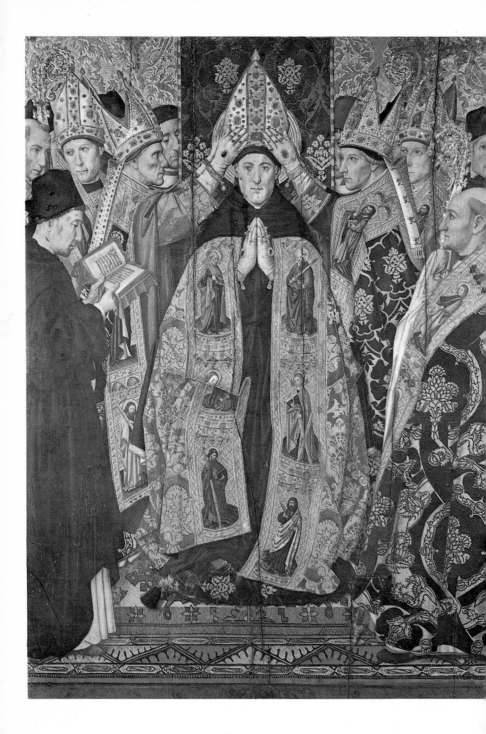

to be seen at Pavia. There are also hints in the figure-style in several of these miniatures that the French artist was familiar with the Leonardesque School of Milan. Still more interesting are the apparent echoes of Bramante in some of the architectural settings. It is tempting to compare Bourdichon with his great predecessor Jean Fouquet, for he gives a similar impression of attempting to bring to the art of the illuminator something of the grandeur of monumental painting on panel or in fresco. At all events, what survives of the once extensive *oeuvre* of Bourdichon presages that fuller assimilation of the Italian style that is epitomized by the building and decoration of Fontaine-bleau.

68 *(opposite)* JAIME HUGUET *(c. 1420–c.1490) The Consecration of St Augustine, detail of an altarpiece, 1463–85. Panel, whole altarpiece 8′ 1″ × 6′ 3″ (247.5 × 191.5). Museo de Arte de Cataluña, Barcelona*

69 BARTOLOMÉ BERMEJO (active 1474–95) *Pietà of Canon Luis Desplà, 1490. Panel, 5′ 9″×6′ 2″ (175 × 189). Barcelona Cathedral*

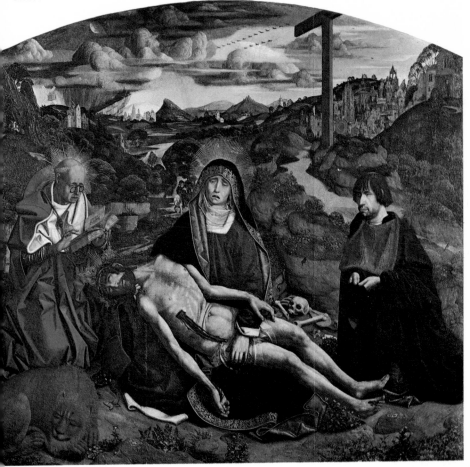

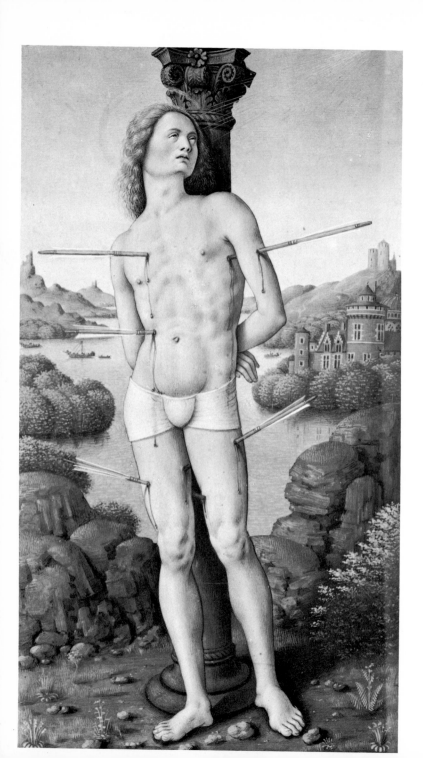

Even today to cross the Pyrenees from south-western France is to enter another world, and for the student of Spanish history that formidable mountain range takes on a symbolic significance, acting as a reminder of the separateness and distinctiveness of a culture that was moulded from the early Middle Ages by the Arab occupation of almost the entire Iberian peninsula. The reconquest of the peninsula was a long and gradual process, and although it had been largely accomplished by the mid-13th century the final expulsion of the Muslim invaders did not take place until the year 1492, when their last stronghold, the kingdom of Granada in the far south, was wrested from them by Ferdinand II of Aragon.

The rule of Ferdinand II marks the beginning of an historical development that was eventually to create out of a newly united Spain not only the dominant European power but also a great empire with vast overseas posses-sions in central and southern America. The immediately preceding period had been one of bitter rivalry and conflict among the various territories that formed late-medieval Spain – Castile, bordering upon Portugal in the west and stretching across the whole central region, Navarre to the north, and Aragon with its Catalonian seabord to the east. The process of change dates essentially from the second half of the 15th century, and the decisive event was the marriage in 1469 of Ferdinand II of Aragon to Isabella I of Castile ('Isabella the Catholic'): the first step had been taken towards the unification of the Spanish territories; and with this union there arose one of the great ages of patronage.

In the 14th century Spanish painting had owed much to the example of the Italian masters of the Trecento: the influence of Giotto can be traced very clearly in the art of

71 LUIS BORRASSÁ (c. 1360–after 1424) *St Peter walking on the water, from the Altarpiece of St Peter, 1411. Santa Maria, Tarrasa*

70 (*opposite*) JEAN BOURDICHON (c. 1457–1521) *St Sebastian, mini-ature from the Hours of Anne of Brittany, c. 1500–1508. 11¾ × 7⅝" (30 × 19.5). Bibliothèque Nationale, Paris*

72 UNKNOWN SCULPTOR *Monu-*
ment to Martín Vásquez de Arce
(died 1486). Polychromed alabaster.
Sigüenza Cathedral

73 *(opposite)* HIERONYMUS
BOSCH *(c. 1450–1516) The Hay-*
Wain, central panel of triptych, c.
1500. Oil on panel, 4′ 5″ × 3′ 3″
(135 × 100). Prado, Madrid

the Catalonian painter Ferrer Bassa, who was employed
at the court of Aragon until his death in 1348; and later
in the century the Florentine Gherardo Starnina, who
may have taught Fra Angelico, was temporarily exiled
to Spain, where he worked in Valencia and especially in
Toledo. Another channel of Italian influence was
provided by the close contacts maintained in this period
between Catalonia and Avignon, where there were works
by Simone Martini. The Catalan School was to become
the most important in Spain, and its dominance can be
related to the fact that Catalonia had been one of the first
of the Spanish territories to free itself from the Moors.

Jheronimus bosch

The charm and refinement of Catalonian painting around 1400 must owe much to Sienese inspiration, as can be seen even in the style of so expressive a master as Luis Borrassá, whose *Altarpiece of St Peter* (*Ill. 71*), in the church of Santa Maria at Tarrasa, was executed in 1411. Some contact with Italy can be deduced similarly from the work of the greatest of the early Catalonian sculptors, Pedro Johan, the author of a tondo relief of *St George* on the façade of the Palacio de la Disputación at Barcelona, datable in 1418, which may be likened, for its liveliness and grace, to the work of Ghiberti.

Two painters of particular importance, Ramón de Mur, who was Borrassá's pupil, and Bernardo Martorell (active also as a manuscript illuminator), continued the traditions founded by Borrassá in Catalonia. Martorell's fine *Altarpiece of St George,* now divided between Paris and Chicago (*Ill. 74*), represents one of the high points of this vigorous development in early 15th-century Catalonian painting, which while partly Italianate in character has close links with the International Style. These traditions were to be continued into the 1480s by Jaime Huguet, who dominated Catalan painting in the second half of the century and commanded a large workshop. We shall return to Huguet presently, stressing only at this point an interesting feature of his art which makes him so representative a figure in the early history of Catalonian painting – its general imperviousness to Netherlandish influence.

The one celebrated exception to this rule is to be found in the almost slavishly Eyckian style of Luis Dalmau, court painter to Alfonso V of Aragon. Dalmau may have met van Eyck in Spain at the time of the Flemish master's diplomatic mission on behalf of Philip the Good: what is of greater consequence, however, is his documented visit to Bruges in 1431. Dalmau probably remained in the Low Countries for several years, for he evidently knew both the *Holy Lamb* altarpiece at Ghent and the *Madonna of Canon van der Paele,* completed in 1436. At any rate he returned from the Netherlands with a full understanding of the new Eyckian methods, and his well-known *Virgin of the Councillors* (*Ill. 75*), commissioned in 1443 for the chapel of the council-house at Barcelona and inscribed with the date 1445, shows the extent of his discipleship. The design as a whole would seem to recall that of the van der Paele *Madonna* (*Ill. 19*),

74 BERNARDO MARTORELL (active *c.* 1430–*c.* 1453) *St George and the Dragon, 1430s. Tempera on panel, 4′ 8″ × 3′ 2″ (142.2 × 97). Courtesy of the Art Institute of Chicago*

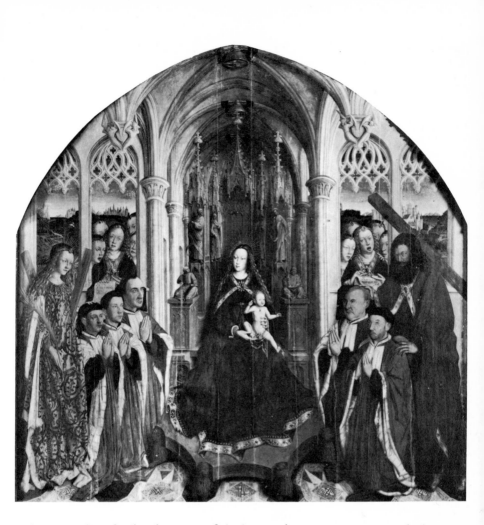

and one revealing detail – the group of singing angels standing beside the Virgin's throne behind the kneeling members of the city council – must have been directly inspired by their famous counterparts on the *Ghent Altarpiece (Ill. 17)*. Exceptional though this work may be in the history of the Catalonian School, the lessons of the Flemish painters were to be more readily absorbed in Castile and elsewhere in Spain, especially in the second half of the century (as in the work of Fernando Gallego and Bartolomé Bermejo). It should be borne in mind that by this time works not only by van Eyck but by many other Netherlandish painters were to be seen in Spain, and

75 LUIS DALMAU (active 1428–60) *Virgin of the Councillors, 1443–5. Panel, 9′ 3″ × 12′ 2″ (282 × 370.5). Museo de Arte de Cataluña, Barcelona*

that Queen Isabella herself owned pictures by such artists as Rogier van der Weyden and Dieric Bouts, two of the most influential figures in this period.

The independence of the art of Jaime Huguet, which preserves, throughout, a distinctively Spanish character, is in itself striking. Huguet, who was probably born about 1420, is documented from 1448 until the late 1480s. He was one of the creators of the typical Spanish *retablo* (altarpiece), usually sumptuous in its decorative effect and in the elaborateness of its carved and gilded framing. A splendid example is the altarpiece which he painted, at the behest of the Guild of Tanners, for the high altar of the church of the Augustinian monastery at Barcelona (*Ill. 68*). This great work was commissioned in December 1463 and must have taken many years to complete. It was intended as an apotheosis of St Augustine, and contained a number of scenes from the saint's life. Only six panels survive, but there is considerable evidence that the altarpiece was conceived and executed on a vast scale. The contract specified (to quote Chandler Post's summary) 'that all carved parts of the structure shall be gilded and, in the paintings, all backgrounds, diadems, mitres, pastoral staffs, and orphreys shall be of embossed gold.' The splendour of the finished work can be judged from the scene of the *Consecration of St Augustine* (*Ill. 68*), where we may also note Huguet's powerful gift for characterization.

In the art of sculpture, the innovations introduced by Sluter at Dijon exerted a considerable influence in Spain from the early decades of the century. In 1439 Juan de la Huerta, from Aragon, succeeded Claus de Werve as principal sculptor at the Burgundian court, being entrusted with the completion of the tombs of Jean Sans Peur and Margaret of Bavaria for Champmol (because of certain delays, however, the work was to be finished by Antoine le Moiturier). An impressive example of the 'progressive' tendency in Spanish sculpture, largely inspired by northern models, is to be found in Guillermo Sagrera's work at Palma, on the island of Majorca. Sagrera's statues for Palma Cathedral and the *Angel* which he executed for the tympanum of the Palma *Lonja*, or exchange building, show a deep sympathy with Sluter's revolutionary aims while preserving a distinctively Spanish vision. The *Angel* in particular exemplifies that inclination towards the suggestion of a mysterious

76 (opposite, above) PIETER BRUEGEL THE ELDER (*c.* 1525/ 30–1569) *Peasant Wedding, c. 1568. Oil on panel, 3′ 9″ × 5′ 4″ (114 × 163). Kunsthistorisches Museum, Vienna*

77 (opposite, below) PIETER BRUEGEL THE ELDER (*c.* 1525/ 30–1569) *The Stormy Day, or February, 1565. Oil on panel, 3′ 9″ × 5′ 4″ (114 × 162.5). Kunsthistorisches Museum, Vienna*

78 JORGE INGLÉS (active *c.* 1455)
*The Marquis of Santillana, from the
retable of the hospital of Buitrago,
1455. Panel. Collection the Duke del
Infantado, Madrid*

79 FERNANDO GALLEGO (active
1466–1507) *Central section of the
Altarpiece of San Ildefonso, com-
missioned 1467. Panel. Zamora
Cathedral*

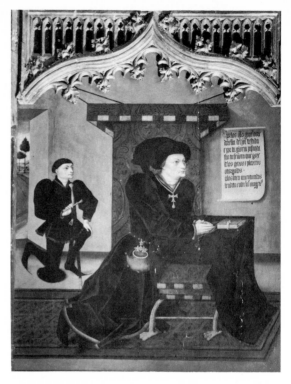

beauty not of this world which, although hard to define,
seems so characteristic of the Spanish genius.

The ultimate independence of taste evinced by Spanish
art cannot be too strongly emphasized. What the
major Spanish masters took from their northern con-
temporaries, or for that matter from the Italians, they
invariably made their own. Even Jorge Inglés, whose
name implies his northern origin, shows this in his great
retablo for the hospital of Buitrago, painted in 1455 on the
order of the Marquis of Santillana, a politician and patron
of learning who was a prominent figure at the court of
Juan II. Here the donor portraits (*Ill. 78*) occupy the
main panels, a daring stroke that is, however, of less
consequence than the freedom of the stylistic inter-
pretation. The Marquis's praying figure, as he kneels at
his *prie-Dieu*, is disposed in so curiously decorative a
manner that he seems to usurp the entire picture-space,
adding a certain poignancy to the relatively tiny form of

the page kneeling behind him. Neither van Eyck nor van der Weyden would have accepted an approach to composition that sacrificed spatial considerations in this way to a more emblematic conception of painting, but both, no doubt, would have respected the psychological intensity of the artist's portrayal of an evidently forceful personality.

The Castilian School produced two major painters in Fernando Gallego and Pedro Berruguete, in addition to others of less importance, such as the so-called Master of Avila (probably Garcia del Barco), whose *Nativity* triptych at Madrid, dated 1475, recalls not so much the style of van Eyck or that of van der Weyden as the more archaic manner of the Master of Flémalle. Fernando Gallego might be called the Konrad Witz of Spain, for he shares with the great Swiss master a precision in the rendering of naturalistic detail and a preference for hard, sculpturesque forms. His major work, the *Altarpiece of San Ildefonso (Ill. 79)*, was commissioned in 1467. Gallego was evidently familiar with Schongauer's engravings, the influence of which seems to be detectable in his designs, but he was more directly affected by the austere, impassive vision of Bouts, both in his figure-style and in the views of the Castilian countryside that he loved to introduce into the backgrounds of his pictures.

A similar indebtedness to Flemish painting – a characteristic feature of the School of Castile in general – is apparent in the work of Pedro Berruguete, who may possibly have been Gallego's pupil. But with Berruguete another important factor enters in, for in the 1470s he visited Italy, where he was employed at Urbino by Duke Federigo da Montefeltro, the patron of Piero della Francesca; and Berruguete was the first major Spanish painter to attain to a satisfactory synthesis between Italian Renaissance ideals and the established Hispano-Flemish tradition. He is documented in Urbino in 1477, but he may have arrived there several years earlier – especially if he, rather than Justus of Ghent, is to be identified with the unnamed Flemish-trained artist who was commissioned to paint the Duke's praying hands (a marvel of realism) in the donor portrait included in Piero's *Brera Altarpiece*. Evidently Federigo had been impressed by the realistic style developed by the Netherlandish masters, and when he conceived the plan of having his *studiolo* in the palace at Urbino decorated with a series of panels of

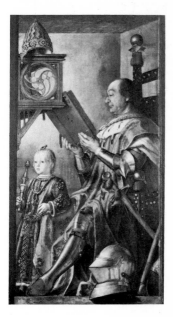

80 PEDRO BERRUGUETE (*c.* 1450–*c.* 1504) *Federigo da Montefeltro with his son Guidobaldo, c.* 1477. *Oil on panel,* 4′ 5″ × 2′ 7″ (135 × 79). *Galleria Nazionale delle Marche, Urbino*

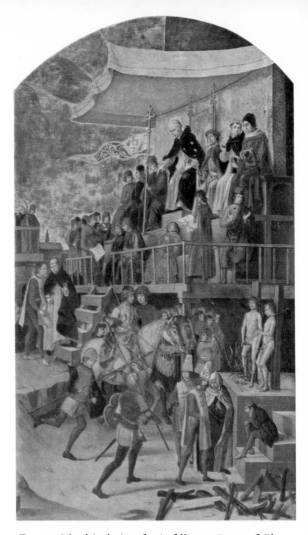

81 PEDRO BERRUGUETE (*c.*
1450–*c.* 1504) *Auto de fe. Oil on
panel,* 5′×3′ (154×92). *Prado,
Madrid*

Famous Men his choice of artist fell upon Justus of Ghent.
The question of Berruguete's participation in this scheme
is still controversial, but the striking portrait of Federigo da
Montefeltro with his son Guidobaldo (*Ill. 80*), formerly
in the *studiolo*, is certainly from his hand.

The portrait had a complex intention, since it repre-
sents the Duke in his dynastic, ecclesiastical and humanist
roles: his young heir bears a sceptre on which is inscribed
the word *potere* ('power'); the Duke himself is panoplied
in armour signifying his authority as Captain-General of
the Church; while the weighty volume which he is
perusing so attentively must allude to his patronage of

humanistic learning, of which the light irradiating his features also seems symbolic. An element of ingenious calculation lies behind this highly original extension of the art of portraiture. The design rises to a climax in the powerful profile of the Duke, isolated from distracting detail, and gives a secondary emphasis to the sympathetic portrayal of the young Guidobaldo, enclosed as he is in a space of his own by the diagonal thrusts that activate the composition.

On the death of Federigo in 1482 Berruguete returned to Castile, where he executed some frescoes in Toledo Cathedral and was employed on various commissions at Avila, to the north-west. He was to die in 1504. His *Altarpiece of St Thomas Aquinas,* painted for the high altar of Santo Tomás at Avila, and two further altarpieces for the Dominican convent, are the most important of his last works: they combine grandeur and inventiveness of design with a remarkable gift for narrative. One of the Dominican panels shows an *auto de fe* presided over in person by St Dominic (*Ill. 81*). The subject is taken from the *Golden Legend* and illustrates the story of the saint's clemency towards a heretic named Raymond, who is given the opportunity of conversion instead of being consigned at once to the pyre. At the Lateran Council of 1215 measures had been drawn up for the extirpation of the Albigensian heresy (a form of Manicheism), the effect of the Council's decrees being to give special powers in this direction to the newly founded Dominican Order. Yet Berruguete based his terrible scene upon contemporary enactments of Inquisitorial 'justice'. The poignant realism of it all is heightened by the artist's command of figure-drawing, his knowledge of anatomy, and his ability to master complex problems of perspective and spatial organization. The analogies that have been seen with the art of Carpaccio must, surely, be coincidental, but in a more general sense the various qualities exhibited in this picture demonstrate the value to Berruguete of his Italian experience.

The Cordovan painter Bartolomé Bermejo, who worked mainly in Aragon and Catalonia, can be likened to Berruguete in that his art was also founded upon a marriage between the Flemish and Italian traditions, although it is very different in character. Bermejo's early style shows his mastery of the Flemish techniques of oil-painting, as can be judged from his *St Michael* at Luton

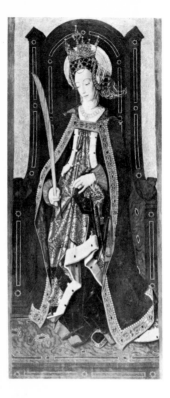

Hoo (England), of the 1470s, and the similar picture at
Edinburgh, in both of which the influence of van der
Weyden and Bouts is prominent. Another early work,
the *Santa Engracia enthroned* (*Ill. 82*), represents a Portu-
guese saint martyred in the reign of Diocletian, and
originally formed part of the high altar of Santa Engracia
at Saragossa. It is a particularly fine example of the
jewel-like brilliancy of colouring and typically Spanish
decorativeness characteristic of Bermejo's style in this
period.

In his later works, however, Bermejo's love of ornament
and graceful effects takes second place to a new largeness
of vision, which is epitomized by the famous *Pietà* of
1490 (*Ill. 69*), commissioned for Barcelona Cathedral by
the archdeacon, Luis Desplà, who is portrayed in the
picture kneeling at the feet of the dead Christ. The
sombre poetry of the landscape, faintly lit by the setting
sun, recalls the lyricism of Giorgione himself, and the
inference that at some date Bermejo visited northern Italy
and the Veneto, although unsupported by any docu-
mentation, appears extremely plausible. Apart from
purely stylistic evidence of this nature, one pointer to the
likelihood of such a visit is the presence of a *Madonna* by
Bermejo in the cathedral at Acqui, north of Genoa. It is
also interesting to compare the iconography of the
Barcelona picture with the almost contemporary *Pietà*
by the Ferrarese master Ercole de' Roberti (now in the
Walker Art Gallery, Liverpool), in which the dead
Christ again lies across the Virgin's lap in a manner
recalling the vesper images of the German woodcarvers.
The same motif can be seen in Spanish sculpture in a
wooden altarpiece, probably from Burgos, in the Cloisters
Museum in New York, where the carved figures, richly
polychromed, are set against a painted background. The
expressive qualities of this anonymous masterpiece sug-
gest the influence of Rogier van der Weyden; and indeed
the art of Bermejo itself must also be regarded as a
fulfilment of the 15th-century Hispano-Flemish tra-
dition: the donor portrait in the Barcelona *Pietà* combines
a quality that is entirely personal and particularly Spanish
in sentiment with something of the brooding intensity of
Hugo van der Goes.

In general, Portuguese art of the 15th century followed
a course that ran parallel to contemporary developments
in Spain; but only one master, Nuño Gonçalves, is

worthy of comparison with painters of the order of Gallego, Berruguete and Bermejo. Gonçalves – active from the 1450s to the late 1470s – was employed as court painter to King Alfonso at Lisbon. His major work, the *St Vincent Altarpiece,* painted for Lisbon Cathedral, was destroyed in the great earthquake of 1755, but a double triptych by him of the same subject (*Ill. 83*), datable about 1465–7, survives. Each of the central panels of this altarpiece includes, besides other figures, a representation of St Vincent of Spain, a 4thcentury martyr venerated especially in Portugal, Spain and France, about whose miraculous relics many legends had grown up, and whose body, according to tradition, had been recovered from the Saracens and enshrined in Lisbon Cathedral.

The panel here illustrated (*Ill. 83*) shows St Vincent surrounded by members of the royal family and other prominent personages of the time; and in the moustachioed man standing beside the saint there can be recognized the features of one of the most memorable figures of this golden age of Portuguese history – Henry the Navigator, a prince of the realm who played a leading part in the Portuguese penetration of West Africa and in encouraging the study of astronomy and geography and a more scientific approach to mapmaking. Many other portraits are included in these crowded panels, all of them individual adaptations of the van EyckBouts tradition.

In the age of discovery of which Columbus and Henry the Navigator have become symbolic figures, along with others such as Bartholomeu Diaz, Vasco da Gama and the Italian Amerigo Vespucci (who gave his name to America), Portugal and Spain were to enter a phase of bitter rivalry when their imperial claims came into conflict in the Americas. Nevertheless the Iberian kingdoms always maintained close cultural links, which were often cemented by marriages between one royal house and another. A case in point is provided by the union, towards the middle of the century, between Isabella of Portugal and John II of Castile. Their images lie side by side in one of the masterpieces of the succeeding period, the monument designed by Gil de Siloe for the Cartuja de Miraflores at Burgos, an abbey of which John II had been the founder. This work and the wall monument to the shortlived Infante Alonso, by the

83 NUÑO GONÇALVES (active *c.* 1450–78) *St Vincent, panel from double triptych, c. 1465–7. Panel, h. 7′ 2″ (218.5). Museu Nacional de Arte Antiga, Lisbon*

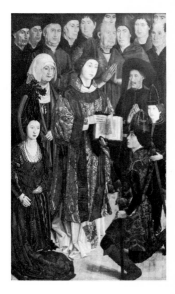

84 GIL DE SILOE (active 1486–99) *Monument to the Infante Alonso, 1489–93. Stone. Cartuja de Miraflores, Burgos*

same sculptor, which is also at Miraflores (*Ill. 84*), were commissioned by Isabella the Catholic, and were executed between 1489 and 1493. They represent two of the highest achievements of Spanish sculpture in the closing years of the century. In the Alonso Monument the Infante kneels beneath an intricately worked canopy within a recess designed to convey a sense of space and so to enhance the three-dimensional reality of the figure, while the cushion and the cloth cover of the *prie-Dieu* are treated with a sensuous appreciation of the textures of materials.

The humanity of this art is matched only by the celebrated monument to Martín Vázquez de Arce (*Ill. 72*), made in alabaster by an unknown sculptor for a chapel in Sigüenza Cathedral (Castile) and datable in the late 1480s. Placed in the context of the two monuments by Gil de Siloe, this luminous work illustrates a significant development in tomb sculpture. In the first of our three examples, the portraits of King John II and Queen Isabella follow the traditional, medieval pattern of the recumbent effigy; in the second, the Infante is no longer represented in death but in an attitude of prayerful preparation for holy dying; in the third, the process has been taken a stage further, and the subject of the memorial, a knight of the Castilian Order who had fallen in battle during the reconquest of Granada, is shown in an informal pose, reclining at his ease with a book as one very much in the world of the living. This new style of monumental tomb sculpture must have seemed revolutionary at the time, and that it was still being criticized in the early 17th century, at any rate in England, is apparent from a passage in Webster's play *The Duchess of Malfi*, where the Duchess is told: 'Princes' images on their tombs do not lie, as they were wont, seeming to pray to heaven, but with their hands under their cheeks, as if they died of toothache: they are not carved with their eyes fix'd upon the stars: but as their minds were wholly bent upon the world, the self-same way they seem to turn their faces.' Yet it is in such works that we discern the advent in funerary sculpture of the humanist portrait of the Renaissance.

The Netherlands, I: Bosch and Bruegel

In the years around 1500, with the decline of the Eyckian
tradition and the incursion into the Low Countries of
new ideas from Italy, Netherlandish painting entered a
period of crisis and change. In brief, it was a period of
assimilation, of a coming-to-terms with the 'grand style'
of the Italian High Renaissance masters and their
Mannerist followers. Two great painters, Hieronymus
Bosch and Pieter Bruegel the Elder, who are closely
linked both by their style and by their common origin in
Brabant, remained nevertheless somewhat aloof from
this development. Especially as the first must be regarded
as a transitional figure, born about the middle of the
15th century and dying in the second decade of the 16th,
it will be convenient to consider their highly individual
and independent art before we come to the Italianizers of
the Antwerp School and other masters of similar
sympathies.

Hieronymus Bosch has fascinated the modern im-
agination for a number of reasons. In the first place,
resemblances have been seen between his fantastic and
often grotesque imagery and that of the 20th-century
Surrealists; secondly, the character of that imagery has
seemed to offer a wealth of material amenable to Freudian
analysis, often producing interpretations of an ap-
propriately fantastic nature; and, thirdly, all that is most
recondite in Bosch's imagery has encouraged speculations
of equally dubious validity, and in particular the famous
Garden of Delights in the Prado has been presented under
the guise of a mystic *arcanum* which reveals the artist as a
secret member of a heretical Adamite sect – although
what evidence there is suggests that Bosch was an
orthodox Catholic, and we know that his work was
admired by that most Catholic of monarchs, Philip II of
Spain.

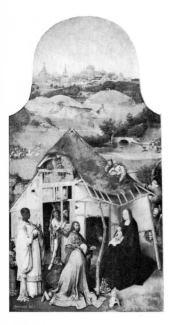

Bosch was born at 'sHertogenbosch in North Brabant, where he appears to have worked until his death in 1516. His real name was Jerome (Hieronymus) van Aaken, but we know little else about him except that he was married and that he was a member of the Brotherhood of Our Lady at 'sHertogenbosch, a Catholic foundation. Nor is it easy to place his works in much more than a tentative chronological sequence, although a stylistic progression from what must be a very early painting, the roundel of the *Seven Deadly Sins* in the Prado, to the *Adoration of the Magi* (*Ills. 85, 86*), also in the Prado, and thence to his greatest altarpiece, the triptych of the *Temptation of St Anthony* (*Ill. 87*) at Lisbon, seems sufficiently clear. The first two of these three works stand closest to the Eyckian tradition, and the disposition of the Virgin and Child in the *Adoration* may reflect a knowledge of van Eyck's Rolin *Madonna* in the Louvre. The anticipations of Bruegel, however, are more obvious, especially in the beauty of the landscape and in the treatment of light and space. The characterization of the three kings also calls to mind the grotesque realism of Bruegel's London *Adoration of the Kings* (*Ill. 90*).

Bosch's picture (*Ill. 85*) contains some curious features that introduce us at once to the bizarre nature of his genius. One is the unusual motif of the four shepherds furtively gaping at the kings, overawed by their presence: one peeps round the corner of the stable; another peers through a window; and two look down from the roof. What is still more remarkable is the introduction of an exotic group of figures, who seem to be mocking at the sacred scene, within the central doorway (*Ill. 86*). There would appear to be an allusion to a description of the Epiphany by the 13th-century German mystic Mechthild of Magdeburg, who wrote that 'when the strange star shone, Satan came to Bethlehem, following swiftly after the three Kings, and looked angrily on the Child, for highest honour was done Him with rich gifts.' Elsewhere the symbolism is less recondite: Melchior, for example (on the left), carries a globe mounted with the figure of a pelican, the age-old symbol of Christ's sacrificial death, while the globe itself is carved with a representation of a pagan sacrifice (of a swan); so that the two symbols add up to a single meaning – the conversion of the pagan world to Christianity.

The triptych of the *Hay-Wain* in the Prado (*Ill. 73*)

contains, likewise, a wealth of symbolic overtones which can be related to Flemish proverbs and other literary sources. Above all it is an extended commentary on one of the oldest of these proverbs: 'The world is a heap of hay, and every one takes from it whatever he can grab.' The left wing contains a representation of the Garden of Eden, and the right wing a scene of Hell: the message of the whole therefore concerns the progress of the human soul from primal innocence to the punishment in store for those tempted by the ephemeral pleasures of this world, whether it be illicit love or greed for power and wealth. All conditions of mankind are included in this imaginative allegory, from the amorous couples on the wagon, tempted by a satanic clarinet-player whose instrument turns out to be a 'surrealist' extension of his own nose, to the princes, bishops and monks below, all intent upon gathering the hay which symbolizes the false and ephemeral happiness of their desire. The *Hay-Wain* marks an important stage in Bosch's stylistic development, for it shows a new mastery of colour and in many passages a notable freedom of brushwork. The date of the triptych must be close to the year 1500, by which time Bosch would seem to have reached his maturity as a painter.

A similar, or slightly later, date can be assigned to his greatest work, the *Temptation of St Anthony* at Lisbon, also a triptych. Its principal literary source was the *Life of St Anthony* written by St Athanasius, although it also reflects Bosch's knowledge of the writings of the late-medieval Flemish mystic Jan Ruysbroeck. In the central scene (*Ill. 87*) St Anthony is presented, in traditional fashion, as the type of the heroic wrestler with temptation – a theme common in northern European art and one that Grünewald was to interpret with equal power.

In Bosch's picture it is magic – the art of Satan – that becomes the agent of the saint's tribulations, for it is a magician who conjures up the phantasms crowding upon St Anthony's tormented imagination. Weird creatures, one composed of a head with legs, attempt to distract the saint from his devotions, to which the figure of Christ, pointing to a crucifix on an altar in the ruined building, seeks to return him. The saint himself turns his head to face us, averting his eyes from a fair temptress who kneels at his side. In the foreground, ape-like devils are fishing from a vessel which is not so much a fishing-boat as a boating-fish: the point here is that they are catching the

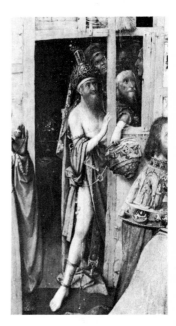

86 HIERONYMUS BOSCH (*c. 1450–1516*) *Detail of the Adoration of the Magi, c. 1500 (See Ill. 85)*

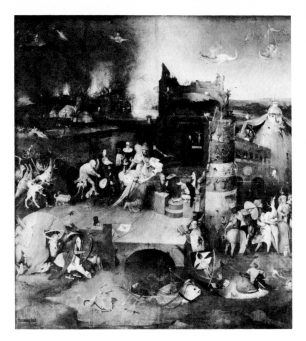

87 HIERONYMUS BOSCH (*c.* 1450–1516) *The Temptation of St Anthony, central panel of triptych, c. 1500. Oil on panel, 4' 7" × 3' 8" (139 × 113). Museu Nacional de Arte Antiga, Lisbon*

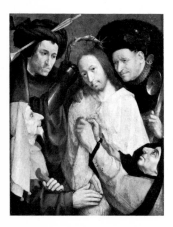

88 HIERONYMUS BOSCH (*c.* 1450–1516) *Christ Mocked, or The Crowning with Thorns. Panel, 29 × 23¼" (73.5 × 59). Courtesy the Trustees of the National Gallery, London*

kinds of fish that were forbidden as unclean under the Old Law and in which Ruysbroeck found an allegory of evil. It should be added that there are precedents for a number of the more fantastic of Bosch's images in classical art, for example on ancient seals that might well have been known in the Middle Ages.

A series of variations upon related themes – the Mocking of Christ and the Carrying of the Cross – is usually although not universally assigned to Bosch's final period. In these pictures we may detect, perhaps, a new serenity of spirit, for it is the Christ at the centre of these tragic compositions who dominates the evil, grimacing figures around him: brutality may seem to triumph, but it is always to the calm and patient Christ within the vortex of these nightmare visions of human depravity that the eye returns to rest. The beauty of the Christ in the London picture (*Ill. 88*) lies almost entirely in his expression: we are far removed here from the Hellenic ideal of the Italian masters; but therein lies also its power, for, as in Rembrandt, the relative lack of idealization adds conviction to this moving image of divine suffering and human dignity.

Bosch's relationship to his closest follower, Pieter Bruegel the Elder (or 'Peasant Bruegel'), who worked in Antwerp and then in Brussels after an extensive period of travel in France and Italy in the early 1550s, is evident enough from the painting known as *Dulle Griet* or *Mad Meg* (*Ill. 89*), one of the most puzzling of Bruegel's works, but one that is redolent of the kind of fantastic imagery familiar to us from the art of the older master. Dulle Griet – to quote van Mander's description of the picture – 'is stealing before Hell; she is very hairy and wears a strange Scottish costume.' In medieval times the name Griet, or Meg, signified a type of evil harridan, foul-tongued and immoral, who was noted for leading her husband a dance; and she appeared all the more fearsome and evil because she flouted the divine command that woman should be subject to man: she was therefore considered a sort of witch in league with the devil. In consequence her proper place was Hell itself, and in Bruegel's picture her approach to the mouth of Hell, at the head of a regiment of other women, is an object of terror even for the local inhabitants. The 'surrealist' imagery that crowds the composition derives straight from Bosch, although nearly half a century separates the picture (dated 1562) from the year of Bosch's

89 PIETER BRUEGEL THE ELDER (*c.* 1525/30–1569) *Dulle Griet, 1562. Oil on panel, 3′ 9″ × 5′ 3″ (115 × 161). Museum Mayer van den Bergh, Antwerp*

death; but Bruegel's indebtedness to Bosch is already apparent in his very early works, notably in a series of drawings made for engravers shortly after his return from his travels abroad.

Bruegel's first dated painting, a *Landscape with the Parable of the Sower,* brings us to the year 1557. All his greatest works were executed in the decade before his death in 1569. A number of them are religious subjects, such as the *Fall of the Rebel Angels* at Brussels (1562), the *Christ carrying the Cross* at Vienna (1564) and the London *Adoration of the Kings (Ill. 90)*; but in general Bruegel preferred to treat biblical themes in a highly individual manner, relating them closely to contemporary life and often making them the starting-point for imaginative and minutely observed explorations of landscape. Only occasionally can we detect in his art some faint echoes of the masterpieces of Renaissance and Mannerist painting that he would have seen in Rome and elsewhere in Italy; it was rather the majestic scenery of Italy, and especially of the Alps, that seems to have filled his eyes during his travels: as van Mander phrased it, somewhat inelegantly, Bruegel 'in passing the Alps swallowed the mountains and crags, to vomit them up, on his return, on his canvases and panels' – a description that brings to mind in particular the curious *Suicide of Saul* of 1562, at Vienna, where Mount Gilboa is imagined as a vast Alpine range dwarfing the embattled hosts below. At all events Bruegel's powers are to be seen at their height in his landscapes, culminating in the great series of the *Months* of 1565 (*see Ill. 77*), commissioned by Niclaes Jonghelinck, one of his principal patrons.

Apart from landscape, Bruegel's *forte* was the interpretation of the life of the peasantry: hence his *sobriquet* of 'Peasant Bruegel'; a title that should not be misunderstood, for Bruegel himself was a cultured and well-educated man. One of his friends was the humanist scholar Abraham Ortelius, whose epitaph upon him describes him as the greatest artist of his age and in conventional style compares him to the ancients; and his work was held in high esteem at the Habsburg court, one of his chief patrons being the Emperor's delegate, Cardinal Granvelle, Archbishop of Malines. Like many other artists of the period, Bruegel seems to have been in sympathy with the reformist movement within the Church for which the humanists had prepared the way

and which was brought to a head by Luther. He would
have witnessed the terrible sufferings of his own people
under Titelmann's Inquisition and, two years before his
death, the Duke of Alva's arrival in the Spanish
Netherlands to intensify the persecution of the Protestant
heretics. It has even been suggested that Alva himself is
portrayed among the officers who direct the grim actions
of the soldiery in Bruegel's *Massacre of the Innocents* at
Vienna. Certainly Bruegel's treatment of the subject must
have been based upon personal experience, and there is
nothing more touching in the whole wintry landscape
than the vain pleadings of the peasants as they beg for
mercy. At the same time the strong satirical bent in
Bruegel's personality led him on occasion to depict the
follies of all classes of men, rich and poor alike, in a spirit
of gentle mockery, as in the *Adoration of the Kings* in
London (*Ill. 90*), although in his *genre* pictures, such as

90 PIETER BRUEGEL THE ELDER
(*c.* 1525/30–1569) *Adoration of the
Kings, 1564. Oil on panel, 43¾ ×
32¾" (111 × 83.5). Courtesy the
Trustees of the National Gallery,
London*

123

the series of scenes of *Peasants Dancing* and the famous *Peasant Wedding (Ill. 76)*, he is at his happiest when this element scarcely obtrudes and when he seems to abandon himself to the simple pleasures of ordinary people.

In the *Adoration of the Kings* the figure of the young Moorish King (on the right), suggests a possible reminiscence of Bosch's *Adoration (Ill. 85)*. A certain concession to Italianate ideals of beauty is discernible in the Virgin and Child, but otherwise the conception is entirely northern in spirit, and the rich, vibrant colours derive ultimately from the 15th-century Flemish tradition. Bruegel's interpretation of this hallowed subject is even more unusual than Bosch's, for a powerful element of satire enters in, and the artist appears to be poking fun at these contrasted representatives of humanity – the kings of the earth, whose trappings of regal splendour and authority do not in the least disguise the raw human nature underneath; and, standing behind them, the simple folk whose very simplicity is the object of an equally uncompromising scrutiny.

Probably Bruegel found such traditional subjects uncongenial: his true genius lay in the depiction of *genre* subjects and landscapes, in both of which he was a pioneer; and his originality is nowhere more in evidence than in the marvellous *Peasant Wedding* at Vienna (*Ill. 76*), which although undated must be a late work – the final consummation, possibly, of Bruegel's aims as a painter of contemporary life. Not only does this picture open the way to the establishment of the *genre* subject as an important new class of painting to be valued in its own right, but it reveals the artist as an absolute master of design and spatial composition. The most obvious precedents for representations of an interior with a feast are to be found in scenes of the Last Supper or the Marriage at Cana, such as Bouts's panel at Louvain (*Ill. 35*); and Bouts certainly, in giving the sacred event a contemporary setting, had prepared the ground for Bruegel's realism: but in freeing such scenes from their traditional subject-matter Bruegel added an entirely new informality, anticipating the 'low-life' pictures of Teniers and Brouwer in the following century. If we compare the *Peasant Wedding* with the stiff, frontal design of the Louvain *Last Supper* we can see how this new informality is assisted both by the varied 'occupational gestures' of the figures and by the oblique perspective,

which brings to mind the experiments in spatial compo-
sition now being undertaken independently by
Tintoretto in Venice. As to the subject, Tolnay, noting
the difficulty in identifying the bridegroom, has sug-
gested that the picture illustrates one of the quainter of
Flemish proverbs, to the effect that it is a poor man who
is absent from his own wedding; but the bridegroom
may in fact be the man greedily feeding himself at the
centre of the composition. However that may be, the
Peasant Wedding brings to a triumphant conclusion the
new realism initiated by Jan van Eyck in the *Arnolfini
Portrait* (*Ill. 13*), and where in van Eyck's masterpiece
we are permitted to look in upon the room in which the
betrothed couple exchange their solemn vows, here we
seem to be in the midst of the throng of merrymakers,
partaking of their revelry.

The same intimacy informs the great series of the
Months, commissioned in 1565 to decorate Niclaes
Jonghelinck's villa in Brussels, of which five have
survived, the most celebrated being the *Huntsmen in the
Snow* (or *January*) in Vienna. The so-called *Stormy Day,*
representing the month of February (*Ill. 77*), is equally
fine, and even exceeds it in poetic sensibility: just as
the *Peasant Wedding* anticipates Teniers, so the *Stormy
Day* sets us thinking ahead to Ruisdael, so intensely does
Bruegel identify himself with the mood of nature in this
wonderfully evocative landscape, its gathering clouds
threatening a downpour as the labourers hasten on their
work, and casting over the broad panorama shifting pools
of darkness. 'Light thickens', Shakespeare wrote in a
different context, and the symbolic overtones of Bruegel's
picture are not far removed from those implicit in the
famous passage in *Macbeth,* for the theme of the *Months* is
an ancient one that tells of the annual rebirth of life after
the death of winter, presenting the changing seasons in
the guise of an allegory of the eternal struggle between
Good and Evil, symbolized by light and darkness. In
Bruegel's series, however, the symbolism has been
generalized and given a universal significance. Apart
from the sheer beauty of these pictures, their importance
lies in their historic place in the development of landscape-
painting as an independent art.

The Netherlands, II: Mannerists and Romanizers

Two years before Bruegel's death, Lodovico Guicciardini, in his *Description of the Low Countries,* drew attention to the important part played by the Netherlandish masters of the 16th century in making known in other countries the glories of the Italian Renaissance. In that process Bruegel himself had been a negligible figure, for his travels beyond the Alps had not fundamentally affected the direction of his art. The task of assimilating the new explorations and innovations of the Cinquecento fell to others, such as Jan Gossaert (known also as Mabuse, a patronymic derived from his father's name Jacques de Mauberge), Quinten Massys (sometimes spelt Quentin Matsys or Metsys), Bernard van Orley, Jan van Scorel and Marten van Heemskerck.

What Italy had come to mean to Flemish painters by the middle of the 16th century is made clear by the precepts laid down by van Mander in his famous treatise: 'From Rome bring home skill in drawing, and from Venice the ability to paint.' In much the same vein the painter Lambert Lombard, when writing to Vasari, had dwelt upon the value of a first-hand knowledge of the masterpieces of antiquity and especially of 'those stupendous figures from Montecavallo' (the *Dioscuri*), 'that perfect *Laocoön*', and the 'slender, vigorous, soft *Apollo*' (the *Apollo Belvedere*). However slow the founders of this new tradition may have been to appreciate the true character of the Italian achievement, their earnest attempts to graft Italian High Renaissance forms on to the still flourishing Netherlandish tradition were the natural accompaniment of the spread of humanism to northern Europe: this was the age of Erasmus, Aegidius and Thomas More; and just as the humanists looked beyond the culture of modern Italy to its sources in ancient Rome and Greece, so the painters were invited to fix their eyes upon the same ideal.

Before we trace these developments in the Low Countries it will be as well to outline some of the more important political events that directly affected the course of northern European árt. As we have seen, the death at Nancy in 1477 of Charles the Bold, whose *sobriquet* reflects his ambition to be crowned as Holy Roman Emperor, marked a turning-point in the fortunes of the Burgundian lands. The marriage of Charles's daughter Mary to the Habsburg prince Maximilian, shortly to become Holy Roman Emperor, now meant that the Netherlands were caught up in the bitter struggles for European hegemony which were typified by the rivalry of the French kings first with Maximilian and then with his successor Charles V. The premature death in 1506 of Maximilian's son Philip the Fair, who had ruled the Low Countries from 1494, had still greater consequences; for Philip had married the daughter of Ferdinand of Aragon and Isabella of Castile, so that his own son – the future Emperor Charles V – fell heir both to the Holy Roman Empire and to the Spanish dominions. Charles being at this time only six years old, his sister Margaret of Austria was appointed by Maximilian Regent of the Netherlands, where she set up her court at Malines (between Antwerp and Brussels) and inaugurated a new phase in the patronage of the arts. A few years later the supremacy of the house of Habsburg was finally established by Charles's succession in 1516 to the Spanish throne and, on Maximilian's death in 1519, by his accession as Holy Roman Emperor. Meanwhile the reigns of Maximilian and Charles V witnessed Luther's attacks upon abuses in the Church (notably the sale of Indulgences) and the consequent rise of Protestantism, a crucial development that besides changing the course of European history brought in its train a long period of religious conflict lasting throughout the 16th century.

The regency of Margaret of Austria, which continued until her death in 1530, and that of her successor Mary of Hungary (Charles V's sister), who was to remove her court from Malines to Brussels, enabled numerous artists to profit from their discerning patronage. Margaret herself appears to have been a connoisseur of wide sympathies. From her inventories we know that she at one time owned van Eyck's *Arnolfini Portrait (Ill. 13)* as well as a painting by Bosch. Conrad Meit's most important works, the great tombs at Brou, were carried out during his Malines

91 LANCELOT BLONDEEL (b. 1496) and GUYOT DE BEAUGRANT (d. 1551) *Chimneypiece in the Franc, Bruges*

period, and several other sculptors, including Pietro Torrigiano, were active at Malines. One of the surviving masterpieces of the period, an ornate chimney-piece in the Franc at Bruges (*Ill. 91*), containing statuettes of Charles V and his ancestors, was commissioned by Margaret of Austria from the painter Lancelot Blondeel (its designer) and the sculptor Guyot de Beaugrant (who executed the work). Among the painters employed at the Malines court we may mention at this point Bernard van Orley, who became official painter to the Regent in 1518, and whose major work is the enormous *Passion Altarpiece* for her memorial chapel in Notre-Dame at Bruges; Jan Gossaert, whose momentous visit to Rome about the year 1508 was undertaken in the service of Philip of Burgundy, Bishop of Utrecht; Jan Mostaert, court painter to the Regent for some 18 years, one of whose most interesting, if relatively minor, works is a landscape of about 1540 (now at Haarlem) showing naked West Indians fleeing from their Spanish conquerors, a remarkable illustration of the exploitation of the New World opened up by the expeditions of Columbus and his ruthless successors; Jan Cornelisz. Vermeyen, from Haarlem, one of the creators of the humanist portrait; Jean Perréal (*see Ill. 67*); and, not least, the Venetian Jacopo de' Barbari, who was attached to the Malines court from 1510 and co-operated with Gossaert on a series of decorations, representing nude divinities (*see Ill. 93*), for Philip of Burgundy's residence at Suytburg in Zeeland.

Barbari's lively intelligence, with its theoretical bent,

was to be one of the principal channels whereby Italian principles of proportion and measure became known in the Low Countries and Germany. Another Italian, the Lombard painter Ambrosius Benson, joined the Bruges guild as Master in 1519, and although conservatively inclined he may well have stimulated Netherlandish artists to study the work of Leonardo. Meanwhile, Michelangelo's marble *Virgin and Child* had been set up in Notre-Dame at Bruges as early as 1506, and the classic grace of this masterpiece of Michelangelo's youthful period must have made a deep impression on local painters and sculptors. Ten years later Raphael's cartoons for the tapestries intended for the Sistine Chapel arrived in Brussels, the main centre of the weaving industry in Europe, the task of superintending the manufacture of the tapestries being entrusted to Bernard van Orley. Furthermore Leo X's desire to present a further set of tapestries to Henry VIII of England brought a member of Raphael's workshop, Tomaso Vincidor, to Brussels to supervise the weaving.

Apart from actual visits to Italy by such Netherlandish masters as Gossaert, Scorel and Lambert Lombard, the principal means by which northern painters acquired a knowledge of Italian and antique art must have been the newly developed media of the line engraving and woodcut, and more particularly those by Mantegna and the vast number produced by Marcantonio Raimondi after compositions by Raphael and other masters (*see Ills. 2, 3*) and after Roman antiquities. Nor should we overlook the immense influence exerted by the engravings of Dürer, who made two visits to Italy and who was himself to travel through the Low Countries in the years 1520–21, seeking out almost every artist of importance and recording in his journals vivid impressions that must have been reciprocal.

Thus in the great nudes commissioned from Gossaert in 1515 for Suytburg Castle, which Guicciardini no doubt had in mind when he observed that Gossaert 'was the first to bring from Italy . . . the art of painting histories and *poesie* with nude figures', there are echoes not only of Italy and the antique but also of Dürer: for example, the *Neptune and Amphitrite* (*Ill. 93*), dated 1516, was certainly based to a great extent on an engraving by Dürer of *Adam and Eve* (*Ill. 92*); although the Italian influences, not least in Gossaert's characteristically fanciful treatment

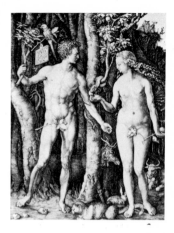

92 ALBRECHT DÜRER (1471–1528) *Adam and Eve*, 1504. Engraving, 10 × 8″ (25.2 × 19.4). *British Museum, London*

93 JAN GOSSAERT, called MABUSE (1478–c. 1533) *Neptune and Amphitrite*, 1516. Oil on panel, 6′ 2″ × 4′ 1″ (188 × 124). *Staatliche Museen zu Berlin*

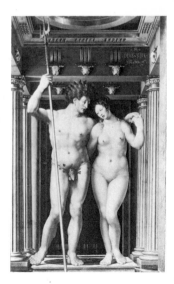

of architectural detail, are no less apparent, and reflect the impact made upon him by his visit to Italy about 1508.

Gossaert's beginnings lay in the traditions of Bruges, and his early manner recalls that of Gerard David. The large *Adoration of the Kings* in London (*Ill. 94*), presumably painted before his Italian visit, is the undoubted masterpiece of his early years, and its ornate beauty may incline us to regret that the older 15th-century Flemish tradition, to which it entirely belongs, had now fulfilled its function, and that changing tastes were to force upon this exquisite master of the Eyckian vision the need to move with the times. A hint that Gossaert himself half-regretted the freedom that his Italian experience had opened up to him is possibly provided by the charming little *Malvagna Triptych* at Palermo (*Ill. 95*). That this work is to be dated after his visit to Italy is indicated by the playful angels in the central panel, suggesting the influence of the *cantorie* (singing-galleries) of Donatello and Luca della Robbia in Florence Cathedral. Yet such borrowings do not disguise the archaizing intention of the triptych as a whole: the pensive Madonna in the central panel might almost have been painted by Gerard David, and her draperies entirely lack the fluttering agitation that is so characteristic of Gossaert's more 'Mannerist' works; while the elaborate canopy, a

94 JAN GOSSAERT, called MABUSE (1478–*c.* 1533) *Adoration of the Kings, c. 1507. Oil on panel, 5′10″×5′3″(177×161). Courtesy the Trustees of the National Gallery, London*

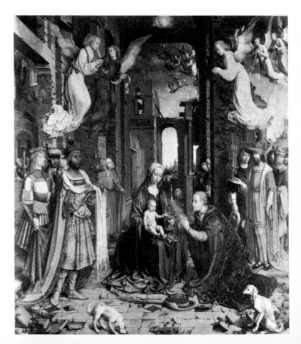

95 (opposite, above) JAN GOSSAERT, called MABUSE (1478– c. 1533) *Central panel of the Malvagna Triptych. Museum, Palermo*

96 (opposite, below) JAN BORMAN THE ELDER (active late 15th–early 16th C.) *Central section of the St George Altar, 1493. Oak, whole altar 5′ 3″ × 16′ 1″ (160 × 489). Musées Royaux d'Art et d'Histoire, Brussels*

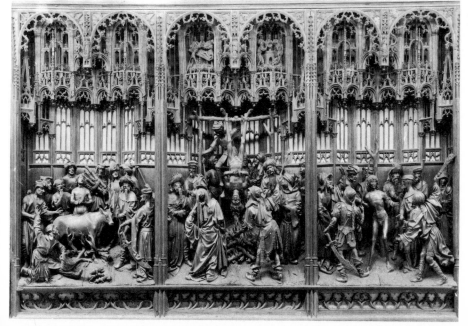

flamboyant exercise in the Late Gothic style, may be compared with the similar traceried canopy of the great *St George Altar* (*Ill. 96*) carved by Jan Borman the Elder in 1493 for Louvain Cathedral, a masterpiece that in other respects anticipates the more classical style of Conrad Meit (*see* Chapter XI), and which Gossaert must assuredly have known. In general, however, Gossaert developed in his last years in a direction that led him to divorce himself from his Gothic origins, and as he fell more and more under the influence of Barbari his work declined into a somewhat vapid although lively Mannerism, as in the pretentious *Danaë* at Munich, painted in 1527.

As a portrait-painter Gossaert is best known for his *Carondelet Diptych* of 1517, now in the Louvre. This type of devotional portrait, in which the sitter – in this case Jean Carondelet, Chancellor of Flanders and friend of Erasmus – is represented (in the left-hand panel) in the act of praying to the Virgin and Child (represented on the right wing), adheres closely to the tradition perfected by Memling; but the intensity and vitality of the portraiture reflect the new taste for a more intimate, psychological approach.

Gossaert's principal rival was the Brussels master Bernard van Orley, who succeeded Jacopo de' Barbari as court painter to Margaret of Austria in 1518 and, after her death in 1530, continued in the same capacity at the Brussels court of Mary of Hungary. A prolific artist, van Orley painted numerous altarpieces and portraits, and also designed tapestries and stained glass. His reputation in his own time was so high that it earned him the title of 'the Raphael of the North'. He is supposed to have visited Italy, and certainly he outdid Gossaert in his Italianisms, as can be seen from his great *Job Altarpiece* of 1521, with its grandiose echoes of Raphael's tapestry cartoons and its tumultuous, Michelangelesque figures. In his portraits he is less pretentious, and his fine full-face portrait of the scholar Georg van Zelle, of 1519, in which the sitter, pen in hand, looks musingly into the distance, belongs to the new style of humanist portrait now being created by Quinten Massys.

Massys was born in 1466, but little is known about his work before 1506, although he is documented in 1491 as being already active at Antwerp, where he soon became the leading painter during the regency of Margaret

97 QUINTEN MASSYS (1466–1530) and JOACHIM PATENIR (d. *c.* 1524) *Madonna and Child, c. 1527.* Oil on canvas, 43¼ × 34¼″ (110×87). *National Museum, Poznan*

of Austria. His *Lamentation* triptych (*Ill. 98*), commis-
sioned for Antwerp Cathedral in 1508 and set up in
1511, stands out as one of the most celebrated works of
the period. This splendid and moving altarpiece
combines all that is best in the art of such earlier masters
as van der Weyden and Bouts with a grandeur of design
and a profundity of characterization that are entirely new –
the one deriving possibly from some acquaintance with
the work of Leonardo da Vinci, and the other touching
a more personal note and anticipating the qualities of
his later portraits. At the same time the tapestry-like
organization of the design, with its absence of defined
focal points, the meticulous detail and that 'neatness' of
execution which van Mander singled out as one of the
virtues of the Flemish School all assert the ultimate
independence of the northern vision.

It is not certain that Massys ever visited Italy, but there
are pictures by him that closely follow Leonardo's
designs, a well-known example being the *Madonna and
Child* at Poznan (*Ill. 97*), a late work based upon
Leonardo's *Virgin and Child with St Anne* in the Louvre,
of which numerous copies and variants were produced by
the Florentine master's Milanese pupils. The landscape
in the Poznan picture is by the prolific and immensely
popular Joachim Patenir, with whom Massys had

98 QUINTEN MASSYS (1466–
1530) *Lamentation over the Dead
Christ, central panel of triptych,
1508–11. Oil on canvas, 8' 6" ×
8' 11" (260 × 273). Koninklijk
Museum voor Schone Kunsten,
Antwerp*

evidently formed an association. Patenir's importance lies in the fact that in his independent works, such as the famous *Flight into Egypt* at Antwerp, he was among the first to develop the art of landscape for its own sake, the subject-matter being usually a pretext for an imaginative composition in which fantastic rock-formations and blue distances are characteristic features.

Massys's late style as a religious painter is well repre-sented by the *Adoration of the Magi* in the Metropolitan Museum in New York, almost certainly painted in 1526. Here an element of caricature discernible in the Magi and their retinue may derive from Leonardo's exaggerated drawings of contrasted facial types. One such drawing by Leonardo unquestionably inspired the grotesque *Old Woman* in the National Gallery in London, the meaning of the picture being possibly connected with a passage in the *Praise of Folly* in which Erasmus ridicules aged women who persist in dressing up and in hopefully displaying their withered charms. A satirical element of some kind doubtless underlies Massys's well-known *Banker and his Wife* of 1514 (*Ill. 99*), which belongs to a class of subject whose popularity in the Netherlands is attested to by the numerous variations on such themes produced by Massys's follower Marinus van Reymers-waele. Their ancestry may go back to the time of van Eyck, for Marcantonio Michiel, writing in the 16th century, mentions a picture by van Eyck, which he had seen in Milan, 'representing a patron making up his accounts with an agent'; and the links between the painting by Massys and Petrus Christus's *St Eligius and the Lovers* (*Ill. 20*) have often been noted.

In Massys's picture the banker's wife is turning the page of a devotional book to lay it open at an illumination representing the Virgin and Child: but she does so absentmindedly, distracted as she is by the glittering gold pieces being counted and weighed by her husband. The convex mirror, suggesting a reminiscence of the *Arnolfini Portrait* (*Ill. 13*), which Massys could have seen at Malines, may be a symbol – deriving from medieval traditions – of the purity of the Virgin. The moral of the picture might be summed up in the biblical text, 'Where your heart is, there will your treasure be also.' The bookshelves sparsely lined with ledgers, account-books and perhaps one of the new manuals on banking and trade bring to mind Renaissance representations of St

Jerome in his study, where the books on the shelves have
a very different significance: Massys may well have
intended an implicit contrast, of an ironic nature, between
earthly and heavenly treasure.

It is understandable that the St Jerome theme should
have been adapted to the new type of humanist portrait
introduced by Massys and developed by Hans Holbein
the Younger. The most interesting of such portraits by
Massys are the pair of *Erasmus* and *Aegidius* (*Ill. 101*) of

99 QUINTEN MASSYS (1466–
1530) *Banker and his Wife, 1514.
Oil on panel, 28 × 27″ (71 × 68).
Louvre, Paris*

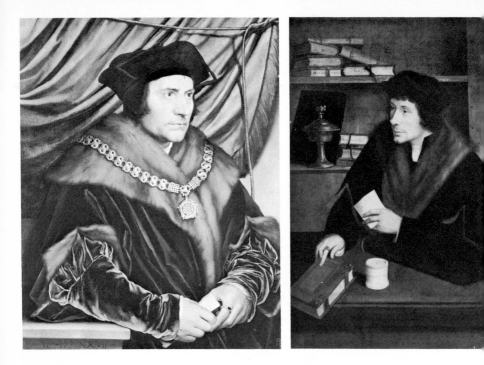

1517, known as the 'Friendship Diptych' from the fact that the pictures were commissioned from Massys by Erasmus, a close acquaintance, as a present to their friend Sir Thomas More. More's own portrait by Holbein (*Ill. 100*), painted ten years later, like the German master's earlier portrait of Erasmus (1523), must owe much to the example set by Massys. The 'Friendship Diptych', now divided, was originally intended to be seen as a unit, since the two men face one another within one room, as though in serious conversation – the great humanist of Rotterdam on the left, and, on the right, his disciple and admirer, the Antwerp scholar Peter Gilles, known as Aegidius, to whom Sir Thomas More dedicated his *Utopia*; the one pausing for a moment as he begins his *Paraphrase of the Epistle to the Romans,* the other holding in his left hand a letter from More, while with his right he reverently fingers another work by Erasmus. In the dedicatory passage in his *Utopia* More had remarked both upon Aegidius's learning and upon his affectionate nature and honesty of character, qualities to which Massys surely did justice in his portrayal of his sitter's eager and sensitive features.

Massys's gifts in portraiture and *genre* subjects were matched by those of his Dutch contemporary Lucas van Leyden, whose early *Self-portrait* at Brunswick and the *Unknown Man* in London are among the most vivid and 'natural' pieces of portraiture of the period, and whose *Card Players* at Wilton House (England), datable about 1515, anticipates the work of the 17th-century masters of *genre* painting. But, as van Mander observed, Lucas van Leyden was a universal genius, excelling both as an engraver and as a religious painter, and his full powers were probably still unrealized at the time of his early death in 1533 (at the age, it appears, of thirty-nine). He was trained in Leyden, and evidently worked there for most of his life.

Lucas van Leyden's major work, the *Last Judgment* triptych (*Ill. 107*) commissioned in 1526 for the town hall at Leyden, demonstrates his originality and range of imagination. The format of the panels, resembling the outline of a bell, is in itself worthy of note, and the avoidance of a rigid, rectilinear framework makes possible an unprecedented liberation of the pictorial space, so that the heavens seem to open out into infinity. Van Mander praised in particular Lucas's renderings of the female nudes in the *Last Judgment,* which while evidently owing much to Marcantonio's engravings after Raphael must have been carefully studied from life. This mastery in the treatment of the human figure, the apparent ease with which every posture and every gesture are handled, the delicate lightness of the colours and the grace and harmony of the whole conception make this an exceptional and unforgettable work. There is little here of the *terribilità* of Michelangelo's *Last Judgment* in the Sistine Chapel, which is of a comparable date: Lucas's vision is remarkable for its serenity; and we forget the awesome nature of the subject-matter in our pleasure in the sheer beauty of the painting, much as we enjoy Lucas's woodcuts for the superb facility of his draughtsmanship.

Another artist from the northern Netherlands, the much-travelled Jan van Scorel, profited from his Dutch origins when Pope Hadrian VI, who himself came from Utrecht, called him to Rome in 1522 and appointed him Raphael's successor as conservator of the Belvedere antiquities. Scorel also visited Venice and even the Holy Land, and he was probably the first artist to attempt (however unsuccessfully) to give subjects taken from the

102 CORNELIS FLORIS (1514–
75) *Lower section of the Tabernacle of
St Leonard, 1550–52. Stone, 10′ 1″
×7′ 3″ (308×220). St Leonard,
Zoutleeuw*

Gospel story something of the correct 'period flavour'. In Rome he came under the influence of Raphael and Michelangelo, and his *Adam and Eve* in New York (*Ill. 3*) derives from Raphael by way of an engraving by Marcantonio (*Ill. 2*). But Scorel was no less appreciative of the Venetians, and his *St Sebastian* at Rotterdam (*Ill. 108*), a late work of 1542, suggests a recollection of one of Michelangelo's celebrated *Slaves* by a mind steeped in the art of Titian. Scorel's rapid method of painting, his rich colour and feeling for light, as well as his Venetian-inspired insistence upon the over-all unity of a composition, distinguish him sharply from a painter like Gossaert, with whom, however, he shares a place in the history of Netherlandish painting: just as Gossaert brought a deeper knowledge of Italian ideals to Flanders, so Scorel undertook the same role with respect to Holland. Yet, for all his learning, Scorel is at his most agreeable in his simple, unaffected portraits, and it was this simplicity of approach that he handed on to his pupil Anthonis Mor, or Moro, who skilfully transposed it into the key of court portraiture.

Another of Scorel's followers, Marten van Heemskerck, belongs to the last phase of northern Mannerism. Heemskerck worked chiefly at Haarlem, but like Scorel he spent several years in Rome. In 1535 he returned to Haarlem, bringing with him countless studies after the antique, many of which were engraved, so that a detailed knowledge of Roman antiquities was made available to artists in northern Europe: even today we still see the Rome of the High Renaissance through his eyes. His *Self-portrait* (*Ill. 1*), painted in 1553, shows the artist posed authoritatively in front of the Colosseum.

By the third decade of the century, the Italian visit had become, if not obligatory, at least a desirable element in an artist's education; and in one instance of note it led to the loss to the Low Countries of one of the supreme geniuses of the age – the sculptor Jean de Boulogne, better known as Giovanni Bologna, who was born at Douai and trained in Flanders but never returned from his visit to Italy in the 1550s, preferring to settle in Florence.

Among contemporary Netherlandish sculptors, special mention must be made of Cornelis Floris, who after visiting Rome in 1538 returned to Antwerp with a deep understanding of the ideals of such High Renaissance sculptors as Andrea and Jacopo Sansovino. His

Tabernacle of St Leonard, executed in marble between 1550 and 1552 for the church of St Leonard at Zoutleeuw, encloses within a soaring Gothic structure reliefs and other features rendered in a purely Renaissance style. The reliefs occupying the lower part of the tabernacle (*Ill. 102*) are enframed by impressive figures of prophets, and illustrate scenes from Genesis. The classic restraint of Floris's style has been justly likened to that of his French contemporary Jean Goujon (*Ill. 147*).

Floris also practised as an architect, and it was he who built, in the early 1560s, the magnificent town halls at Antwerp and The Hague. The town hall at Antwerp (*Ill. 103*) was the first building erected in the Netherlands to show a thoroughgoing application of Renaissance principles on a grand scale. Its most original feature lies in the contrast achieved in the façade between the towering thrust of the great gabled entrance, with its imposing Venetian windows and arched niches (containing statues), and the more static harmony of the nine-bayed extensions on either side, dominated by their two central tiers of alternating rectangular windows and pilasters.

Inspiration for architects throughout the north, including England (see p. 191), was provided by the treatises of the Dutch theorist Vredeman de Vries – the *Architectura* (1563) and the *Compartimenta* (1566) – in which the ornamental use of strapwork and cartouches, or scroll-work, reflecting Mannerist design at its most wilful and decorative, is a dominant feature. In Germany,

103 CORNELIS FLORIS (1514–75) *Antwerp town hall, 1561–5*

104 FRANS FLORIS (*c.* 1517–70)
*Fall of the Rebel Angels, centre of
triptych for the altar of the Escrimeurs
(swordsmen) in Antwerp Cathedral,
1554. Panel, 8′ 2″ × 6′ 4″ (249 ×
193). Koninklijk Museum voor
Schone Kunsten, Antwerp*

at the end of the century, de Vries's engravings were
paralleled and even exceeded in fantasy by those of
Wenzel Dietterlin.

The work of Cornelis Floris brings us to the last
quarter of the century, for he died as late as 1575. It would
be difficult to find anything in Netherlandish painting of
the late 16th century to match his fine sensibility. Various
tendencies were at work – the Mannerist influences from
Italy, still strong, as in the large *Fall of the Rebel Angels* at
Antwerp (*Ill. 104*), painted by Cornelis's brother
Frans Floris, in which tumbling, Michelangelesque
bodies in violent movement give an impression only of a
virtuoso display of *disegno* and striking foreshortening –
qualities repeated in his *Last Judgment* of 1565, now at
Vienna. The same ambition to rival the Italian followers

of Michelangelo can be seen in the work of many other painters of the period.

Far more interesting, and far more fruitful in terms of the later history of Flemish and Dutch painting, are the *genre* subjects, such as those of Pourbus and Pieter Aertsen, which now begin to come into their own, anticipating Brouwer, Teniers and Jordaens, and the development – following the pioneering explorations of Bruegel and Patenir – of an independent art of landscape painting, as in the severe, perspectival scenes of Grimmer and the more open and painterly landscapes of Joos de Momper (*Ill. 105*). In the hands of such painters, minor figures though they were, Netherlandish painting may be said to have cast off its pretensions to Italian grandeur and to have returned to its roots. Except in rare instances, there had always been an element of conflict in the attempt to come to terms with an essentially alien, Mediterranean vision. For reasons that lie outside the scope of this book, it was the emergence of the Baroque style that made possible a more harmonious union between the northern and the Italian genius; and when Italy was wooed again, this time by one of the supreme masters of European painting, Peter Paul Rubens, that union could never be in danger of becoming less than an equal partnership.

105 JOOS DE MOMPER (1564–1635) *Harvesting Scene. Oil on panel, 2′ 8″ × 4′ 8″ (82.5 × 143.5). Collection Captain P. J. B. Drury-Lowe*

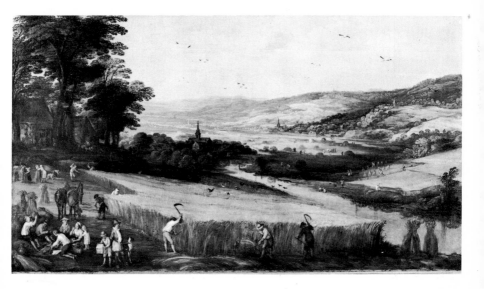

Germany, I: Dürer and Grünewald

Albrecht Dürer, Germany's greatest artist, might be described as the Leonardo of the Northern Renaissance. Both men were transitional figures, and at the same time the founders of a new style. Above all, Dürer approaches Leonardo in his insatiable curiosity about the natural world, which is reflected especially in his drawings, embracing as they do studies of the human figure and human physiognomy, of animals, plants and landscapes; and like Leonardo he was deeply interested in theory, and was the author of a *Treatise on Proportion* and other writings. Again like Leonardo, he was noted for his graciousness of manner and personal beauty, and, equally famous throughout Europe, he was courted by great patrons and revered by his fellow-artists. On the other hand there are obvious differences, such as the fact that the German master worked principally as an engraver; nor is there any evidence that Leonardo was ever tortured, as Dürer was, by religious problems.

Dürer was the son of a Nuremberg goldsmith of Hungarian extraction. He became the pupil first of his father and subsequently of Michael Wolgemut, whose workshop supplied a constant demand for altarpieces, portraits and woodcuts for printed books. Under Wolgemut, with whom he remained until 1490, when he was in his twentieth year, he would have received a thorough training in drawing, painting and the techniques of woodcut and copperplate engraving. Dürer then set out on a period of travel in Franconia, Swabia, the Rhineland and Alsace – the traditional *Wanderjahre* of German custom. He had hoped to make contact with Martin Schongauer at Colmar, but arrived there only to learn that the great painter-engraver was dead. He eventually settled for a while at Basle, which vied with Nuremberg as a centre of printing, and worked there as a

designer of book-illustrations: his entrance to the world of publishing at Basle would have been made easier by the fact that his godfather, Anton Koberger, was Germany's leading printer. Dürer's woodcuts from his early period show the influence both of Schongauer and of the Master of the Housebook (*see Ills. 48, 50*).

In 1494 Dürer returned to Nuremberg to marry: it was an arranged marriage which brought the young artist some financial security, but it may not have been a happy one. Dürer's early *Self-portrait* of 1493 (in the Louvre) was probably painted as a wedding-present to his future bride, for the thistle that he holds in his hand was a symbol of fidelity. In a later *Self-portrait* (*Ill. 106*), painted after his first visit to Venice, the basic conception remains virtually unchanged, but the image presented expresses a new confidence and assurance, and the artist is dressed in a manner worthy of a Venetian patrician. The portrait combines the sensitivity of a profoundly searching eye with a nobility, a sense of 'presence', that is unprecedented

in German painting. This intense self-scrutiny, not unmixed with vanity, seems wholly in keeping with Dürer's introspective nature, in which his evident pride in his own gifts was counterbalanced by a tendency to deep melancholy.

Dürer set out on his first visit to Italy in the autumn of 1494 (not long after his marriage), returning home the following summer. During the long outward and return journeys his imagination was fired by the scenery of the Alps and the Tyrol, and some remarkable landscape drawings and watercolours date from this time. A particularly fine although slightly later example of Dürer's gifts as a landscape-painter is provided by the lovely *Pool in the Woods* (*Ill. 111*) of about 1497, which already anticipates the 'Romanticism' of the so-called 'Danube School' (to be considered in the next chapter). The sensitive observation and rich poetry of sentiment that inform such studies are scarcely more astonishing than their independence of known precedents: in a later age Dürer might well have become one of the major landscape-painters of all time. Yet these are but incidental studies, the overflow of supreme creative genius: what drew Dürer to Italy was not the scenery of the country (indeed most of his studies were made in the Tyrol) but Mantegna and the antique. He was also to absorb much of the spirit of Venetian portraiture, as practised especially by Giovanni Bellini, and his *Self-portrait* of 1498 not only pays tribute to the Venetians but hints at his study of Leonardo.

Back in Nuremberg, Dürer enjoyed the patronage of the Elector of Saxony, Frederick the Wise, who sat to him for his portrait and commissioned from him important works for his residence at Wittenberg. Although not a man of wide culture, Frederick was the founder of the famous University of Wittenberg (the advice given to Hamlet, 'Go not to Wittenberg', alludes to the university's connections with the Protestant heresy), and he also took many other artists besides Dürer into his service, including Cranach, Burgkmair, Conrad Meit and Peter Vischer the Elder. The finest of all Dürer's works for Frederick the Wise is unquestionably the altarpiece of the *Adoration of the Magi* (*Ill. 112*), painted in 1504. The central panel, now in the Uffizi, strikes a strangely Venetian note beside its Florentine neighbours there, so rich and vibrant is the colouring. If we did not

107 LUCAS VAN LEYDEN (*c.*
1494–1533) *Last Judgment, com-
missioned 1526: shutters open. Oil
on panel, 9′ 8″×6′ (269.5×184.4).
Stedelijk Museum de Lakenhal,
Leyden*

108 JAN VAN SCOREL (1495–
1562) *St Sebastian, 1542. Oil on
panel, 5′ 1″×3′ 9″ (155×115).
Museum Boymans-van Beuningen,
Rotterdam*

know its date we might indeed assume that it was the product of Dürer's second visit to Venice, which in fact followed immediately afterwards in the year 1505. Yet the Venetian aspect of the picture forms only one element of a highly complex composition. The utterly convincing and yet almost grandiose setting, with its ruined buildings and makeshift manger and its distant glimpse of a wooded hill-town, belongs to that characteristically northern genius for realism which some thirty years earlier had expressed itself in the *Portinari Altarpiece* of Hugo van der Goes (*Ill. 40*). Yet all this is managed with conscious science, and with a mastery of perspectival and spatial organization which allows the eye to play, fascinated, over subtle planar relationships and variations. No less skilful is the manner in which the foreground group of the Virgin and Child and kneeling king is related to the two standing figures of Caspar and Balthasar, the one dominating the central space and turning to his Moorish companion, so giving added emphasis to that noble and unforgettable figure, which brings to mind a passage in Dürer's *Treatise on Proportion*: while expressing his opinion that Negro faces are rarely beautiful, he adds, 'I have nevertheless seen some amongst them whose whole bodies have been so well built and handsome in other ways that I never beheld finer figures, nor can I conceive how they might be bettered.'

The Venetian qualities of the Uffizi altarpiece were probably inspired, at least in part, by Dürer's contacts with Jacopo de' Barbari, who worked in Nuremberg from 1500 to 1503. He was certainly impressed at this time by Barbari's concern with theories of human proportion: Dürer, indeed, was obsessed by the thought that the Italians were in possession of recondite formulae as yet inaccessible to foreign artists; and, as he tells us himself, the only person who had ever communicated to him anything of such mysteries was Jacopo de' Barbari – 'a good, amiable painter, born in Venice, who showed me the figures of a man and woman which he had drawn in proportion.' At all events it was in the years immediately prior to his second visit to Italy that Dürer began making studies of the human figure built up according to a system of geometrical proportioning evidently deriving from Barbari (*Ill. 109*). Two of these were translated into the figures of *Adam and Eve* in a copperplate engraving issued by Dürer in 1504 (*Ill. 92*), in which we

109 ALBRECHT DÜRER (1471–1528) *Constructional figure, c. 1504. Pen drawing. Albertina, Vienna*

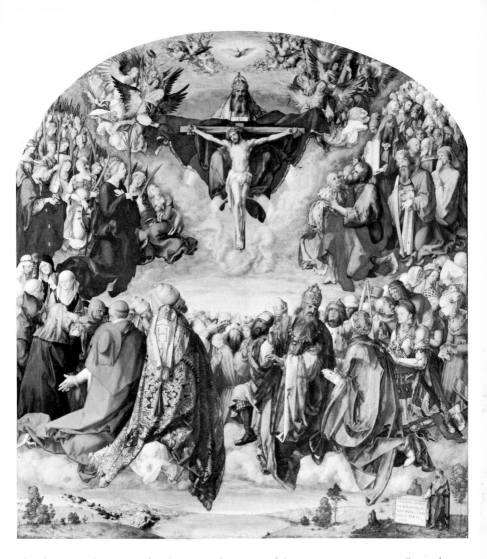

also detect, in the figure of Adam, an adaptation of the
pose of the *Apollo Belvedere.*

Dürer arrived in Venice in 1505 no longer as the poor
student of his earlier visit but as a recognized master
worthy of comparison with Giovanni Bellini himself,
who although a much older man now became his
admirer and friend. Dürer's reputation in Venice reached
its zenith on his completion in 1506 of a great altarpiece
commissioned for the church of the German community,
San Bartolomeo. This was the *Madonna* known as the

110 ALBRECHT DÜRER (1471–
1528) *Adoration of the Trinity, 1511.
Oil on panel, 4′ 9″ × 4′ 4″ (144 ×
131). Kunsthistorisches Museum,
Vienna*

147

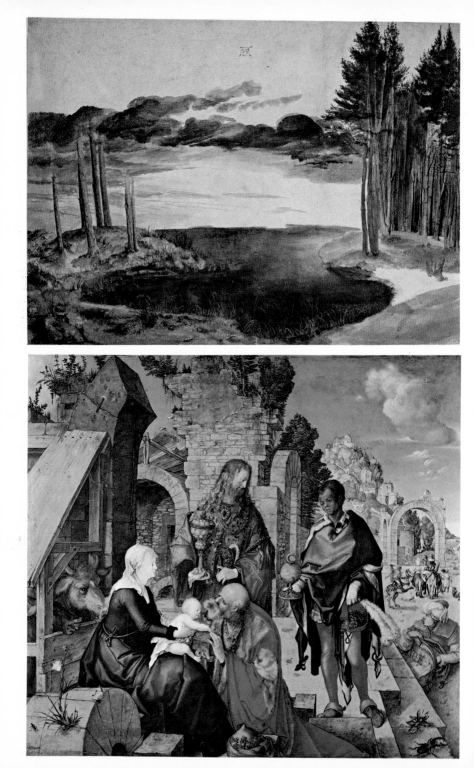

Festival of the Rose Garlands (now at Prague), a work no less inventive than the Uffizi *Adoration* and altogether charming in the joyousness of its mood. This second visit to Italy helped to release the painter in Dürer, while his access to the ideas of Leonardo, Luca Pacioli and Alberti helped him to establish his art upon firmer theoretical principles. Temporarily, the phenomenal energy that he had shown as an engraver was allowed to lie fallow, to be renewed on his return to Nuremberg. Yet if he suffered one disappointment it was that Mantegna, whose engraved work had meant so much to him, died before he could meet him: it was the story, all over again, of the ill luck that had attended his youthful visit to Colmar.

Recollections of both Schongauer and Mantegna had been marked in the engravings and woodcuts executed in the interval between his two Italian visits; but after the second visit his work in these media began to assume a more pictorial quality, and he now modified the more linear approach of his earlier manner by an enhanced sense of tonal relationships and by a more monumental realization of form and mass. Furthermore, his Venetian experience had evidently awakened in him a deeper awareness of the potential role of light in composition. We can appreciate these developments in his art if we compare the *Adam and Eve* (*Ill. 92*) of 1504 with the *St Jerome* (*Ill. 116*), also a copperplate engraving, of ten years later.

Nevertheless many of Dürer's early engravings and woodcuts are to be numbered among his supreme works. The greatest of them all are the fifteen woodcuts of the *Apocalypse* series of 1498, inspired by the awesome visions of the Book of Revelation but not in any sense slavishly dependent upon the biblical narrative. The powers of invention exhibited in such sheets as the *Four Horsemen of the Apocalypse* and *St Michael quelling the Dragon* (*Ill. 113*) are unapproached in German art, and it has been justly observed that the small scale of these compositions in no way makes them unworthy of comparison with the masterpieces in fresco of Michelangelo and Raphael. Did not Dürer himself remark that 'many a man sketches something on half a sheet of paper in one day, or cuts something on a little bit of wood with his little iron, and there is more and better art in it than in some great work by another who has laboured on it for a whole year'?

111 (opposite, above) ALBRECHT DÜRER (1471–1528) *The Pool in the Woods, c. 1497. Watercolour,* 10⅜ × 14¾" (27 × 36). British Museum, London

112 (opposite, below) ALBRECHT DÜRER (1471–1528) *Adoration of the Magi, central panel of altarpiece,* 1504. Oil on panel, 3′ 3″ × 3′ 8″ (98 × 112). Uffizi, Florence

113 ALBRECHT DÜRER (1471–1528) *St Michael quelling the Dragon, from the Apocalypse series,* 1498. Woodcut, 15½ × 11⅛" (39 × 28). British Museum, London

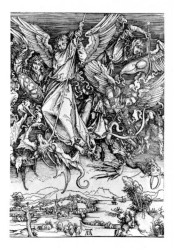

Dürer was now his own publisher, and he issued the *Apocalypse* in two editions, one with a Latin and one with a German text. An important innovation was that each scene, instead of accompanying the text, which was consigned to the *verso*, was allowed to fill the whole page: in consequence Dürer's compositions assumed an independence hitherto denied to book illustration, and the artist was enabled to give freer rein to his imagination. Two further series of woodcuts, both begun in 1498 but completed some twelve or thirteen years later, the *Great Passion* and the *Life of the Virgin*, form a bridge between his early and late style.

In the years immediately following upon his return from his second visit to Italy Dürer was under constant pressure from the Elector of Saxony and other patrons, including the Emperor Maximilian himself. For the Elector he executed the ambitious *Martyrdom of the Ten Thousand* which is now at Vienna; but greater importance is to be attached to an altarpiece of the *Adoration of the Trinity* (*Ill. 110*) commissioned by a wealthy Nuremberg citizen, Matthäus Landauer, for the chapel of an old people's home which he had lately endowed. This superb painting, illustrating St Augustine's *City of God*, was completed in 1511, and Dürer designed a magnificent Renaissance frame for it, embellished with carved reliefs of the Last Judgment. Not for the first time, Dürer included a portrait of himself: he can be seen standing in the lower right-hand corner, displaying a tablet inscribed with his name. Although not imposing in scale, this harmonious composition may be regarded as the first work of the northern genius to fuse together, without any obtrusive element of conflict, the delicate embroidery of the tradition that has its roots in the 15th-century Netherlandish School and the Italian ideal of grandeur of design and sublimity of expression.

A year after the completion of this altarpiece the Emperor Maximilian made a state visit to Nuremberg, and Dürer was appointed his court painter at Augsburg. Among the works executed by Dürer for the Emperor the series of coloured decorations for a prayer-book published at Augsburg in 1513, which contains further illustrations by Cranach, Burgkmair, Baldung Grien, Altdorfer and other artists, shows us another side to Dürer's genius – that playful and wholly charming fancy that he seems to have indulged in his happiest moments.

In 1518, during the Diet of Augsburg, he made a chalk study of the Emperor for the half-length now at Vienna, a work completed after Maximilian's death in the following year.

A new age had now dawned, for in October 1517 Luther had nailed his *Ninety-Five Theses* to the door of the castle church at Wittenberg, so setting in motion the process that was to lead to his own excommunication and to the final breach of the Reformers with Rome. Dürer himself responded warmly to Luther's mission to reform a corrupt Church, and he could not understand the hesitations of Erasmus, whose portrait he drew in charcoal in 1520 and of whom six years later he made a copperplate engraving (partly based on a medallion by Massys). In many ways Erasmus had prepared the way for Luther; but the great humanist drew back from any irremediable action against the Romanists – an attitude that dismayed Dürer, whose cry of despair is now famous: 'O Erasmus of Rotterdam! Where art thou? Listen, thou Knight of Christ, ride out with the Lord Christ, defend the truth and earn for thyself the martyr's crown!'

This passage comes from the journals kept by Dürer during his travels in the Low Countries in 1520-21, which had the primary object of securing from the new Emperor, Charles V, then on the point of being crowned at Aachen, the endorsement of his annuity as court painter. In this aim he was eventually successful, and he was also graciously received by the Regent of the Netherlands, Margaret of Austria. Dürer's protracted stay in the Low Countries had important consequences for Netherlandish art, for such painters as Quinten Massys, Bernard van Orley, Lucas van Leyden and Joachim Patenir now came into direct contact with the great Nuremberg master, who was fêted wherever he went and treated as a modern Apelles. For Dürer himself, however, this was no time for relaxation. The opportunity of meeting the cream of Antwerp and Brussels society and, above all, the artists and men of learning appears to have stimulated his interest in portraiture, and a phenomenal burst of energy produced in these months numerous portraits in pen, drypoint, chalk or charcoal. The fruits of this intense activity are to be seen in the marked development of his portrait style during the 1520s, which is apparent, for example, in the incisively characterized and informal half-length of *Jacob Muffel*, a

114 ALBRECHT DÜRER (1471–1528) *Jacob Muffel, 1526. Oil on canvas (transferred from panel), 18⅞ × 14¼" (48 × 36). Staatliche Museen Preussischer Kulturbesitz, Gemäldegalerie Berlin (West)*

prominent member of the city council of Nuremberg, who sat to Dürer in 1526 (*Ill. 114*).

By the time of his visit to the Netherlands, Dürer's greatest achievements, with the exception of the late portraits and his last major painting, the *Four Apostles* (*Ill. 117*) at Munich, lay behind him. He had become known in the Low Countries principally for his engravings and woodcuts: in particular, three works executed in the previous decade – the justly named 'master engravings' of *The Knight, Death and the Devil* of 1513 (*Ill. 115*), *Melencolia I* and the *St Jerome in his Study* (*Ill. 116*), both of 1514 – had finally established his reputation as the supreme exponent of the art of engraving in Europe. As Erasmus observed, there was nothing that Dürer seemed incapable of expressing without 'the blandishment of colours' – 'light, shade, splendour, eminences, depressions . . ., proportions and harmonies . . . and all the sensations and emotions.' Dürer preferred to issue the 'master engravings' to friend or patron as a set of three, for they complement each other in their thematic content, which is saturated with the neo-Platonic thought of Renaissance humanism. The *Melencolia* is the symbol of the creative, intellectual soul burdened by despair as he contemplates the difficulty of realizing his conceptions. By contrast the Knight, in his courageous confrontation of a world darkened by sin and death, represents the active life; he is the type of the

115 (below) ALBRECHT DÜRER (1471–1528) *The Knight, Death and the Devil, 1513. Engraving, 10 × 7½″ (25 × 19). British Museum, London*

116 (below right) ALBRECHT DÜRER (1471–1528) *St Jerome in his Study, 1514. Engraving, 10 × 7½″ (25 × 19). British Museum, London*

'soldier of Christ' of Erasmus's *Enchiridon*; and signifi-
cantly Dürer made Luther a present of this noblest of all
his engraved works. On the other hand the *St Jerome*
offers us an image of the contemplative life of the scholar-
saint whose calling is not to overcome evil by strenuous
action but, through his humble receptivity to the divine
will, to understand the sacred mysteries and to conquer
the inner world of the spirit.

What may be described as Dürer's last testament to the
world, the pair of panels of the *Four Apostles* (*Ill.* 117),
was painted in 1526, two years before his death, as a gift
to his native city. It is clear from the attitudes and
expressions of the four figures – St John and St Peter in
the left-hand panel and St Mark and St Paul in the other –
that Dürer intended to distinguish contrasting spiritual
types, and they were interpreted from an early date as
representatives of the four humours – the sanguine (St
John), the phlegmatic (St Peter), the choleric (St Mark)
and the melancholic (St Paul). The biblical texts in-
scribed on the panels, with their warnings against false
prophets and others who abuse their authority, make it
evident that the work was conceived not only as a
monument to the cause of Reform but also as a reminder
of the dangers that threatened Lutheranism from within.
Aesthetically, these are the most sculpturally monumental
of all Dürer's figures and possess a grandeur that belongs
to the fullness of the High Renaissance. They provide a
fitting conclusion to the life's work of a master whose
importance in the history of Northern Renaissance art
cannot be exaggerated, embodying in one final and
majestic statement not only his artistic ideals but also his
profound religious convictions during a period of
spiritual crisis and change.

Dürer's religious allegiances relate him in a general
way to his great contemporary Mathis Grünewald, who
was equally affected by the Lutheran Reformation.
Otherwise the two masters present an almost complete
contrast, for whereas Dürer sought to emulate the heroic
style of the Italian High Renaissance Grünewald
remained loyal to older traditions, and his art may be
described as essentially a restatement in modern terms of
the Gothic spirit. They seem, however, to have had some
contact with one another: Grünewald apparently knew
Dürer's work and derived ideas from it, an example
being the figure of the Virgin on the *Isenheim Altarpiece*

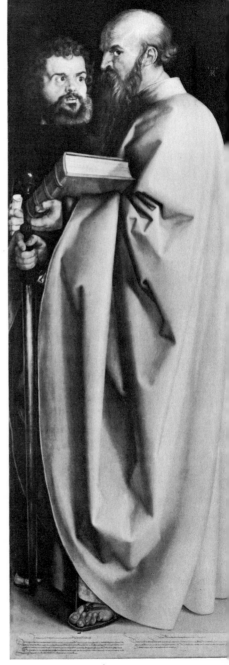

(*Ill. 121*), which recalls a famous watercolour by Dürer in the Albertina. Nor was he unacquainted with contemporary developments in Italy, but what he learnt from Leonardo and others, which can be seen especially in his handling of space and perspective and in his treatment of light, he placed at the service of an emotional expressiveness that is fundamentally medieval in character.

The name 'Grünewald' by which he will doubtless always be known was given to him by his first biographer, the 17th-century writer Joachim von Sandrart: his real name was Mathis Gothardt Neithardt. Despite this error, Sandrart's biography was a genuine attempt to rescue from oblivion the memory of an artist whom he considered to be 'second to none among the greatest of the old German masters in the arts of drawing and painting'. The German historian expatiates upon the beauty of Grünewald's surviving drawings – all working drawings for paintings which are remarkable both for the knowledge of structure shown in them and for their expressive power. According to Sandrart, Grünewald 'led a secluded and melancholy existence', and the tragic tone of his art is consonant with this tradition. At the same time Grünewald enjoyed considerable fame and success, and at the height of his powers he held the post of court painter and architectural adviser to the Archbishop of Mainz, Uriel von Gemmingen, and to his successor Cardinal Albrecht of Brandenburg. He was probably born at Würzburg in the 1470s, and is known to have died at Halle in 1528.

His earliest known painting, the *Mocking of Christ* at Munich, of about 1504, suggests certain affinities with Bosch: above all, Grünewald resembles the Netherlandish master in his obsession with the demonic forces that lurk in the shadows of the late medieval world, and which make their presence felt so tangibly in the *Temptation of St Anthony* on the *Isenheim Altarpiece* at Colmar. Grünewald's sense of the tragic made him a unique interpreter of the theme of Christ's Passion: the stark agony of the famous *Crucifixion* (*Ill. 119*) on the *Isenheim Altarpiece* is anticipated in the slightly earlier representation of the same subject at Basle, and it is repeated in the later variants at Washington and Karlsruhe.

The whole art of Grünewald is comprehended by the *Isenheim Altarpiece*, completed in 1515 for the chapel of a hospital which was in the care of the Anthonite Order

117 (*opposite*) ALBRECHT DÜRER (1471–1528) *Four Apostles*, 1526. Oil on panel, each panel 7′ 1″ × 2′ 6″ (215.5 × 76). *Alte Pinakothek, Munich*

118 NICLAS HAGNOWER (late 15th C.) *St Anthony enthroned with SS. Augustine and Jerome, wooden shrine of the Isenheim Altarpiece, c. 1500–1510. Musée Unterlinden, Colmar*

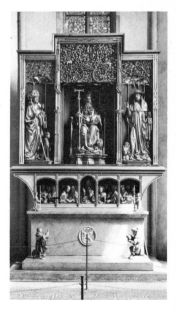

at Isenheim, near Colmar. The altarpiece takes the form of an elaborate series of painted wings for a carved wooden shrine by Niclas Hagnower (*Ill. 118*), which dates from the first decade of the century and represents, in high relief, St Anthony of Egypt, the patron saint of the sick, enthroned between St Augustine and St Jerome. On either side of Hagnower's shrine Grünewald added two wings, with the *Meeting of St Anthony and St Paul the Hermit* (*Ill. 120*) and the *Temptation of St Anthony*. The figure of St Anthony in the first of these panels must be a portrait of the Abbot of Isenheim, Guido Guersi, whose coat of arms appears below, while the St Paul bears the features of the artist himself, as we know them from a self-portrait drawing. The wings closed to reveal a majestic *Nativity* (*Ill. 121*), flanked by an *Annunciation* and a *Resurrection of Christ* (*Ill. 122*). These wings in turn closed, to form the well-known *Crucifixion* (*Ill. 119*), with the figures of St Anthony and St Sebastian, painted on fixed wings, on either side.

119 MATHIS GRÜNEWALD (*c.* 1470/80–1528) *Crucifixion; central panel of the Isenheim Altarpiece, 1515. Oil on panel, 8′ 10″ × 10′ 1″ (269 × 307). Musée Unterlinden, Colmar*

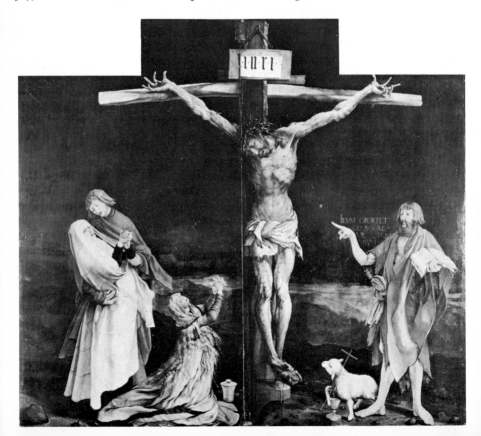

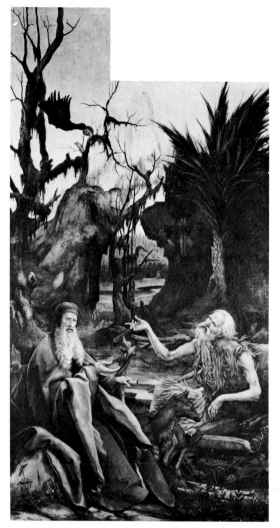

120 MATHIS GRÜNEWALD (*c.* 1470/80–1528) *The Meeting of St Anthony and St Paul the Hermit, wing of the Isenheim Altarpiece, 1515. Oil on panel, 8′ 8″ × 4′ 7″ (265 × 141). Musée Unterlinden, Colmar*

The three stages represented by these successive trans-formations of the altarpiece correspond, respectively, to its function on feast-days, Sundays and weekdays. On weekdays it was a plague altar, all the figures represented being associated with the cure of such diseases as the plague, epilepsy and syphilis. The theme of the Sunday stage is the deliverance brought by Christ's incarnation and victory over death. The Virgin, to whom the chapel was dedicated, here occupies a central place. The feast-day stage is devoted to St Anthony himself, the

Kneeling at the entrance is the tiny figure of the pre-destined Virgin herself, as one already chosen for her patron of the Order: his sufferings were to be a reminder to the inmates of the hospital that through the most extreme tribulations he remained inseparable from Christ. In the same sense, the lacerated body of Christ in the Crucifixion is yet that of a victor, despite all his agony. Much of the imagery of the altarpiece derives from the *Revelations of St Bridget* and other devotional works popular in the late Middle Ages and the Renaissance, but its fundamental message is the hope and consolation offered to sufferers by Christ's sacrifice and by his conquest of the powers of darkness – always associated in Christian thought with disease and death.

The mood of the *Isenheim Altarpiece* swings, as it were, from the tormented realism of the *Crucifixion* and the *Temptation of St Anthony* to the joyousness of the tender *Nativity* scene and the visionary *Resurrection,* in both of which Grünewald explores the language of light as the vehicle for an intensely mystical interpretation of his subject-matter. In the *Nativity* (*Ill. 121*), a golden shower of light rains from the heavens upon the Virgin as she smiles upon the Child in her arms; in the stupendous *Resurrection* (*Ill. 122*), the glory surrounding the risen Lord illumines the night with a supernatural radiance that, while recalling the comparable treatment in Geertgen's London *Nativity* (*Ill. 28*), far exceeds it in its dazzling evocation of light-effects.

The altarpiece contains a number of unusual iconographical features, one of them being the presence of St John the Baptist at the scene of Christ's Crucifixion (*Ill. 119*). Grünewald's intention is explained by the Johannine text inscribed in Latin beside the Baptist's dramatically pointing hand: 'He must increase, but I must decrease.' This theme of the passing away of the Old Law with the coming of Christ also underlies the scene of the Nativity, where it is expressed by a striking metaphor – a division of the composition (which is made up of two panels) into contrasting fields, the one set against a dark background and the other, in which the Virgin rapturously embraces the Christ-Child, against a broad landscape filled with light. On the left we see the Temple, symbolizing the Old Dispensation and decorated with figures of Old Testament prophets; within, a group of musician-angels faces towards the Virgin and her Child.

sacred role in history: between this figure and the Madonna and Child hangs the veil of the Temple. The Temple takes the form of a fantasy upon Late Gothic intricacy and ornamentalism, while the image of the Virgin and Child, placed against a landscape which is partly of Leonardesque derivation, has an amplitude that must owe something to the same source of inspiration, as it also recalls Dürer: the progression is stylistic as well as symbolic.

The distinctive character of Grünewald's genius may finally be illustrated by a consideration of one of his most outstanding qualities – his mastery of expressive gesture. Whether we instance the shrill appeal to heaven implicit in Christ's twisted fingers in the *Crucifixion* or, in the *St Anthony and St Paul the Hermit* (*Ill. 120*), the nervously discoursing hand of St Paul – Grünewald himself, as we have seen, – placed at the very centre of a composition filled with the writhing forms of a fantastic landscape, the language of gesture attains in Grünewald an unprecedented power and directness. If its ultimate origins are Gothic, the humanity and pathos conveyed by this emotive and yet considered imagery are touched by a new spirit, partaking of the Renaissance concept of the essential dignity of man, whatever the wretchedness of his condition, as it is presented to us in such a scene as the *Temptation of St Anthony*, and as it was known to those who came to be healed, or to end their days, in the hospital at Isenheim.

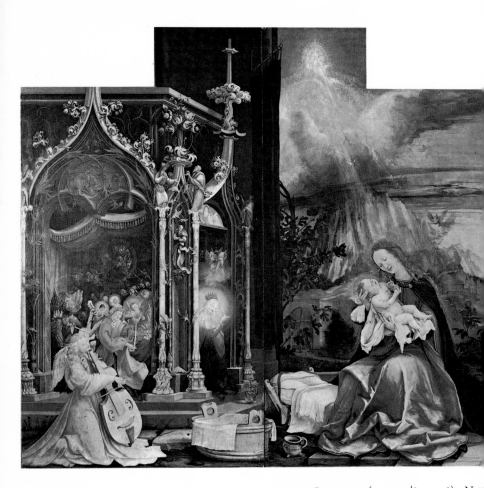

121 MATHIS GRÜNEWALD (c. 1470/80–1528) Nat▪
from the Isenheim Altarpiece, 1515. Oil on panel, 8′ 8″ ×
(265 × 305). Musée Unterlinden, Colmar

122 (opposite) MATHIS GRÜNEWALD (c. 1470/80–1
Resurrection, from the Isenheim Altarpiece, 1515. Oil on p
8′ 10″ × 4′ 8″ (269 × 143). Musée Unterlinden, Colmar

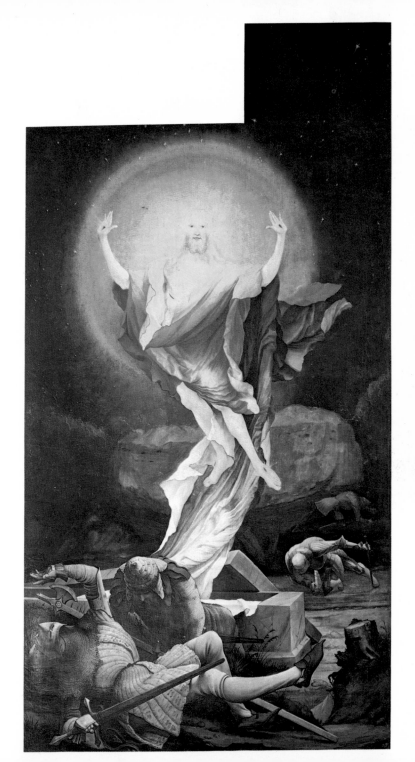

Dürer's contemporaries and followers

In the history of painting and the graphic arts Nuremberg will always be chiefly remembered as the birthplace and home of Albrecht Dürer. Few of his pupils and followers were to remain there: to mention two eminent examples, the great Baldung Grien, his friend and associate, eventually settled at Strasbourg, while Bartel Beham, whose early woodcuts owed much to Dürer's inspiration, was exiled from Nuremberg in 1525 for his political views and mystical atheism and became court painter to William of Bavaria at Munich, where he excelled as a portraitist in the tradition of Dürer.

Of all Dürer's followers, perhaps the most versatile was Hans Baldung, known as Baldung Grien, whose *œuvre* embraces altarpieces, portraits, allegories and mythological subjects, as well as woodcuts and designs for windows and tapestries. His masterpiece is ·an altar for Freiburg Cathedral, completed in 1516. In the central panel, the *Coronation of the Virgin,* the crowded detail and the motif of playful child-angels recall Dürer's *Festival of the Rose Garlands* of a decade earlier. The *Adoration* scene is more original, hinting at the expressive qualities of Baldung's later style: like the famous *La Notte* of Correggio and Geertgen's much earlier *Nativity,* it is an exercise in dramatic effects of light – a light that adds an element of surprise as the silvery radiance from the Christ-Child catches certain forms while others remain lost in deep shadow. The *Trinity and Mystic Pietà* in London (*Ill. 123*) dates from about the same period, and in its tender pathos represents all that is best in Baldung's early manner. Here an interesting feature of the iconography (and one that goes back at least to the early 15th century) is the inclusion behind the dead Christ, in what would otherwise be a realistic scene – such as the well-known variations on the *Pietà* theme by Giovanni

123 *(opposite)* HANS BALDUNG GRIEN (1484/5–1545) *Trinity and Mystic Pietà,* 1512. *Oil on panel,* 43¼ × 34⅛" (110 × 87). *Courtesy the Trustees of the National Gallery, London*

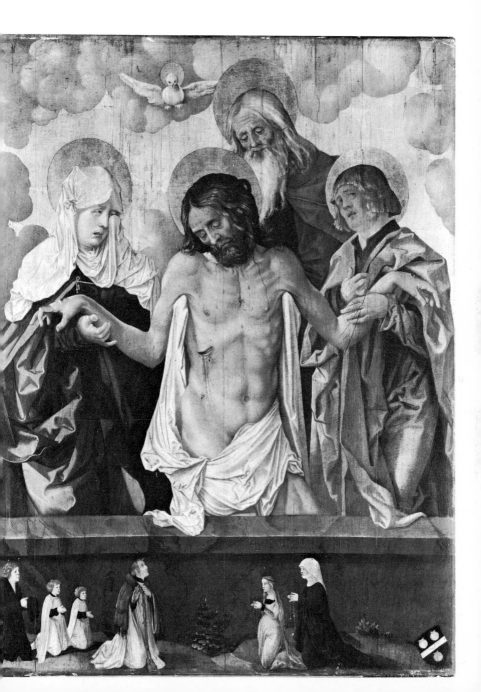

Bellini – of the two other Persons of the Trinity, God the Father and the Holy Ghost (symbolized by a haloed dove). Below are donor figures, on a smaller scale: it would seem that the picture was commissioned as an epitaph.

Quite a different aspect of Baldung's genius is presented by a series of allegorical pictures on the medieval theme of the Dance of Death, a class of subject that attracted other northern artists, such as Hans Holbein the Younger and

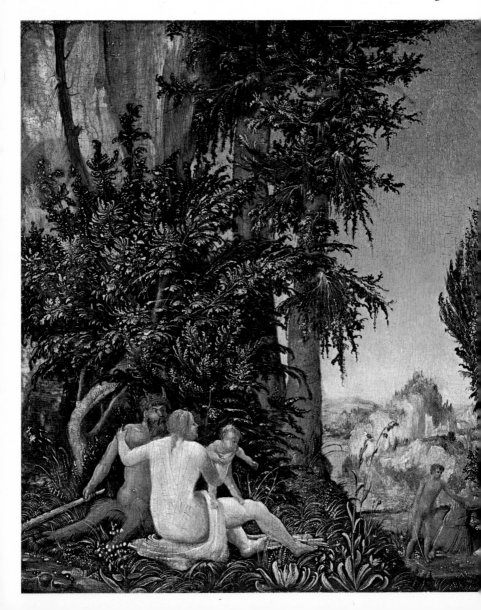

Nikolaus Manuel Deutsch. Baldung's *Death and the Maiden* (*Ill. 125*), at Basle, datable 1517, must appear to 20th-century eyes astonishingly free and modern in style. An earlier series of *Vanitas* panels suggests that Baldung's mastery of the nude, and especially the female nude, owed much to the example of the Elder Cranach; but by the time that he painted the Basle picture Baldung had progressed far beyond the sophisticated eroticism of Cranach's world into regions of stark expression that make us think ahead to the art of Max Beckmann.

Mention of Lucas Cranach brings us to a consideration of the painters who have been grouped together under the somewhat loose title of the 'Danube School'. Apart from Cranach himself, the most important of these masters were Jörg Breu the Elder, Rueland Frueauf the Younger, Albrecht Altdorfer and Wolfgang Huber; and what they shared, above all else, was an advanced, and often poetic, interest in landscape, inspired by the magnificent scenery of the Danube. Cranach, who took his name from his birthplace, Kronach in Franconia, belongs to the 'Danube School' only in respect of his early years in Vienna, before his appointment in 1505 as court painter at Wittenberg, far to the north in Saxony. It was Cranach's arrival in Vienna around the year 1500, together with the visit to Austria made at about the same time by the Augsburg painter Jörg Breu, that stimulated this intense interest in landscape-painting, already pioneered by Dürer and soon to be developed in the direction of mysticism by Altdorfer and Huber.

Breu led a wandering life in Austria, and eventually returned to Augsburg, where he executed his ambitious *Battle of Zama* for a series of classical battle-pieces commissioned from various artists by William IV of Bavaria for his palace at Munich. To this series Burgkmair contributed a *Battle of Cannae* and Altdorfer his great *Battle of Issus* of 1529 (*Ill. 126*), representing Alexander's celebrated victory over Darius, where in a splendid panoramic landscape lit by the rays of the setting sun the elements themselves seem to partake in the battle and to give cosmic significance to the historic event. Already in his *Aggsbach Altarpiece* of 1501, one of a number of works painted for monastic foundations in Austria, Breu had given added importance to the landscape setting in interpreting biblical subject-matter; and in Frueauf's *St Leopold Altarpiece* at Klaternenberg, executed four years

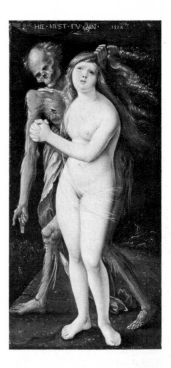

125 HANS BALDUNG GRIEN (1484/5–1545) *Death and the Maiden*, 1517. *Tempera on panel, 11¾ × 5⅝″ (29.5 × 17.5). Öffentliche Kunstsammlung, Basel*

later, we see a still more intimate sense of the *genius loci*.

Altdorfer's 'Danube period' is well illustrated by the almost pantheistic *Satyr and his Family* in Berlin (*Ill. 124*). Pure landscapes of this kind were still unknown south of the Alps, and Altdorfer's imaginative interpretations of the wooded mountains of Austria were to make a deep

126 ALBRECHT ALTDORFER (*c.* 1480–1538) *The Battle of Issus, 1529. Oil on panel, 5′ 3″ × 3′ 10″ (159 × 117). Alte Pinakothek, Munich*

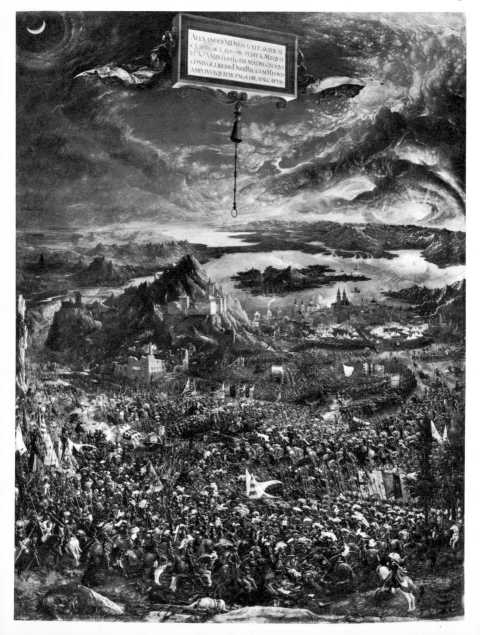

impression upon northern Italian painting. There is a
primeval quality about these landscapes, and their eerie
wildness gives Altdorfer a place among the forerunners of
Romanticism. His pupil Wolfgang Huber, a Swabian
who worked at Passau on the Danube as court painter to
the Prince Bishop, was no less overwhelmed by the
beauty of the Austrian scenery, of which he introduced
reminiscences into his religious paintings and portraits.
Some of his landscape drawings reveal a remarkable
sense of the sublime in nature: the *View of Feldkirch* of
1523 (*Ill. 127*) does not so much record, in the manner of
Dürer's watercolours, the response of a sensitive eye to the
character of a particular place, as translate into the
medium of the rapid sketch a great visionary artist's rev-
elatory experience before nature's grandeur and mystery.

127 WOLFGANG HUBER (*c.*
1490–1558) *View of Feldkirch,*
1523. Pen and ink. British Museum,
London

167

Cranach would appear to have played the leading part in this development. His dramatic *Crucifixion* of 1503, now at Munich, and the gentler *Rest on the Flight into Egypt* in Berlin (*Ill. 132*), painted in the following year, anticipate the forest landscapes for which Altdorfer is so well known, with their pines and fir-trees. In contrast to the tragic power of the *Crucifixion,* the mood of the Berlin picture is light, even gay, and the playful angels might almost be the elfin denizens of the forests of German folk-tales. It is only a short step from this joyous picture to the long series of paintings of Venus and kindred subjects that are most typical of Cranach's art after his arrival at Wittenberg, where he served as court painter to Frederick the Wise, and subsequently to his successors John the Steadfast and Frederick the Magnanimous.

The panel of the *Judgment of Paris* in New York (*Ill. 128*), datable about 1530, is one of a number of representations by Cranach of Ovid's famous story. The earliest was a woodcut of 1508, the year of his brief but fruitful visit to the Low Countries – a visit that may have stimulated his interest in such High Renaissance masters as Leonardo and Raphael, now much in vogue in the Netherlands, and which may also account in some measure for the polished technique of his later style. There is nothing in European painting quite to compare with the winsome eroticism of Cranach's treatment of the female nude in such pictures; and where – as in the New York panel – the figures are made to blend into a land-scape of comparable charm, Cranach does full justice to his varied gifts. The goddesses, it may be added, were clearly inspired by antique representations of the Three Graces – a subject treated by Cranach himself in a panel now at Kansas City.

Although mythological subjects of this kind may be regarded as Cranach's most characteristic works, his portraits are among his greatest, and many of them are worthy of comparison with those of Dürer. His full-lengths at Dresden of Duke Henry of Saxony and his wife Katherine, of 1514, have a particular historical importance, since full-length portraits of a purely secular nature were unknown before Cranach's time: they were now to become the rule for state portraiture in Germany and subsequently in other countries. Cranach's moving portrait of Luther on his deathbed, which was repeated in several versions, evidently acquired something of the

128 (opposite) LUCAS CRANACH THE ELDER (1472–1553) *The Judgment of Paris, c. 1530. Oil on panel, 41 × 28⅜″ (104 × 72). The Metropolitan Museum of Art, New York*

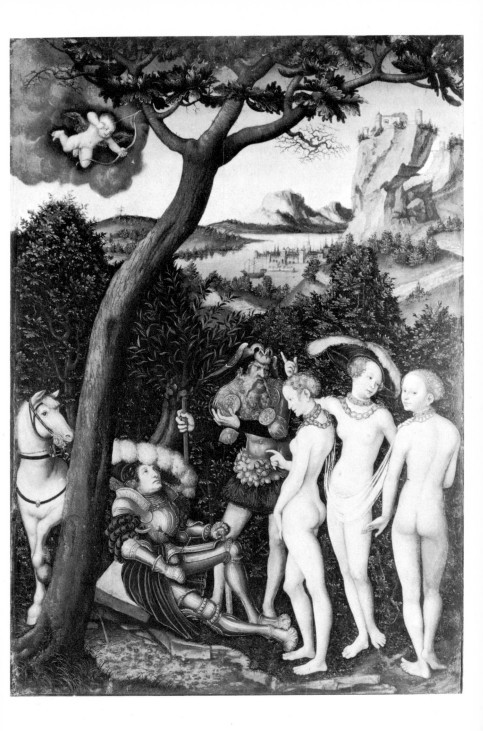

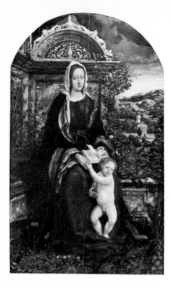

129 HANS BURGKMAIR (1473–1531) *Virgin and Child, 1509. Panel, 41⅜ × 40⅛" (105 × 103). Germanisches Nationalmuseum, Nuremberg*

value of an icon for the great reformer's disciples. Cranach was a personal friend of Luther and his ardent admirer, and his woodcuts satirizing the Roman Church made him the true artist of the Reformation. One of these, issued about 1545, displays on the one hand the sale of Indulgences and on the other Luther preaching on the subject of salvation through Christ, with the Elector John Frederick, bearing a heavy wooden cross, prominent among the congregation. The Elector's defeat at the hands of Charles V at Mühlberg in 1547 was a decisive victory for the Catholic cause in its struggles with the Protestant princes. Cranach was to follow the Elector into exile at Augsburg and Innsbruck.

After Nuremberg, the imperial city of Augsburg has the best claim to be regarded as the dominant centre of artistic activity in 16th-century Germany. It was there that the Habsburg emperors held their courts when they were not busy with affairs of state in other parts of their vast dominions; and it was to Augsburg, in 1548, that Titian came on the invitation of Charles V: but that momentous visit took place long after the establishment of the Augsburg School, which produced such masters as Hans Holbein the Elder, who may be said to have bridged the gap between the van der Weyden tradition and the style of the High Renaissance; Hans Burgkmair, himself a potent influence upon Augsburg's greatest son, Hans Holbein the Younger; Jörg Breu the Elder; and the portrait-painter Christoph Amberger.

We have already encountered Breu and Burgkmair in the context of their battle-pieces for William of Bavaria, and we have noted Breu's importance in the history of the 'Danube School'. Of the two artists Burgkmair is the more interesting. His visit to Venice and northern Italy in 1505 helped to open the eyes of other German masters, including the Elder Holbein, to the Italian achievement. Burgkmair's *Virgin and Child* at Nuremberg (*Ill. 129*), painted in 1509, indicates the impression made upon him by Leonardo and Bellini; while the architectural details, deriving from Venetian prototypes, contribute in an essential way to the mood of a picture that is at once magisterial in conception and tender in sentiment. Burgkmair was one of the principal influences upon Amberger, who also visited Venice. Amberger's reputation rests chiefly upon his portraits, of which the three-quarter-length of the young Christoph Fugger (*Ill.*

130), of 1541, is perhaps his masterpiece. Here the searching naturalism apparently indigenous to the northern genius has been successfully and harmoniously married to the grand style of Venetian and north Italian portraiture as practised by such masters as Titian, Palma Vecchio and Moretto.

Hans Holbein the Younger belongs to the School of Augsburg only in respect of his origins and early training. In 1514 his father left Augsburg for Isenheim, whence Hans the Younger travelled south to Basle, where he was to remain until his first visit to England twelve years later. In Basle Holbein formed a friendship with Erasmus, who had temporarily made his home there with the aim of working in close association with his publisher Froben. Holbein was to contribute a series of woodcuts to an edition of Erasmus's most famous work, the *Praise of Folly*. Holbein was then only eighteen years of age. Shortly before he left for England he also produced most of the great woodcuts of the *Dance of Death* (to be published in 1538).

During this early Basle period Holbein was vastly employed – as a painter of portraits, religious works and large-scale decorations of a secular character. One of his

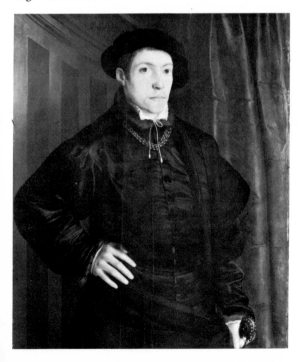

130 CHRISTOPH AMBERGER (*c.* 1500–61/2) *Christoph Fugger, 1541. Oil on panel, 38½ × 31½″ (97.5 × 80). Alte Pinakothek, Munich*

first patrons, the Burgomaster Jakob Meyer, com-
missioned a portrait of himself and another of his wife and,
in 1526, the celebrated *Madonna and Child with the Meyer
Family* at Darmstadt. Among various religious paintings,
special emphasis must be given to a group of four panels
of scenes from the Passion, which probably formed the
shutters of an altarpiece, with a further panel of the Last
Supper as the centrepiece. These panels suggest that
Holbein had recently visited Italy, for they contain
echoes of Mantegna, Leonardo and Raphael: the
Entombment (*Ill. 131*), for example, shows clear remi-
niscences of Raphael's picture of the same subject in the
Borghese Gallery. All these sources of inspiration,
together with others deriving from Dürer and Baldung
Grien, are nevertheless assimilated within a deeply
personal style. Such early works, with their powerful
directness of statement and their mastery of design and of
dramatic lighting, bring home to us the loss suffered by
German and, indeed, European art when the deterio-
ration of the religious climate in Basle, due to the conflicts
produced by the Reformation, compelled Holbein to
seek employment in England, where the opportunities
open to him were chiefly limited to portraiture. It is tragic
that so little has come down to us of Holbein's secular
decorations, although much can be inferred from some
original designs and from copies by later hands. These
decorations included scenes devoted to the theme of
Justice on the façade of the Hertenstein House, the
magistrate's residence at Lucerne, and further façade
decorations on the 'House of the Dance' at Basle, the
home of a rich goldsmith, both of which were carried
out in a noble classicizing style.

In 1526 Holbein left Basle for England with a letter of
introduction from Erasmus to Sir Thomas More (*Ill.
100*). Although he was to return briefly to Basle he
finally settled in England in the year 1532, becoming
court painter to Henry VIII and so taking his place in
the history of English rather than German art (see
Chapter XIII).

Besides being the home of Dürer, the city of Nuremberg
has another claim to an important place in the history of
art. By the reign of Maximilian it had become a flourish-
ing centre of sculptural activity; recognition of which has
been partly obscured by the loss of many major works,
notably the decorations in the Fugger Chapel, to which

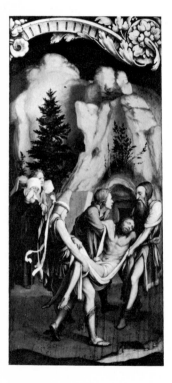

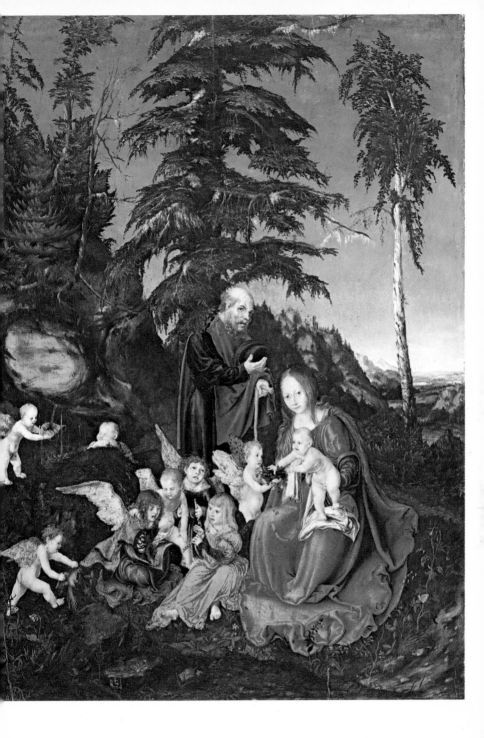

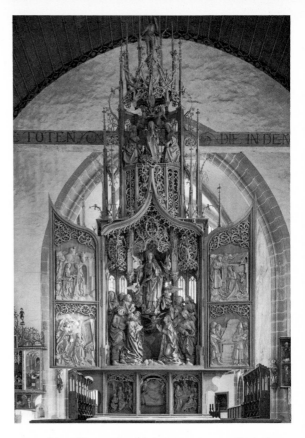

133 TILMAN RIEMENSCHNEIDER
(c. 1460–1531) *Assumption of the
Virgin, c. 1505–10. Linden wood.
Herrgottskirche, Creglingen*

Dürer himself contributed designs. In 1496 Veit Stoss,
who has been mentioned in an earlier chapter (see pp.
84–5), returned to Nuremberg after his long residence
in Cracow, and although at first he fell into disgrace,
having been convicted of forgery, he was subsequently
restored to favour through the intervention of the
Emperor. After passing through a serene, classical phase,
well represented by the *Crucifix* at St Lorenz (*Ill. 56*),
Stoss developed what has been described as a 'proto-
Baroque' style in which intense emotional expression is
allied to a new sense of freedom in the rendering of the
human figure, as in the spatially conceived *Annunciation*
of about 1517 in St Lorenz, originally part of a
candelabrum.

Veit Stoss has often been compared with his younger
contemporary Tilman Riemenschneider, who received
his initial training as a wood-carver but also worked in
stone. A Franconian like Stoss, Riemenschneider set up

practice not in Nuremberg itself but in nearby Würzburg. His altarpiece of the *Assumption of the Virgin* (*Ill. 133*) in the Herrgottskirche at Creglingen was carved about 1505–10. Although very much in the Late Gothic tradition, the treatment of the narrative in the four lateral reliefs representing episodes from the Virgin's life shows a new emphasis upon individual characterization and a new simplicity of compositional organization, while the central scene of the *Assumption* demonstrates Riemenschneider's mastery of spatial design.

A slightly earlier step into the Renaissance had been taken by the Nuremberg stone-carver Adam Kraft, whose major work is the immense tabernacle at St Lorenz, executed in the middle 1490s. One of the most striking figures in this impressive work is the portrait of Kraft himself (*Ill. 134*), in which we again note – besides the lifelikeness and implicit energy of the figure – a general simplicity and clarity of form, suggesting possibly some remote contact with Italy.

134 ADAM KRAFT (*c.* 1430–1507) 'The Master', *figure supporting the tabernacle, 1493–6. Stone. St Lorenz, Nuremberg*

By the early years of the 16th century, there can be observed in Germany a growing awareness of native achievement comparable with the national pride of a Ghiberti or a Ficino, an example of which is the glowing encomium written by the humanist poet Helius Hessus – whose features are familiar to us from a drawing by Dürer – upon the shrine in the church at Nuremberg dedicated to the legendary apostle of Christianity in Germany, St Sebaldus (*Ill. 135*). The *St Sebaldus Shrine* was the work of Peter Vischer and his sons Hermann and Peter the Younger, who controlled a large workshop and had close contacts with Dürer. The *St Sebaldus Shrine* was begun in 1507 and completed in 1519. 'Not even the Muse', Hessus declaims, 'would be capable of such labour or of doing justice in words to this immortal work, which neither Praxiteles nor Myron nor Polycletus, nor Chares nor Scopas could duplicate. Although fame commends these masters of the noble art of working in metal, greater glory shall fall to our times. For as that earlier age was crude and more ignorant, so it behoves us to grow with our growing years, to add better things to our heritage, and happily excel the ancients in the field of art.'

The *St Sebaldus Shrine* combines Gothic elements with Renaissance forms based upon a knowledge of Italian and antique sculpture. Peter Vischer the Younger and his brother Hermann are both known to have visited

135 PETER VISCHER THE ELDER (1454–1529) and his sons HERMANN and PETER THE YOUNGER *St Sebaldus Shrine, 1507–19. Bronze. St Sebald, Nuremberg*

136 ROSSO FIORENTINO (1494–
1540) and FRANCESCO PRI/
MATICCIO (1504/5–70) *Galerie
François I, Fontainebleau, c. 1533–40*

Italy. Such contacts with Italy are still more apparent in Peter the Younger's own tomb of Anton Kress executed about 1514 for St Lorenz at Nuremberg: here the donor kneels before a crucifix within a barrel-vaulted chapel designed in pure Renaissance style and orna-mented with antique motifs, the precise sources of inspiration being probably Venetian and Bramantesque rather than Tuscan.

What must have been the absolute masterpiece of this phase of Italianism in German sculpture – the decoration of the Fugger Chapel at Augsburg – is now known to us only in part. The powerful Fugger family (*Ill. 130*),

whose banking-house bolstered the finances of the Empire, built their chapel at Augsburg between the years 1510 and 1518, entrusting the main work of its decoration to Sebastian Loscher, who after an early training in Augsburg had made a visit to Italy. His charming *putti* (*Ill. 137*) from the choir-stalls in the chapel are worthy of comparison with the work of Luca della Robbia, and Loscher may indeed have spent some time in Florence.

The same tendencies are to be found in the work of several German sculptors who are not likely to have made the visit to Italy – as, for instance, in the small bronzes and alabasters of Conrad Meit, of which the *Judith with the Head of Holofernes* of about 1510–15 (*Ill. 138*) is a superb example. Meit, who came from the Middle Rhine, was in contact with Cranach at the Wittenberg court before settling in the Netherlands, where he was patronized by the Regent, Margaret of Austria. The great tombs at Brou of Margaret of Austria and her family were carried out by Meit, although originally commissioned from the French artists Jean Perréal and Michel Colombe.

It was in Nuremberg, in the work of Peter Flötner, that the impulse towards an Italianizing classicism reached its climax. Peter Flötner, a sculptor of Swiss origin, visited Italy twice, about 1520 and about 1530. By the time of his second visit he had evolved a completely classical style which is seen to perfection in his celebrated *Apollo Fountain,* executed in bronze in 1532 (*Ill. 140*). This is perhaps the finest work in free-standing statuary of the entire German Renaissance. The figure of Apollo derives directly from an engraving by Barbari of *Apollo and Daphne,* but it far surpasses its model in elegance, and anticipates the refined Mannerism of Cellini himself.

139 ADRIAEN DE VRIES (*c.* 1560–1626) *Nymph on the base of the Hercules Fountain, Augsburg, 1602. Bronze*

140 PETER FLÖTNER (*c.* 1490/ 95–1546) *Apollo Fountain, 1532. Bronze, h. 3' 3" (100). Collection the City of Nuremberg*

Wenzel Jamnitzer, a Viennese goldsmith who settled in Nuremberg, was to carry on the traditions of Italian Mannerism into the second half of the century in numerous small *objets d'art* – elaborately decorated utensils, figures, animals and other ornamental pieces, – and here the parallels with Cellini are still closer. The final phase of this development is represented by the bronze statuary of Adriaen de Vries, who had been a pupil of Giovanni Bologna in Florence before entering the service of the Emperor Rudolf II at Prague. One of his principal works, the *Hercules Fountain* at Augsburg, surrounded at the base by graceful nymphs (*Ill. 139*), strongly recalls Giovanni Bologna's own *Hercules Fountain* at Bologna as well as the *Neptune Fountain* by Ammanati in Florence. De Vries died as late as 1626, by which time the early Baroque masters were already directing European taste into new channels. A parallel development in painting is presented by the work of his contemporary Bartholomeus Spranger, originally from Antwerp, who after a period spent in Italy carried the Mannerism of Parmigianino to extreme limits of ingenious artificiality (*Ill. 142*), being employed first by Maximilian II at Vienna and subsequently joining de Vries at Rudolf II's court at Prague.

The impact of Italian ideas upon architecture within this period, whether in Germany or Austria, is by contrast more difficult to assess. Until the early 17th century German architects were on the whole attracted more by the decorative than by the functional aspects of Renaissance style – as is evident, for instance, in the highly ornate wing added from 1556 onward to Heidelberg Castle by the Elector Otto Heinrich, and hence known as the Ottheinrichsbau (*Ill. 143*). Nevertheless the Ottheinrichsbau may be said to mark the birth of German Renaissance architecture, which was to attain its maturity in the following century in Elias Holl's nobly conceived town hall at Augsburg, completed in 1620. Turning to ecclesiastical architecture, we can point to the clear evidence of the influence of the Gesù in Rome upon the Jesuit church of St Michael at Munich. The grandiose interior of this great church, which was erected between 1582 and 1597 by Wolfgang Miller and Friedrich Sustris, is notable for its vast tunnel-vaulted nave and side-chapels (*Ill. 141*).

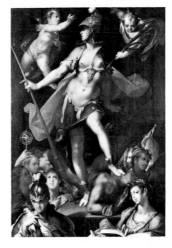

142 BARTHOLOMEUS SPRANGER
(1546–1611) *Pallas protecting the
Arts and Sciences. Panel, 5′ 4″ ×
3′ 10″ (163 × 117). Kunsthistor-
isches Museum, Vienna*

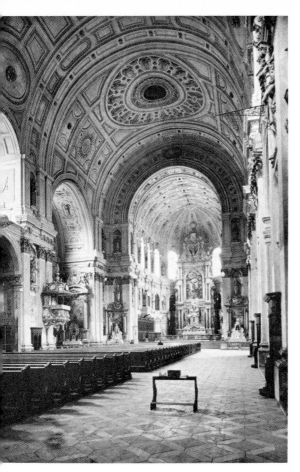

141 *(left)* WOLFGANG MILLER
and FRIEDRICH SUSTRIS *St
Michael's, Munich, 1582–97*

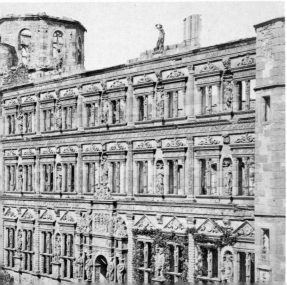

143 *Ottheinrichsbau, Heidelberg
Castle, begun 1556 and left unfinished*

CHAPTER TWELVE

France and the School of Fontainebleau

The acceptance of Renaissance ideals in France was directly related to her emergence after the Hundred Years' War as a powerful, centrally governed state and to the ambitions of that paragon of elegance and courtly pomp, François I. The reign of François I extended from 1515 to 1547, and in its earlier years was dominated by the King's rivalry with the Emperor Charles V and by his at first successful but eventually disastrous invasions of Italy, culminating in his defeat at Pavia in 1525 and his temporary imprisonment in Italy and Spain. Yet these military adventures, like the earlier Italian campaigns of Charles VIII and Louis XII, had an important effect upon Northern Renaissance art, since they opened a door to Italian influence. For a considerable period both Milan and Genoa became French dependencies, and direct contact with the art of Renaissance Italy and, not least, with the modes and manners of Italian court life made a steadily increasing impact upon French culture and taste.

François himself, whom a later historian described as having 'a noble passion for everything beautiful', was anxious that his patronage of the arts should rival in splendour that of the greatest Italian princes: he did everything in his power to attract Italian painters, sculptors and architects to his court, and the list of Italians who came to work in France is certainly an impressive one – including as it does the names of Leonardo da Vinci, Giacomo Vignola, Andrea del Sarto, Benvenuto Cellini, Francesco Salviati, Niccolò dell'Abbate, and, most influential of all, the architect Sebastiano Serlio and the painters Rosso Fiorentino and Francesco Primaticcio.

The manifold enrichments of the visual arts consequent upon this enlightened patronage, which was to be

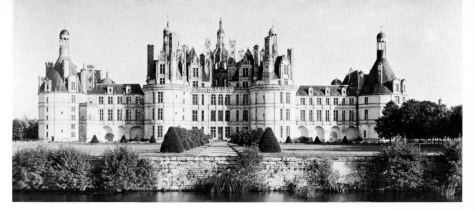

144 *Entrance front of the château of Chambord, probably by Domenico da Cortona and others, 1519–50*

continued by François' son Henri II, who married Catherine de Médicis, and after Henri's premature death in 1559 by his own son Charles IX, formed only one aspect of a general cultural Renaissance. The revival of classical learning, promoted by three great humanists, Lefèvre d'Etaples, Guillaume Budé and Antoine Macault, was securely established in the reign of Charles IX by such scholars as Denis Lambyn, Marc Antoine Muret and Léger Duchesne. Montaigne, that most fascinating of essayists, even had texts from the classics inscribed on the rafters of his stately mansion. Moreover, the publication in 1549 of Joachim du Bellay's *Défense et illustration de la langue française* encouraged the development of a vernacular literature, of which the poet Ronsard (the most eminent member of the group known as *La Pléiade*), Rabelais and Montaigne himself were to be the brightest stars. It may be added that François' learned sister Marguerite of Navarre was second only to him in her patronage of the liberal arts: an authoress herself, she was the correspondent of Erasmus and the patroness of Rabelais, and she gathered around her some of the finest intellects of the age.

Yet the early history of French architecture during the reign of François I shows how superficially the Italian ideals were at first understood. The great château built by the king at Chambord from about 1519 onwards (*Ill. 144*), although evidently designed by an Italian, Domenico da Cortona, must have undergone radical modifications by French masons during the protracted course of its completion, which occupied some thirty years, and its aspect remains fundamentally medieval: with its pinnacles and rounded turrets, it brings to mind the castles built a century earlier by Jean de Berry, of which we have glimpses in the *Très Riches Heures* (*Ill. 10*).

145 Detail of the façade of the Certosa, Pavia, designed in 1481

However, the plan of one important feature of Chambord, the central keep, derives ultimately from Domenico da Cortona's master Giuliano da Sangallo. Moreover much of the decoration of Chambord, notably on the exterior, owes its inspiration to Italian models. At the same time it is characteristic of this phase in the assimilation of the principles of Italian Renaissance architecture that it was the more decorative aspects of the new style that caught the imagination of the French. Above all, the fantasy and rich ornamentation of the Certosa of Pavia (*Ill. 145*), not far from Milan, having certain affinities with Flamboyant Gothic, were correspondingly easier to appreciate than the more austere classicism of either Brunelleschi or Bramante: it is significant that a Frenchman of letters of the period, Philippe de Commines, should have called the Certosa the finest church he had ever seen.

A similar note of enthusiasm for decorative embellishment and fanciful variety rings from the description by La Fontaine in the 17th century of the château of Blois, the first of François' major architectural enterprises: 'The part built by François I, seen from the outside, pleased me more than anything else. There are many little galleries, little windows, little balconies, little ornaments without regularity or order . . .' Indeed the same instinct for the ornamental, which in the perspective of history appears so characteristically French, was to inform the greatest of all the buildings erected by François I – the palace of Fontainebleau, with its ornate decorations by Rosso Fiorentino and Primaticcio (*Ills. 136, 146*). It must also be borne in mind that French architecture of the early and middle years of the 16th century eagerly responded to the qualities that we associate with the word *maniera* – ranging from stylishness and elegance to a seemingly wilful distortion and disregard for the classical 'rules', – without having passed through the same long process which preceded the development of Mannerism in Italy itself.

Fontainebleau, the grandest of the châteaux which François I built in the neighbourhood of Paris on his return from captivity, was originally a medieval hunting-lodge. Its rebuilding was entrusted to Gilles Le Breton, whose style is epitomized in the impressive façade of the Cour du Cheval Blanc (unfortunately spoilt by later modifications) and in the so-called Porte Dorée, the

entrance to the Cour Ovale. The design, with its flat pilasters framing pedimented windows, shows clear evidence of Italian influence, and is remarkable for its simplicity. But the chief glory of Fontainebleau was the series of rooms decorated by Rosso and Primaticcio in an unprecedented union of painting, panelling and stucco relief. Alterations made at a later date leave us with an incomplete impression of the original splendour of these decorations, and the loss is particularly severe in the case of Primaticcio's contributions to the total scheme. Even the magnificent Galerie François I (*Ill. 136*) decorated by Rosso and his assistants in the 1530s, has suffered from drastic restorations.

Rosso had been called to the French court in 1530, after a period of deep personal distress occasioned by the Sack of Rome in 1527. Primaticcio, a Bolognese pupil of Giulio Romano, arrived at the French court two years after Rosso, but it was probably he, rather than Rosso, who introduced the practice of combining painted panels with stucco figures and decorative motifs, since it had already been employed by Giulio Romano, although not on the scale seen at Fontainebleau.

The Galerie François I (*Ill. 136*) was designed as a show-piece for state ceremonies and festivities, and Rosso's decorations comprise a series of mythological paintings and allegories glorifying the monarch and his family. Each picture is surrounded by reliefs and statues executed in stucco which offer an elaborate gallimaufry of elegant nudes, herms, *putti,* animals and curling strap-work giving an impression of endless variety and a sense of continual surprise. This is full-blown Mannerism, and the contemporary decorations by Primaticcio in the Chambre du Roi (now lost) and in the Chambre de la Reine (where the famous fireplace can still be seen) were carried out in a similar style. A good deal can be inferred about Primaticcio's early work at Fontainebleau from his drawings. Later, after the deaths of François I and Rosso, Primaticcio continued the embellishment of the palace, notably in the Chambre de la Duchesse d'Etampes (*Ill. 146*), the Galerie Henri II and the Galerie d'Ulysse. His services were also enlisted in the designing of certain extensions to the great château – the grotto of the Jardin des Pins, a gateway for the Cour du Cheval Blanc and the dignified Aile de la Belle Cheminée (1568).

In the meantime – in the year 1540 – Primaticcio had

146 FRANCESCO PRIMATICCIO
(1504/5–70) *Apelles painting Campaspe (in oval), surrounded by stucco figures, c. 1541–5. Chambre de la Duchesse d'Etampes, Fontainebleau*

made a visit to Rome, and the influence of Raphael, Michelangelo and Perino del Vaga can be detected in various parts of his later decorations at Fontainebleau. The extent to which decorative inventiveness and fantasy now ruled Primaticcio's imagination can be judged from the *Apelles painting Campaspe* (*Ill. 146*) in the Chambre de la Duchesse d'Etampes, where the painting itself (since restored) virtually serves as an excuse for the creation of a beguiling framework of erotic nudes and ornamental features. In the exquisiteness of his forms and in the graceful refinement of his figures, with their stylish elongations and attenuated extremities, Primaticcio here stands closer to Parmigianino and Cellini than to the more forceful Rosso. It was this elegance that was to permeate French art in the latter part of the century and to exert its spell generally over European taste. During his last years Primaticcio came under the influence of the illusionism practised by the painter Niccolò dell'Abbate (from Modena), who had been called in to help in the decoration of the Galerie d'Ulysse in the early 1550s; this influence is apparent not only in the later parts of the Galerie but also in Primaticcio's designs for the chapel of the Hôtel de Guise.

An important consequence of Primaticcio's visit to Rome in 1540 was the importation into France of a number of casts of antique sculptures and of works by contemporary masters, such as Michelangelo, which Primaticcio persuaded François I to allow him to purchase on his behalf. As we are told by Benvenuto Cellini, he explained to the king that 'when His Majesty had once set eyes upon those marvellous works, he would then, and not until then, be able to criticize the arts of design, since everything that he had seen by us moderns was far removed from the perfection of the ancients.' The impact made by these casts is evident, for instance, in the sculpture of Pierre Bontemps, who assisted Primaticcio in the decoration of Fontainebleau and later worked under the direction of Philibert de l'Orme on the tomb of François I and the monument for the heart of François I, both at St Denis.

A still greater sculptor of the period, Jean Goujon, whose reliefs of nymphs on the *Fontaine des Innocents* (1547–9) in Paris bring together the decorative qualities of Cellini and the elegance of Primaticcio, must also have studied the casts brought from Italy with special

care. Their influence must account in particular for the classical character of his *Tribune of the Caryatids* (Ill. 147) which he executed about 1550 as the support for a gallery in Lescot's new wing at the Louvre. (The tribune was partly restored in the 19th century.) Goujon's caryatids follow their antique prototypes so closely that they might be mistaken at first sight for Greek statues. Closer examination of these figures will, however, be sufficient to dismiss any suggestion of plagiarism, for these graceful reinterpretations of the Greek ideal are treated in a very personal manner. In part, their historical importance lies in the fact that, unlike the Fontainebleau decorations, they are the work of a French rather than an Italian master.

Primaticcio's return to France in 1541 coincided with the arrival at the French court of the Bolognese architect Sebastiano Serlio, best known as the author of an influential treatise on architecture issued in several volumes over a long period, one of the volumes being dedicated to François I. Serlio's very presence in France, where he was now put in charge of the building works at Fontainebleau, and where he built the château of Ancy-le-Franc (*c.* 1546), seems to have had a decisive effect upon the course of French architecture. A new comprehension

147 JEAN GOUJON (active 1540–62) *Tribune of the Caryatids, c.* 1551. *Marble. Louvre, Paris*

148 PIERRE LESCOT (d. 1578)
and JEAN GOUJON (active 1540–
62) *Detail of the Cour Carrée of the
Louvre, begun 1546*

of the principles of Italian High Renaissance architecture
is already evident in Lescot's Cour Carrée for the palace of
the Louvre (*Ill. 148*), begun in 1546. There is something,
admittedly, a little bookish about Lescot's design: we
note the variety of the use of classical forms, the different
systems of fenestration employed on the three floors, and
the correctness of the orders (as in the fluted Corinthian
pilasters that articulate the entire façade); and yet with all
this the resultant effect lacks the grandeur of idea that we
should expect to find in an Italian building of comparable
scale. Once again the French taste for the decorative makes
itself felt, and, as Sir Anthony Blunt has observed, 'it is
possible to talk of Lescot's style as a form of French
classicism, having its own principles and its own
harmony.' The sculptural decoration of the façade,
which is of a refined delicacy entirely in tune with its
architectural context, was entrusted to Goujon.

But the supreme French architect of the period was
Philibert de l'Orme, who after a period of study in Italy
settled in Paris about 1540. One of his first major works,
the château of Anet, was built for Diane de Poitiers, the
mistress, successively, of François I and Henri II. One of
the main points stressed by de l'Orme in his *Architecture*,
one of two treatises which he published in the 1560s, was
the futility of indulgence in excessive ornamentation,
'without reason, proportion or measure': richness of
decoration, he argued, should generally be eschewed, and
employed only where it was appropriate – as for example
in a royal palace. The simplicity of the arrangement of
block-like forms on the entrance to Anet (*Ill. 149*) – an
almost abstract exercise in geometry – perfectly illustrates
these principles. At the same time, without their being
allowed to detract from the monumental aspect of the
whole, room is found for a number of exquisite details,
such as the open-work balustrades, the lunette reserved
for a bronze relief of *Diana* by Cellini (now in the
Louvre), and, surmounting the entire structure, the clock
with its stag and hounds which move at the striking of
the hours.

The chapel of Anet is still more geometrical in con-
struction, comprising in effect a complex and ordered
series of variations upon the circle, as the perfect figure and
therefore – as Bramante had also insisted – ideally
appropriate to the design of a church. Once again the
decorative elements are unobtrusive, and the imposing

Corinthian order, with its simple frieze, contributes to the sublime tone of this unsurpassed masterpiece of French Renaissance architecture, which can be described as the first French building to stand comparison with the works of Bramante and Michelangelo.

After the death of Henri II in 1559, Philibert de l'Orme temporarily fell out of favour at the French court; but from the year 1563 he found a new patron in the Queen Mother, Catherine de Médicis, who was then projecting the construction, not far from the Louvre, of a splendid palace for her own use – the Tuileries. De l'Orme prepared the designs, but he died before work had advanced very far. The palace was demolished under the Commune in 1871 (only fragments survive, in the Tuileries Gardens), and it is difficult to know precisely how much was due to his own plans and how much to others. We can, however, certainly ascribe to him the invention of the 'French Order', in which ornate motifs on the column shafts mark their division into drums.

The history of French painting in the middle years of the 16th century remains obscured by inadequate documentation. The beautiful *Diana of Poitiers* in the Louvre, inspired no doubt by the famous antique statue known as the *Diana of Versailles,* which François I had acquired, is perhaps the most celebrated of a group of paintings that can be assigned loosely to the Fontainebleau School, but whose authorship is uncertain. Recent research, however, has identified the painter of the somewhat Leonardesque *Eva Prima Pandora* (also in the Louvre) – a reclining nude in which, according to Panofsky's interpretation, the Hebrew Eve and the classical Pandora are fused into a single image of temptation, and placed against a representation of Rome – as Jean Cousin the Elder. But the major figure of the period was the portrait-painter François Clouet, who succeeded

149 PHILIBERT DE L'ORME (*c.* 1505/10–70) *Entrance to the château of Anet, 1552*

in 1541 to the official position held at the French court by his father Jean, best known for a series of drawings of notabilities at the court of François I.

The Clouets seem to have originated in the Low Countries, and may well have kept up some connection with their Flemish contemporaries. Thus the influence upon François Clouet of the Leonardesque 'Monna Vanna' portraits (nude variations on the *Monna Lisa*) that has been detected in the remarkable *Lady in her Bath* at Washington (*Ill. 150*) could have been mediated by the Netherlandish master Joos van Cleve, who according to Guicciardini was at one time employed by François I as a portraitist and who was fully acquainted with the pastiches of Leonardo's compositions typified by the 'Monna Vanna' pictures. Yet resemblances between Clouet's style and that of Bronzino suggest the possibility that he had actually studied in Florence. Whatever his precise sources may have been, Clouet was unquestionably the true creator of the Renaissance portrait in France, and the Washington picture is a masterly evocation of one aspect of courtly life: as Linda Murray has so aptly expressed it, this is 'the classic portrayal of a Royal mistress in her official role, cool, beautiful, aloof, bejewelled even in her bath, accompanied by the trappings of her state – fine rooms, a noble child in the arms of its leering accomplice-nurse, the sly Love-child stealing the fruits, the flower of passion in her hand.'

The tradition established by the Clouets was continued into the latter years of the century, but no painter of outstanding genius emerged in a period that was increasingly beset by religious conflict and civil strife. The School of Fontainebleau burnt itself out in the flickering talent of Antoine Caron, who had assisted Primaticcio on the Fontainebleau decorations and whose later work mirrors the fantastic character of the court fêtes and entertainments promoted by Catherine de Médicis and Henri III. The Wars of Religion caused by the persecution of the French Protestants, or Huguenots, reached a climax in the reign of Charles IX in the notorious Massacre of St Bartholomew's Day (24 August 1572), and continued until the Edict of Nantes of 1598, whereby the Huguenots were given religious liberty and permitted to hold 'any office or position in this Realm', although they were forbidden to hold services in Paris and its environs. Much of the anguish of these times would seem to be

reflected in the sculpture of Germain Pilon, the one great genius of the closing decades of the century, who had his origins in the Fontainebleau School and worked under Primaticcio's direction on the tomb of Henri II and Catherine de Médicis, begun in 1563. The over-powering emotionalism of Pilon's art finds supreme expression in the bronze relief of the *Deposition* (*Ill. 151*) in the Louvre, which probably formed part of the monumental works executed by Pilon in the 1580s for the chapel of Cardinal René de Birague at Ste Catherine du Val-des-Escoliers in Paris. These con-stituted the tombs of the Cardinal, who was Chancellor of France from 1573 to 1578, and his wife Valentine Balbiani. Only fragments of the tombs are now preserved. Among these, the impressive bronze portrait of the Cardinal, kneeling at his *prie-Dieu*, reveals the monu-mentality and sublime dignity of Pilon's late style, which now shows something of the influence of Michelangelo. As in the case of the *Deposition* relief, its sombre note, however appropriate to tomb sculpture, may also be taken as the expression of a great artist's response to a troubled age, which had succeeded the brilliant achieve-ments initiated in the reign of François I.

151 GERMAIN PILON (c. 1535–90) *Deposition, c. 1580–85. Bronze relief. Louvre, Paris*

England under the Tudors

The accession of François I to the French throne in 1515 had ushered in an age of artistic achievement inspired by Italian Renaissance ideals. In England, on the other hand, the 'waning of the Middle Ages' maintained a slower tempo; and it is instructive to note that one of the architectural masterpieces of the Tudor era, King's College Chapel in Cambridge, was being completed in the purest Perpendicular style at the very moment when Bramante was undertaking the rebuilding of St Peter's. It is true that Henry VIII brought over a Florentine sculptor, Pietro Torrigiano, who had been a fellow-pupil with Michelangelo in Ghirlandaio's workshop, to execute the bronze tomb of Henry VII and Elizabeth of York in Westminster Abbey, and that other Italian sculptors were thereafter employed on various projects for Cardinal Wolsey. Giovanni da Maiano provided terracotta roundels of Roman emperors to decorate the brick gates of Wolsey's palace, Hampton Court – itself a transitional building, in which some Renaissance ornament is used on a structure that is still Late Gothic. But such works were to make no lasting impression upon 16th-century English sculpture.

The principal foreign influences upon English art and architecture during the middle and later years of the century were not directly Italian but French and Netherlandish and, in the case of Holbein and his school, German. The great palace of Nonsuch (which no longer survives) had been built by Henry VIII in direct emulation of Chambord, and the King must also have been impressed by reports of Fontainebleau. French influence upon English architecture was to become paramount during the latter part of Henry's reign and was to extend into those of his successors Edward VI and Mary I, to be replaced by the dominance of Netherlandish

taste in the Elizabethan period; a development paralleled in sculpture in the sepulchral monuments executed towards the close of the century by Gerard Johnson (or Jansen), who had emigrated to England from Amsterdam in 1567. Explanations can be sought in England's close political and commercial ties with France and the Netherlands, or, for example, in the consequences of the English Reformation – set in motion by Henry's divorce of Catherine of Aragon, the daughter of Ferdinand and Isabella of Spain, and by his marriage to Anne Boleyn, and established in law by the Act of Sovereignty whereby the King became the supreme head of the Church of England, – which attracted to English shores Huguenot refugees from France and Dutch Protestants fleeing from Alva's ruthless suppression of heresy in the Low Countries.

Admittedly this general picture requires certain qualifications. The greatest architect of the Elizabethan age, Robert Smythson, was undoubtedly familiar with the writings of Serlio, and its greatest painter, the miniaturist Nicholas Hilliard, with those of Alberti and Lomazzo: but their styles were Italianate only in a limited sense; and just as Smythson stands closer to Vredeman de Vries, so Hilliard's stylistic roots lie ultimately in the miniatures of Holbein and in contemporary French painting (he is known to have visited the court of Henri III around the year 1577). At the same time we cannot forget that during the reign of Henry VIII the writings and teachings of the 'Oxford Reformers', John Colet and Thomas More, together with the frequent visits of their lifelong friend Erasmus of Rotterdam, had established the foundations of humanistic learning in England. Colet had himself travelled in Italy, where he had imbibed the ideas of Ficino and Pico della Mirandola, while More had translated Pico's works into English. In Holbein's portraiture, fleetingly, the noble idealism of More and his circle finds its reflection.

It is very possible that it was Erasmus himself, impressed by the promising beginning to Henry VIII's reign, when the ruthlessness and dangerous instability of the young monarch's character had not fully manifested themselves, who encouraged Holbein to seek his fortunes in England. As we have seen, he gave Holbein a letter of introduction to Thomas More, who became the artist's principal patron and protector during this first visit of

eighteen months. Meanwhile Holbein had presented one of his early portraits of Erasmus to the Archbishop of Canterbury, William Warham (who was later to sit to him).

The most ambitious work undertaken by Holbein on his arrival in England was a large group of *Sir Thomas More and his Family,* now destroyed. An early reference to it describes it as being 'in watercolours', a description that would be applicable to a cartoon. Its composition is known from a drawing by Holbein at Basle and from a copy, while the quality of the original can be guessed at from some superb studies for the individual portraits which are preserved at Windsor Castle. The artist's sympathy for the great humanist is apparent enough from the marvellous half-length of *Sir Thomas More* in New York (*Ill. 100*), which bears the date 1527. Here Holbein develops, in terms of a perfected realism and an altogether subtler mastery of the 'speaking likeness', the tradition of the humanist portrait created by Massys (*Ill. 101*), whom he had met at Antwerp on his journey to England. Not even Dürer excels him here in the directness of his humane scrutiny of the inner man or in the sureness of his touch. As in many of Holbein's other portraits, special emphasis is laid upon the expressive and sensitively modelled hands.

The lost group-portrait is scarcely less significant, for it was not merely a representation of one of the great figures of the time, surrounded by his family, but a tribute to a man of gentle wisdom and daring intellect whose household was likened by Erasmus to the Academy of Plato. More's courageous independence of thought – surely captured in the Frick portrait – shines from the pages of his most famous work, the *Utopia,* wherein he firmly places his finger upon contemporary injustices (such as the monstrous law that demanded the death-penalty for petty theft) and asserts the right of every man to his personal religious beliefs, even maintaining that beliefs founded upon reason alone are to be held superior to any form of the Christian faith supported only by dog-matic argument. Thus far had free thought advanced under the tyrannical rule of Henry VIII, whose execu-tion of More for his refusal to take the oath required by the new Act of Supremacy has been justly described as one of the blackest crimes in English history.

Henry VIII now aspired to imperial claims, and under

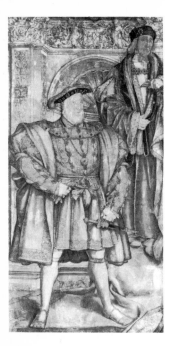

153 HANS HOLBEIN THE YOUNGER (1497/8–1543) *Henry VIII, detail of cartoon for Whitehall Palace decorations, 1537. Pen and brush on paper, 8' 5" × 4' 6" (258 × 137). National · Portrait Gallery, London*

the Lord Protector, Thomas Cromwell, an extensive propaganda campaign was waged to assert the supreme authority of the monarchy. When Holbein became court painter shortly after his second visit to England in 1532, it was this imperial image that was demanded of him in his official likenesses of the King. It was in this guise and as the head of the Tudor dynasty that Holbein portrayed Henry VIII in 1537 in another lost work, a large wall-painting for the Privy Chamber in the palace of Whitehall, which is known from a copy in the Royal Collection and for which the cartoon for the left-hand area of the composition still survives (*Ill. 153*). After the death of Catherine of Aragon and the heartless execution of Anne Boleyn, Henry had married Jane Seymour, by whom he was at last to have a son, the future Edward VI. In the Whitehall painting, as it has come down to us in the copy, Henry and his new Queen stand on either side of an altar, against a richly decorated marble setting, while the King's parents, Henry VII and Elizabeth of York, occupy corresponding positions behind them on a raised dais. There is, however, some reason to suppose that in the original decoration the figures were disposed not in relation to an altar but on either side of an actual window high over the throne of the Privy Chamber, so that the final effect would have been completed by the majestic presence of the king himself, enthroned beneath the painted semblance of his regal authority.

The official portraits of Henry VIII which issued from Holbein's studio derive ultimately from the Whitehall fresco, but only one of these (in the Thyssen collection) can be definitely ascribed to Holbein's own hand. The beautiful portrait of Jane Seymour (*Ill. 155*), painted shortly after her marriage in 1536, is, however, entirely autograph, and exemplifies the exquisite qualities of Holbein's late style, being surpassed only by the vibrant full-length of the widowed niece of the Emperor Charles V, Christina of Denmark, Duchess of Milan (*Ill. 152*), painted in 1538. Like the slightly later *Anne of Cleves* in the Louvre (a three-quarter-length), the *Christina of Denmark* gains in directness by the fully frontal pose. But before we consider further the stylistic character of Holbein's final manner, let us turn for a moment to the *raison d'être* of these portraits of fair – and not so fair – women.

The portrait of Jane Seymour was painted as a

wedding-picture: those of Christina of Denmark and Anne of Cleves, on the other hand, were commissioned as aids to Henry VIII in his search for a new bride after Jane Seymour's death in childbed. What the King most desired was a Queen who would combine physical attractiveness with political advantage – and hence his approach not only to the Emperor but also to François I, with whom he proposed a meeting in France at which the two monarchs might inspect together the eligible maidens connected with the French court; a request that, not unnaturally, was refused. The consequence, in brief, was the despatch of Holbein – like Jan van Eyck before him – to procure the likeness of one prospective bride after another. Henry's choice eventually fell upon the Protestant princess Anne of Cleves: perhaps Holbein flattered

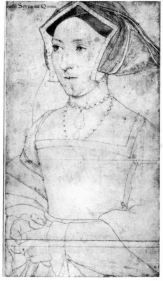

154 HANS HOLBEIN THE YOUNGER (1497/8–1543) *Study for the portrait of Jane Seymour, 1536. Chalk on prepared paper, 17⅝ × 11½″ (50 × 28.5). Reproduced by Gracious Permission of Her Majesty Queen Elizabeth II*

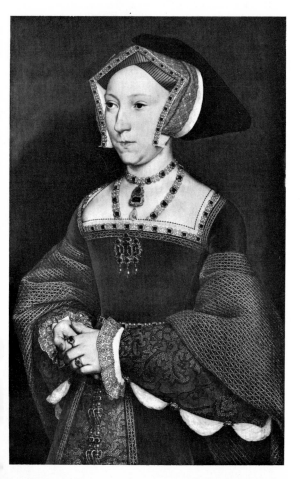

155 (left) HANS HOLBEIN THE YOUNGER (1497/8–1543) *Jane Seymour, 1536. Oil on canvas, 25⅝ × 18⅞″ (65 × 48). Kunsthistorisches Museum, Vienna*

156 NICHOLAS HILLIARD (1547–1619) *A Youth leaning against a tree with roses, c. 1590. Miniature on parchment, 5¼ × 2¾″ (13.5 × 7). Victoria and Albert Museum, London*

her, for the king divorced her after six months, professing a physical aversion to his 'Flanders mare'.

What is so extraordinary is that the enchanting full-length of *Christina of Denmark* (*Ill. 152*), Holbein's absolute masterpiece in female portraiture, was completed after a sitting in Brussels lasting only three hours. In order to understand how this was possible we must turn back to the *Jane Seymour* (*Ill. 155*) of some ten years earlier and consider it in the light of the preliminary chalk study at Windsor (*Ill. 154*) which also relates to another, very similar portrait of the same sitter in The Hague. Almost all the information that Holbein required for the finished painting is present in this masterly piece of draughts-manship, which restricts attention to the outline and from which every superfluous detail has been excluded. The inference must be that Christina of Denmark posed only for a similar chalk study, and that Holbein painted the actual picture after his return to London. If that was so his achievement is all the more astonishing, for this is the most lively, as it is also the most harmonious, of all his portraits.

The lovely economy of the drawings of this final period is now translated in the finished paintings into a style from which Holbein's earlier concern with form and substance has virtually disappeared: it is the elegant embroidery on Jane Seymour's sleeve that catches Holbein's attention rather than the underlying form of the arm; and we observe throughout, as also in the *Christina of Denmark,* a new quest for the gracefully decorative, leading to an almost two-dimensional con-ception of painting. As Sir Joshua Reynolds was to observe, the late portraits of Holbein present 'the ap-pearance of having been inlaid'. This development in Holbein's art seems to have lent itself easily to the demands of fashionable taste, and there can be no doubt about its influence on English painting in the Elizabethan period.

After Holbein's death in 1543 painting in England continued to be dominated by foreign practitioners, and only with the appearance of Nicholas Hilliard, born about 1547 (the year of Henry VIII's death), did England produce a native master of supreme gifts. Little is known about the John Bettes whose well-known *Portrait of a Man* of 1545 in the Tate Gallery, London, is proudly signed (although in French), '*Jehan Bettes Anglois*'; but

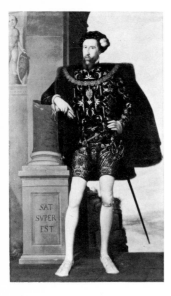

GUILLIM SCROTS (active
1546–56) *Henry Howard, Earl of
Surrey, 1546. Oil on canvas, 6' 6" ×
4' (198 × 122). Collection Mrs
P. A. Tritton, Parham Park, Sussex*

he was clearly one of Holbein's closest followers and was
perhaps his pupil. The most important of the foreign
artists working in England were Anthonis Mor (Antonio
Moro), Guillim Scrots and Hans Eworth, all from the
Netherlands. Mor, who was court painter in the Spanish
Netherlands, was only briefly in England, being brought
over by Mary I, whose Catholicism and marriage to
Philip II of Spain made her one of England's most
unpopular queens, to paint her marriage-portrait (now
in the Prado, Madrid). Mor's place belongs properly in
the history of Spanish painting, and his cold, Bronzino-
like style and his influence on court portraiture in Spain
will be touched on in the next chapter.

Scrots arrived in England about 1545, succeeding
Holbein as King's Painter and continuing in that office
in the reign of Edward VI (1547–53). Scrots's major
contribution was his establishment in England of the
single full-length portrait first created in Germany. A
representative example is the commemorative portrait of
the ill-fated Henry Howard, Earl of Surrey (*Ill. 157*),
painted in 1546, evidently just after the earl's execution
for treason. Holbein's *Christina of Denmark* must be
considered as exceptional in his *œuvre*, but the *Earl of
Surrey* and other full-lengths by Scrots herald the
development of this type of portrait by Van Dyck and
Lely in the following century.

Eworth was patronized both by Queen Mary, who sat
to him soon after her accession, and by Elizabeth I. In
the portrait of Queen Mary Holbein's influence is
paramount, but other works by Eworth demonstrate his
appreciation of the reserved manner of Anthonis Mor.
His gifts for allegorical subjects were enlisted, on
Elizabeth's accession, in the service of the universal
adulation of the new Queen. The *Queen Elizabeth con-
founding Juno, Minerva and Venus* (*Ill. 158*), painted in
1569, can be considered his major work. The picture
adapts the ancient story of the Judgment of Paris to the
contemporary panegyric: the compliment implicit in
Elizabeth's appearance in the role of Paris, and in her
award to herself of the golden apple – here transformed
into the royal orb, – is an obvious one, but it is wholly in
keeping with the tributes paid by the Elizabethan poets
and courtiers to the 'Virgin Queen', whom her flatterers
would liken to Diana or on occasion directly apostro-
phize as a goddess.

Indeed, one of the motives that lay behind the building of the great 'prodigy houses' of the Elizabethan age, such as Burghley (the seat of the Cecils), was the desire to provide a worthy setting in which the aristocracy could receive the Queen, and express loyalty to her, during her Royal Progresses through the land – a custom whereby she attempted to identify herself with the country as a whole. At such houses the Queen would be entertained to elaborate festivities, embracing musical performances, the enactment of masques and, above all, hyperbolic tributes to her greatness, to her virtue, and to her beauty.

Of such houses Longleat in Wiltshire, begun by its owner Sir John Thynne in 1568, is the absolute master-piece of Elizabethan domestic architecture. While presenting a strikingly Renaissance aspect, notably in its application of the classical orders (*Ill. 159*) and in the symmetry of the whole, it yet combines French and Flemish elements to achieve a result that has no precedent in Italy itself. Another great mansion of the same period, Burghley House in Northamptonshire (the work of an unknown architect), reflects the impact of a more specific source of French influence – the style developed at Anet and elsewhere by Philibert de l'Orme.

158 HANS EWORTH (active 1540–73) *Queen Elizabeth confounding Juno, Minerva and Venus, 1569. Panel, 25 × 33″ (63.5 × 83.8). Reproduced by Gracious Permission of Her Majesty Queen Elizabeth II*

159 *Detail of Longleat, begun 1568*

Thynne's assistant on the building works at Longleat, Robert Smythson, was to become the greatest domestic architect in England before the time of Inigo Jones. One of his most famous houses, Wollaton Hall near Nottingham (*Ill. 160*), designed for the Sheriff of Nottinghamshire Sir Francis Willoughby and completed in 1588, unites principles derived from the writings of Serlio with the style promoted by Vredeman de Vries (see p. 139).

Wollaton is one of the most original buildings of the period: nothing comparable with the square, central hall, illuminated from a clerestory and surmounted by a turreted chamber that rises from the midst of the huge, lavishly ornamented structure, is to be found in European architecture before this date. The powerful element of fantasy in Smythson's genius has led some architectural historians to dismiss Wollaton as a curiosity: but we should see it rather in the context of the age that produced that great poet of fantasy, Edmund Spenser. In glorifying Queen Elizabeth in his epic poem *The Faerie Queene*, Spenser transposed the characters and events of his own times to the enchanted world of Gloriana and Britomart. Wollaton, rising up from the hill that dominates the park, seems almost like an emanation of Spenser's dreamy poetry.

In similar fashion the miniatures of Nicholas Hilliard recall the faintly Italianate world of the early Shakespeare, a golden age that found its ideal in Castiglione's *Courtier* (translated into English in 1561) and the living epitome of that ideal in the person of Sir Philip Sidney, aristocrat, statesman and poet. The anonymous young man of Hillyard's famous miniature in the Victoria and Albert Museum, London (*Ill. 156*), seems a no less representative figure, and he might have stepped straight out of the pages of *The Two Gentlemen of Verona* or of Shakespeare's *Sonnets:*

> Nor did I wonder at the lily's white,
> Nor praise the deep vermilion in the rose;
> They were but sweet, but figures of delight
> Drawn after you, you pattern of all those.

Holbein had himself practised miniature-painting – in England called 'limning', – and Hilliard acknowledged his debt to him in his charming *Treatise concerning the Art of Limning,* written in the years around 1600 at the instigation of Richard Haydocke, the translator of Lomazzo. The limner painted with fine brushes in

160 ROBERT SMYTHSON (*c.* 1536–1614) *South front of Wollaton Hall, 1580–88*

watercolours (usually opaque) on parchment mounted on cards, which were often playing-cards cut to size. He worked principally for the aristocrat and the man of fashion: moreover he regarded his own avocation as one particularly suited to a gentleman-artist, being nobler than painting in oils or fresco, which required vulgar and time-consuming labour.

Hilliard's career spans all but the first few years of Elizabeth's reign, and he was to live on until 1619. He was official limner both to Queen Elizabeth and to her successor James I. But during James's reign tastes had changed, and the more 'Continental' realism of Hilliard's pupil Isaac Oliver, a Frenchman from Rouen, was now ousting in popular favour the gem-like style of the older master, in which the extensive use of shadow and chiaroscuro – so fundamental to Oliver's practice – had been carefully eschewed. Hilliard himself had given it as his opinion, on one occasion when Queen Elizabeth was sitting to him, that much use of shadow, although effective in large-scale works meant to make an impression at a distance, was inappropriate to the art of the limner, whose pictures were to be held in the hand and examined at close quarters. Certainly it is the unstudied perfection and elegant decorativeness of Hilliard's drawing, enclosing in lucid outlines exquisite arrangements of subtle tints, enhanced by deeper notes of colour, that lends his miniatures their superlative delicacy and charm.

The Golden Age of Spain and Portugal

The Spanish Renaissance spanned the long reigns of the Emperor Charles V (Charles I of Spain), who succeeded to the throne in 1516, and Philip II, whose rule extended from 1556, the year of his father's abdication, until 1598. Much of its character is summed up in the two great palaces built for these powerful and ambitious monarchs – Charles V's palace at Granada and the famous Escorial, both of which, in their different ways, illustrate the desire of the Habsburg rulers to emulate at their courts the magnificence of the princely patrons of the Italian Renaissance.

The palace of Granada, begun in 1527, was the work of Pedro Machuca, who had practised in Italy as a painter, and its design was clearly inspired by the palace architecture of Bramante and Raphael. One of its unique features is a circular colonnaded courtyard (*Ill. 161*), suggesting a conscious reminiscence of the Colosseum. The double row of columns, one above the other, correctly follows the Ionic and Doric orders, and the effect as a whole is one of measured harmony and grace.

Perhaps the most dramatic manifestation of the new Renaissance ideal in Spanish architecture within this period was the remodelling in 1528 of the original Gothic design of Granada Cathedral in terms of a thoroughgoing classicizing style. The architect, Diego de Siloe (the son of Gil de Siloe, considered in Chapter VII), turned the Gothic piers into Corinthian columns, and transformed the choir into a vast rotunda surrounded by an ambulatory and crowned by a lofty dome (*Ill. 162*). The magnificence of the conception and the sense of scale and space make this the most grandiloquent of all Spanish churches of the early Renaissance. Siloe's ideals were transmitted to his pupil Andrés Vandelvira, who designed what is generally considered the most beautiful cathedral of the period – Jaén. Although it was not to be

161 PEDRO MACHUCA (d. 1550) Courtyard of the Palace of Charles V, Granada, begun 1527

completed until the early 18th century, Jaén Cathedral had an extensive influence, not least in Portugal (as, for example, in the work of Afonso Álvarez).

These developments coincided with the dying splendours of that unique expression of the Spanish genius, the so-called Plateresque Style: the term means 'silversmith-like', and alludes to its ornamental intention, in which the Moorish instinct for the decorative is no doubt to be detected. The entrance to the University of Salamanca (Ill. 163), completed in 1529, shows the Plateresque Style at the moment of its richest evolution. The double portals are dominated by an immense decorative façade, and the intricate workmanship of the applied columns is no less characteristic. Itself a monument to the royal house and to its Catholic allegiance and imperial status, it includes, amidst the wealth of varied ornament, a sculptural group at the top representing the Pope in the act of promulgating Indulgences, a lunette at the bottom containing relief portraits of Ferdinand and Isabella, and at the centre the imperial crown, eagles and escutcheon of Charles V. There is much to remind us here of the elaborate ornamentalism so much admired by northern, and especially French, architects in the Certosa at Pavia (Ill. 145).

In the art of sculpture the assimilation and reinterpretation of Italian Renaissance and Mannerist ideals must have been stimulated by the presence in the Iberian peninsula of such distinguished Italian masters as Andrea Sansovino, who was already working in Portugal as early as 1491, Domenico Fancelli (possibly a pupil of Mino da Fiesole), who designed the monument of the Catholic Kings in the Royal Chapel at Granada (1514–17), and Pietro Torrigiano, who after his English visit settled at Seville, where he was to die in tragic circumstances in 1528. Two works by Torrigiano at Seville, a *Madonna* and a *St Jerome,* both in polychromed terracotta, remained in Spain to uphold the Michelangelesque ideal of expressive grandeur.

It is not surprising, therefore, that many Spanish sculptors of the period, such as Bartolomé Ordóñez, Diego de Siloe and Alonso Berruguete, should have made the journey to Florence to imbibe the new style at the fountainhead. The three artists just named, together with Pedro Machuca, belong to that brilliant constellation of Spanish masters whom Francisco de Hollanda

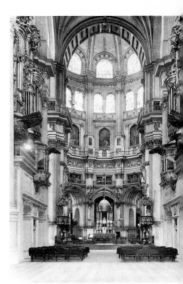

162 DIEGO DE SILOE (c. 1495–1563) Choir of Granada Cathedral, after 1528

163 Entrance to the University of Salamanca, 1529

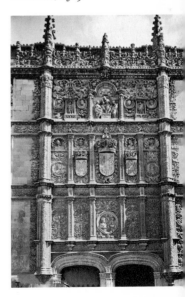

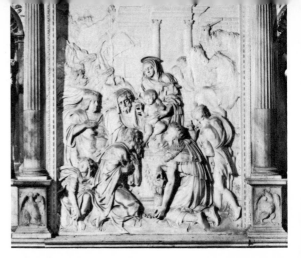

164 BARTOLOMÉ ORDÓÑEZ (c. 1490–1520) *Adoration of the Magi, c. 1514–15. Marble relief.* San Giovanni a Carbonara, Naples

165 DIEGO DE SILOE (c. 1495–1563) *St Sebastian, c. 1525. Marble, h. 33" (85). Parish church, Barbadillo de Herreros*

(most famous for his conversations with Michelangelo, published in his *Roman Dialogues*) called the 'Spanish eagles'. Ordóñez, a wealthy citizen of Burgos who died in 1520 at the height of his powers, possibly studied under Andrea Sansovino himself: he certainly fell under the spell of the early work of Michelangelo, as is evident from his *Adoration of the Magi* at Naples (*Ill. 164*), executed for an altar in San Giovanni a Carbonara. The concentration here upon the type of pyramidal design first developed by Leonardo and upon an effect of total unity shows how thoroughly Ordóñez understood the principles of High Renaissance composition. And we cannot fail to observe, in the Christ-Child and other figures, an almost self-conscious application of Michelangelesque *contrapposto*, while the artist's knowledge of the classical orders, as well as of perspective, is displayed in the architectural detail skilfully introduced into the background.

Like Ordóñez, Diego de Siloe, who has already been encountered as the architect of Granada Cathedral, received his essential training in Florence, where he too came under Michelangelo's influence. His marble *St Sebastian* in the parish church at Barbadillo de Herreros (*Ill. 165*), an early work datable about 1525, indicates his response to the polished perfection of the young Michelangelo's treatment of the marble surface, while the pose suggests a reminiscence of one of the *Slaves* for the tomb of Julius II. The *St Sebastian* shows, besides, a tendency towards a gracile Mannerism which can be seen in other works by Siloe, such as the *Virgin and Child* relief carved in the late 1520s for the choir-stalls of San Jerónimo at Granada.

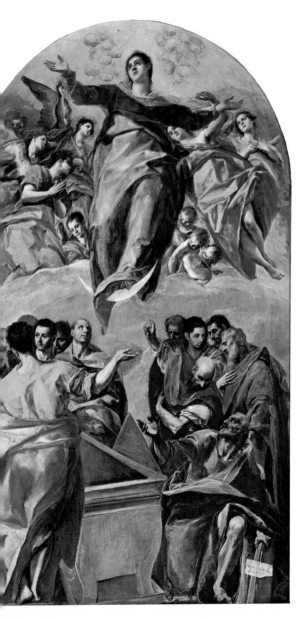

166 EL GRECO (1541–1614)
Assumption of the Virgin, 1577. *Oil
on canvas,* 13′ 2″ × 7′ 4″ (401 ×
228). *Courtesy of The Art Institute
of Chicago*

But the sculptor who established Mannerism in Spain was Alonso Berruguete, the son of Pedro (see Chapter VII). Berruguete was formed under the influence of Michelangelo in Italy, where he remained for nearly fourteen years, and in Rome he made a wax copy of the *Laocoön*, the famous Hellenistic group whose discovery in 1506 so deeply impressed itself upon the imagination of the age. Like Michelangelo himself, Berruguete was never to forget the *Laocoön,* with its message of *terribilità*, and memories of it are embedded in many of his works. Again like Michelangelo, he was both sculptor and painter. In Florence he completed an altarpiece of the *Coronation of the Virgin* (Louvre) left unfinished by Filippino Lippi on his death in 1504, and his contact with Filippino's art, which is so curiously prophetic of Mannerism, may well have helped to shape his own Mannerist inclinations, just as his study of the *Cascina* cartoon and, above all, the Sistine Chapel ceiling must lie behind what Chandler Post called his 'fondness for those twists of the body by which later he was to give vent to Spanish religious intensity.'

In 1518 Berruguete is recorded as painter to Charles V, who had temporarily established his court at Valladolid. On the Emperor's departure for Germany Berruguete continued to work for the nobility in Valladolid, leading a princely life at his palatial mansion, rather in the manner of Titian. His masterpiece is probably the large altarpiece for San Benito el Real at Valladolid (now dismantled), which was commissioned in 1526 and completed in 1532. This was an elaborate retable ideally suited to the range of Berruguete's gifts, for it combined polychromed

167 ALONSO BERRUGUETE (*c.* 1489–1561) *Abraham and Isaac, from the altarpiece of San Benito el Real, 1526–32. Polychromed wood. Museo Provincial de Bellas Artes, Valladolid*

168 JUAN DE JUANES (1522/3–79) *Last Supper. San Nicolás, Valencia*

statered, reliefs and paintings. The *Abraham and Isaac* (*Ill. 167*) shows little of the classic restraint of Donatello's interpretation of the same subject for the campanile of Florence Cathedral: although Berruguete may well have been influenced to some extent by Donatello's composition, the agitation and frenzy of his own figures descend rather from the *Laocoön* group, and the tendency towards elongation recalls Rosso. The energy of the design can be admired merely as a technical triumph, but within these restless forms Berruguete compressed a nervous excitement that is wholly typical of his profound religious expressionism: we are not far now from the world of El Greco, who himself produced many sculptures as aids to him in his paintings. These qualities inform the altarpiece as a whole, from the graceful yet active *Christ on the Cross* to the painted panels, among which the *Flight into Egypt* (*Ill. 169*), although inconceivable without the example of Raphael, is marked by a gravity that is Berruguete's own. The sculptural qualities of the composition and the emphasis upon large masses and simple colours indicate Berruguete's concern to bring the painted panels into harmony with the dominant sculptural components of the altarpiece. Such a marriage of the two arts was facilitated by the pictorialism of his approach to sculpture, which was to attain triumphant expression in the 1540s in the vast alabaster *Transfiguration* in Toledo Cathedral, where a virtuoso display of illusionism and soaring movement transports the spectator into an ethereal world of spiritual rapture.

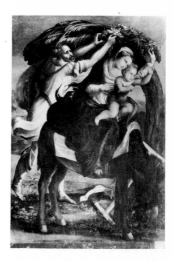

169 ALONSO BERRUGUETE (*c. 1489–1561*) *The Flight into Egypt, from the altarpiece of San Benito el Real, 1526–32. Panel. Museo Provincial de Bellas Artes, Valladolid*

The style of Berruguete's most important successor at Valladolid, the French sculptor known in Spain as Juan de Juni, is also distinctly Italianate, and his *Pietà* group of the early 1540s recalls the theatrical representations of this subject first developed by Guido Mazzoni at Modena. His progression towards an individual form of Mannerism anticipatory of the Baroque can be traced in a series of large altarpieces commissioned from him in the 1550s, of which the high altar for the cathedral of Burgo de Osma illustrates the turbulent excess of his final period.

Such works make a forcible contrast to the subsequent attempt of Juan de Ancheta, who was influenced by Juni at Valladolid, to achieve a more restrained interpretation of Michelangelesque grandeur, as in his altarpiece at Jaca Cathedral (1575–8), where the figure of God the Father in the central scene of *The Trinity* is a

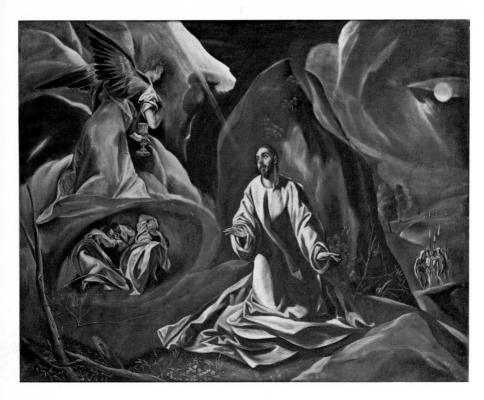

When, in 1558, Mor fled from Spain on a suspicion of Protestantism, he left the field open to Coello, who succeeded him as painter to the Spanish court and became Philip II's special favourite. His full-length of Philip's second wife, *Elizabeth of Valois* (*Ill. 173*), reflects the simple directness and majesty of a style that was to set a standard for court portraiture throughout Europe. Unfortunately many of Coello's works were destroyed by a fire in the Escorial, and doubt surrounds the authenticity of several portraits ascribed to him. Coello remained in Philip's service until his death in 1588, that memorable year in European history in which Philip's imperial ambitions were checked by the crushing English defeat of the Great Armada. Almost inevitably, Coello's influence was felt particularly strongly in Portugal – already annexed by Spain – and can be seen, for instance, in the court portraiture of the Portuguese painter Cristóvão de Morais.

Portugal had long maintained close trading relations with the Low Countries, and at the time of her meteoric rise as a major sea-power with a great overseas empire, which reached its climax in the reign of Manuel the Fortunate (1495–1521), Portuguese painters tended to look to the Netherlands for inspiration. One of the most gifted Portuguese artists working in this period and during the reign of Manuel's successor John III, Vasco Fernandes, based his style initially on that of Rogier van der Weyden but subsequently fell under the spell of Flemish Mannerism. The *St Peter enthroned* (*Ill. 175*) of about 1540, a late work which comes from an altarpiece for Viseu Cathedral, recalls Lucas van Leyden and Mabuse, although more fundamentally it belongs only to the solemn, courtly tradition of the Portuguese School. Meanwhile King Manuel's court painter Gregório Lopes followed his own independent path towards a personal form of Mannerism characterized by a dramatic play of flickering light which contributes to a highly charged emotionalism of expression.

In Spain itself, the humble Luis de Morales, whose origins are obscure, in some respects anticipated El Greco; and, like Greco, he was never to be appreciated at the Spanish court. After Philip II's rejection of a picture that he had been invited to submit as a trial-piece for the Escorial, Morales retired to the provinces, painting altarpieces for numerous churches which strongly ap-

175 VASCO FERNANDES (d. 1541/3) *St Peter enthroned, from an altarpiece, c. 1540. Panel, 7′ 11″ × 7′ 8″ (216 × 233). Museo Regional 'Grao Vasco', Viseu*

programme was largely entrusted to such Italian masters as Luca Cambiaso, Federico Zuccaro, Pellegrino Tibaldi and Bartolommeo Carducci, who helped to disseminate the late Mannerist style in Spain, but some Spanish painters were also involved. At the same time sculptors were being employed on various works, the most notable being the bronze statues made by the Milanese sculptor Pompeo Leoni for the Escorial church, which include impressively realistic portrayals of Charles V and Philip II, together with their families: these statues represent the culmination of the Italian 'invasion' of the Iberian peninsula, and contain strong intimations of the Baroque.

Although Titian painted some of his supreme masterpieces for Philip II, few of the major Italian masters agreed actually to work in Madrid, and the leading exponent at the Spanish court of the Venetian manner so much admired by the King was to be a Spaniard – Juan Fernández de Navarrete, the mute artist known as El Mudo. Navarrete made copies of some of the Titians that had already arrived in Spain, and according to an old tradition he even studied under Titian in Venice. Yet, like Juanes, he was receptive also to the naturalism of the Netherlandish masters, which he contrived to adapt to the free brushwork of Titian and Sebastiano. In his last works, such as the *Adoration of the Shepherds (Ill. 172)* in the Escorial, painted in 1575, four years before his death, he sometimes approaches the poetic 'tenebrism' of Jacopo Bassano.

While Philip II recognized the supremacy of the Italian genius, he was nonetheless an admirer of Netherlandish painting, and it was Anthonis Mor from Utrecht (see Chapter XIII), known in Spain as Antonio Moro, whom he appointed as his official portrait-painter; in which capacity Mor worked both in Spain itself and in the Spanish Netherlands, as well as undertaking important commissions in Lisbon. Mor had been trained under Jan van Scorel, but after a visit to Italy developed an austere but refined style in which northern realism was flavoured with Italian dignity and grace. This polished manner he passed on to his great Spanish pupil Alonso Sánchez Coello, a painter of noble birth whose family had connections with the Portuguese court and who after an early education in Lisbon studied under Mor in the Low Countries.

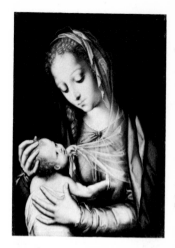

174 LUIS DE MORALES (active 1546, d. 1586) *Madonna and Child; between c. 1555 and c. 1575.* Oil on panel, 11¼ × 7¾" (28.5 × 19.6). Courtesy the Trustees of the National Gallery, London

173 ALONSO SÁNCHEZ COELLO (1531/2–90) *Elizabeth of Valois, Queen of Spain. Oil on canvas, 5′ 4″×3′ (163 × 91.5). Kunsthisto-risches Museum, Vienna*

the Flemish Italianizers, notably Quinten Massys, whose influence is detectable in his physiognomic types and in his predilection for realism of detail. In his attempts to marry Italian and Flemish traditions Juanes was not untypical of the general tenor of Spanish painting during the reign of Philip II.

On his accession 1556 Philip II was determined to impress upon his European rivals the growing might of Spain and to demonstrate that Spanish culture could match that of the Italians. The great symbol of that ambition was to be the building and decoration of the Escorial (*Ill. 171*). Compared with the palace of Granada (*Ill. 161*), the Escorial makes an impression of somewhat forbidding austerity. As Philip wrote to the architect, Juan de Herrera, what he required was 'simplicity of form, severity in the whole, nobility without arrogance, majesty without ostentation.' But the original design had not been Herrera's, having been entrusted to Juan Bautista de Toledo, to whom must be due the grim frontage of grey granite which gave the palace its name of Escorial ('slag-heap'). Work had been begun in 1563, and it was Herrera's task, on the death of the first architect four years later, to adapt his cold, geometric vocabulary to the more harmonious rhythms of his own eloquent style, to which proportion and measure were fundamental.

The Escorial had a complex function: it was intended, above all, as a great palace expressing all the magnificence of Philip II's court; but it was also to include a mauso-leum glorifying the King's father Charles V, a vast domed church rising from the centre, and an adjoining monastery. The whole complex, seen in plan, resembles an extensive grid. Herrera's originality is most in evidence in his conception of the church, San Lorenzo, the last part of the Escorial to be built. Plans had been commissioned from Palladio and other Italian architects, but they had all been rejected. Herrera's solution may well have owed something to one or other of them. The church was begun in 1574 and completed eight years later. It is a centralized, aisled building with a clerestory, and one of its important and most influential features was the sacramental chapel built over the mausoleum behind the altar. In the elegant narthex Herrera's classicism attains its purest and richest expression.

By the 1570s Philip II was already turning his attention to the decoration of the rooms of the Escorial. The vast

benign variation upon Michelangelo's *Moses,* drained of all its *terribilità* and again flavoured by Mannerism. Much the same development from a Renaissance to a Mannerist idiom characterizes Portuguese sculpture of the 16th century, which was largely the creation of artists of French or Walloon origin, such as Nicolas Chanterene, Jacques Longuin and João Ruão.

To trace the influence of the great Italian masters upon the art and architecture of the Iberian peninsula is in no way to belittle the Spanish genius, which always possesses an individual character of its own, tending to the expression of interior feeling and mystical yearning. That Spanish artists should have looked to Italy for inspiration was inevitable, for the Renaissance, in its strict sense, was an Italian achievement, and was recognized as such throughout Europe. The history of 16th-century Spanish painting must be seen in the same context, and the variegated qualities of Italian Renaissance painting, ranging from the subtleties of Leonardo and the graceful idealism of Raphael to the Venetian splendour of Giorgione, Titian and Tintoretto, elicited a corres-pondingly varied response from their Spanish contemporaries.

The Venetian influence, already noticeable, as it would seem, in the work of Bermejo in the closing years of the previous century (see Chapter VII and *Ill. 82*), reappears in that of the founding fathers of Spanish High Renais-sance painting, the two Fernandos – Fernando Yáñez de la Almedina and Fernando de los Llanos, – one of whom (it is not certain which) assisted Leonardo in the execution in 1505 of the *Battle of Anghiari* for the Palazzo Vecchio in Florence. Giorgionesque elements inter-mingle with the Leonardesque in the great shutters for the high altar of Valencia Cathedral, comprising twelve scenes of the Joys of the Virgin, a joint work by the two Fernandos completed in 1510.

The Valencian painters Vicente Juan Macip and his son Juan de Juanes were no less receptive to the complex innovations of the Italian High Renaissance, although Juanes appears to have known them only at second hand. Juanes' *Last Supper* at Valencia (*Ill. 168*) must have been partly based upon Marcantonio's engraving of Leonardo's famous fresco, and perhaps because he was so dependent upon prints in evolving ideas for his compositions, Juanes shows an almost equal interest in

172 JUAN FERNÁNDEZ DE NAVARRETE, 'EL MUDO' (*c.* 1526–79) *Adoration of the Shepherds, 1575. The Escorial*

170 (*opposite, above*) EL GRECO (1541–1614) *The Agony in the Garden, c. 1585. Oil on canvas, 3′ 4″ × 4′ 3″ (102 × 131). Courtesy the Trustees of the National Gallery, London*

171 (*opposite, below*) JUAN BAUTISTA DE TOLEDO (d. 1567) and JUAN DE HERRERA (*c.* 1530–97) *The Escorial, begun 1563. En-graving after Herrera, 1587, showing the complex with the church of San Lorenzo in the centre, begun 1563*

pealed to popular taste. His style was formed under the influence of the Scorel tradition, and he early acquired a knowledge of the *sfumato* technique of Leonardo; he seems to have been acquainted, through engravings, with the work of Michelangelo, Rosso and Sebastiano del Piombo; and he could have studied originals by Sebastiano in Spain. Such sources coalesce in Morales' art into a deeply personal style of melancholy tenderness and mystical intensity, a quality that earned him the name of 'Morales el Divino'. His most characteristic works are his Madonnas and *Pietàs,* which are remarkable for their simplicity of statement and a tendency to expressive distortion. The Virgin of the London *Madonna* (*Ill. 174*), datable only vaguely between the mid-1550s and mid-1570s, upholds an ideal of fragile beauty which is ultimately Leonardesque in inspiration; but the nervous delicacy of the treatment and the pathos of the sentiment – somehow evoking a sense of suffering humility – remain quite unique to Morales' genius.

The art of Morales has the restricted range of a relatively minor master: that of El Greco ('the Greek'), one of the giants of European painting, opens up a vast imaginative world, as well as penetrating to the deepest spiritual currents of the Counter-Reformation. Yet El Greco's true greatness was not fully appreciated until the 20th century – although Delacroix and Degas, among 19th-century painters, both possessed examples of his work. Shortly after his arrival in Spain about 1576 Greco was commissioned by Philip II to paint a large *Martyrdom of the Theban Legion* for the Escorial church, but the picture met with the King's disapproval, and it is easy to understand why Greco's spiritualized interpretation of his subject should have seemed eccentric. In consequence he never again enjoyed royal patronage, and he settled in Toledo, where he was to spend the rest of his life.

This original and arrogant genius came from Crete, then a dependency of the Venetian Republic, his real name being Domenikos Theotokopoulos. His decisively formative years were spent in Venice itself, where he saturated himself in the art of Titian (whose pupil he may have been) and also took much from Tintoretto and Bassano. In 1570, after twelve years in Venice, he made a visit to Rome, having been recommended to Cardinal Alessandro Farnese by his friend Giulio Clovio, an eminent miniaturist. In Rome El Greco is said to have

caused a scandal by declaring that he could paint better than Michelangelo. A Venetian-trained artist might well have expressed such an opinion at the time: nevertheless Greco held Michelangelo in high regard as a sculptor, and his early *Pietà* at Philadelphia must have been inspired by Michelangelo's famous group in Florence Cathedral. Moreover he paid tribute to Michelangelo in his *Christ driving the Traders from the Temple* at Minneapolis (*Ill. 176*), of *c.* 1572, by including his portrait among those inset into the lower right corner of the picture: on either side of Michelangelo we see Titian and Clovio, with Raphael (probably) on the right. This work, the second of a series of variations upon the same theme (others are in Washington, London and the Frick Collection in New York), is in some sense a declaration of the artist's learning, of his appreciation of Roman architecture and of the grand style of the High Renaissance masters. But it is also a declaration of his ultimate independence, and the later versions of the subject significantly heighten the emotional intensity of the main group, already pronounced in the Minneapolis picture, while paying less attention to purely representational considerations, so that Christ, in his violent reproof of the moneychangers, acquires the insubstantiality of a visionary apparition.

This visionary quality is fundamental to all Greco's religious masterpieces, and one recalls Clovio's striking account of a visit that he once made to Greco's house in Rome on a lovely, sunny day in spring, only to find the

176 EL GRECO (1541–1614) *Christ driving the Traders from the Temple*, c. 1572. Oil on canvas, 3′ 10″ × 4′ 11″ (117 × 150). The Minneapolis Institute of Arts

artist seated in a darkened room. 'He would not go out
with me,' Clovio explained, 'for he said that the daylight
blinded the light within him.' There could be no more
revealing illustration of the profound spirituality of
Greco's vision than the splendid *Assumption of the Virgin*
in Chicago (*Ill. 166*), executed in 1577 as the centrepiece
of an elaborate altar for the convent church of Santo
Domingo el Antiguo at Toledo. This is one of the most
Venetian of all Greco's works, but its mystical tone and
its disregard of the spatial principles of the High Renais-
sance relate it also to the painter's Byzantine heritage. It
possesses little of the intense realism of Titian's celebrated
Assunta in the Frari Church in Venice, although it was
from Titian that Greco learnt to orchestrate his brilliant
colours.

The London *Agony in the Garden* of about 1585 (*Ill.
170*) is still more remarkable. The rising moon sheds a
bluish light over the unearthly scene, picking out in
gleaming flashes the armour of the soldiers who are on
their way to arrest the Saviour. This is no mere night-
effect, but rather the evocation of a night-vision; and the
eerie forms of the landscape take on a primarily symbolic
value, from the towering rock – an apparent allusion to
St Paul's description of Christ as a Rock (I Corinthians
10:1-4) – to the warring skies and that fantastic inven-
tion, the cloudy hollow enclosing the disciples in their
sleep and emphasizing their obliviousness of Christ's
communion with his angelic comforter. As Christ
accepts his destined sacrifice, a ray of light streams down
upon him from the heavens. Exhausted after his inner
struggle, he gazes at the angelic minister with an ex-
pression at once agonized and ecstatic. Greco's mystical
language belongs to the same climate of thought that
produced the *Spiritual Exercises* of the great Jesuit divine
St Ignatius Loyola and the writings of St John of the
Cross, who lived at Toledo. An analogue to Greco's
picture is to be found, for instance, in Loyola's insistence
upon the utter surrender of the individual will to God
and upon the nurture of 'that filial fear which is truly
worthy of God, and which gives and preserves the union
of pure love.'

The *Burial of Count Orgaz*, painted in the late 1580s for
San Tomé at Toledo (*Ill. 178*), is generally considered
to be El Greco's absolute masterpiece. This vast canvas,
illustrating a legend concerning a nobleman of the 14th

century, at whose burial St Stephen and St Augustine appeared from heaven to lower his body into the tomb, certainly enabled El Greco to do justice to the whole range of his gifts. The commission required the scene to be represented 'as one viewed by many spectators and with the heavenly hosts above', and while the mystical side of Greco's nature found fulfilment in the upper area of the composition, where the count's soul is received into the company of heaven, in the lower half he was able to indulge in a gorgeous display of colour, in the Venetian manner, as well as to exert his powers as a portrait-painter by filling the background with the likenesses of celebrated contemporaries (chiefly priests and members of the nobility) – although Philip II himself, in deference to his exalted status, appears in the heavens among the assembled apostles.

Greco's qualities as a portrait-painter can be judged no less adequately from his seated full-length of the Chief Inquisitor, *Cardinal Fernando Nino da Guevara,* now in the Metropolitan Museum in New York, a work that brings us to the close of the century and one that takes its place in the history of portraiture midway, as it were, between Titian's *Pope Paul III* at Naples and Velázquez's *Innocent X* in Rome. There can indeed be no doubt about the influence of the New York picture on Velázquez, whose realism is also anticipated in the art of the Valencian painter Francisco Ribalta, a disciple of Navarrete who in reaction against the prevalent Italian ideals developed a powerful, naturalistic style founded upon a vigorous use of chiaroscuro akin in certain respects to that of Caravaggio. Ribalta's major works belong, however, to the succeeding age, and he was active until 1628, outliving El Greco by fourteen years. His realistic style was to be developed to perfection by his presumed pupil, the great Jusepe Ribera.

The final evolution of El Greco's independent genius offers an absolute contrast. From about 1600 his figures become still more divorced from normal visual experience, still more elongated, still more ethereal, so that in the *Visitation* in Washington (*Ill. 177*), datable around 1610, the Virgin and St Elizabeth seem to meet on a supernatural plane, and only the barest indications are given of a particular locality, while the forms of the holy women, enclosed in voluminous draperies that conceal virtually all references to anatomical structure, take on the ap-

177 EL GRECO (1541–1614) *The Visitation, c. 1610. Oil on canvas, 37¾ × 28" (96.5 × 71.4). Dumbarton Oaks Collection, Washington, D.C.*

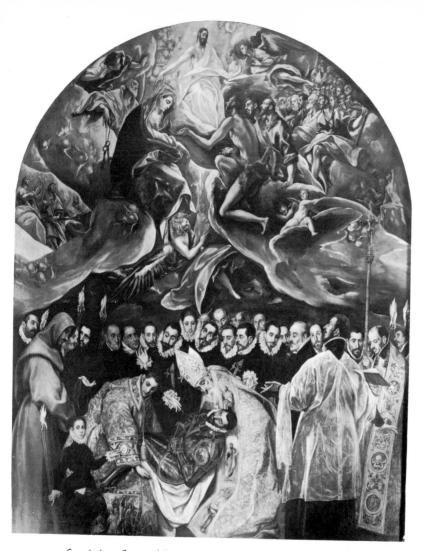

pearance of twisting flames blown by gusts of wind. Never could we be more conscious of the spiritual foundations of Greco's art, which made him, although a Greek by origin and a Venetian by training, the supreme exponent of Spanish mysticism. At the same time the stylistic character of the Washington picture, with its restless, swirling movement and startling directness of statement, evoking emotions of surprise and wonderment, reminds us that we now stand upon the threshold of a new age – the age of the Baroque.

178 EL GRECO (1541–1614) *The Burial of Count Orgaz, c. 1586. Oil on canvas, 16′ × 11′ 10″ (487 × 360). San Tomé, Toledo*

Bibliography

This list is confined to books available in English. It omits a number of important works on Renaissance history and thought and on various cognate subjects, the titles of which are listed in the companion volume *The Renaissance and Mannerism in Italy*.

I GENERAL

O. Benesch, *The Art of the Renaissance in Northern Europe: its Relation to the Contemporary Spiritual and Intellectual Movements*, rev. ed. 1965; D. Hay (ed.), *The Age of the Renaissance*, 1967; G. Henderson, *Gothic*, 1967; H. H. Hofstatter, *Art of the Late Middle Ages*, 1968; J. Huizinga, *The Waning of the Middle Ages*, Penguin ed. 1955; H. Keutner, *Sculpture: Renaissance to Rococo*, 1969; J. Lassaigne and G. C. Argan, *The Fifteenth Century: from Van Eyck to Botticelli*, 1955; M. Levey, *Early Renaissance*, 1967; L. Murray, *The Late Renaissance and Mannerism*, 1967; P. and L. Murray, *The Art of the Renaissance*, 1963, and *A Dictionary of Art and Artists*, 1965; N. Pevsner, *An Outline of European Architecture*, Jubilee ed. 1960; J. L. Schrader, *The Waning Middle Ages* (catalogue of an exhibition commemorating the 50th anniversary of the publication of Huizinga's *Waning of the Middle Ages*, Kansas), 1969; J. Shearman, *Mannerism*, 1967; E. Wolf and R. Millen, *Renaissance and Mannerist Art*, 1968.

II CONTEMPORARY SOURCES AND DOCUMENTS

W. M. Conway, *The Literary Remains of Albrecht Dürer*, 1889, and *The Writings of Albrecht Dürer*, (with an introduction by A. Werner), 1958; N. Hilliard, *A Treatise concerning the Art of Limning* (ed. P. Norman for the Walpole Society), 1912; E. G. Holt, *A Documentary History of Art*, 1957; K. van Mander, *Dutch and Flemish Painters* (trans. by C. van de Wall of the *Schilder-Boeck* of 1604), 1936; W. Stechow, *Northern Renaissance Art, 1400–1600: Sources and Documents*, 1966.

III SPECIAL SUBJECTS

A. Chastel and R. Klein, *The Age of Humanism*, 1964; J. M. Clark, *The Dance of Death in the Middle Ages and the Renaissance*, 1950; K. Clark, *Landscape into Art*, Penguin ed. 1956, and *The Nude*, 1961; W. G. Constable, *The Painter's Workshop*, 1954; C. Harbison and B. T. Ross, *Symbols in Transformation: Iconographic Themes at the Time of the Reformation* (catalogue of an exhibition held in memory of Erwin Panofsky at Princeton), 1969; P. O. Kristeller, *Renaissance Thought*, 1961; E. Panofsky, *Renaissance and Renascences in Western Art*, 1966, and *Tomb Sculpture*, 1964; J. Pope-Hennessy, *The Portrait in the Renaissance*, 1966; J. Rich, *The Materials and Methods of Sculpture*, 1947; D. V. Thompson, *The Materials of Medieval Painting*, 1936.

IV HISTORIES OF INDIVIDUAL SCHOOLS

The Netherlands, Burgundy and the Parisian School of Manuscript Illumination J. A. Crowe and G. B. Cavalcaselle, *The Early Flemish Painters*, 2nd ed. 1872; M. Davies, *Early Netherlandish School* (catalogue of the National Gallery, London), 1955; M. J. Friedländer, *Early Netherlandish Painting from Van Eyck to Bruegel* (rev. F. Grossman), 1965; R. Fry, *Flemish Art: A Critical Study*, 1927; R. Genaille, *Flemish Painting from Van Eyck to Brueghel*, 1954; J. Lassaigne and R. L. Delevoy, *Flemish Painting from Bosch to Rubens*, 1958; M. Meiss, *French Painting in the Time of Jean de Berry*, 1967 et seq.; T. Müller, *Sculpture in the Netherlands, Germany, France and Spain, 1400 to 1500*, 1966; G. von der Osten and H. Vey, *Painting and Sculpture in Germany and the Netherlands, 1500 to 1600*, 1969; E. Panofsky, *Early Netherlandish Painting*, 1953; A. E. Popham, *Drawings of the Early Flemish School*, 1926; L. van Puyvelde, *The Flemish Drawings at Windsor Castle*, 1942, and *The Flemish Primitives*, 1948; M. Whinney, *Early Flemish Painting*, 1968; R. H. Wilenski, *Flemish Painters, 1430–1830*, 1960; *Flanders in the Fifteenth Century: Art and Civilization* (catalogue of an exhibition entitled *Masterpieces of Flemish Art: Van Eyck to Bosch*, Detroit), 1960.

Germany J. A. Crowe, *The German, Flemish and Dutch Schools of Painting* (ed. of the Kugler-Waagen Handbook), Part I 1911; P. Descargues, *German Painting from the 14th to the 16th Centuries*, 1958; F. W. H. Hollstein, *German Engravings, Etchings and Woodcuts, c. 1400–1700*, 1954; C. L. Kuhn, *A Catalogue of German Paintings of the Middle Ages and Renaissance in American Collections*, 1936; M. Levey, *The German School* (catalogue of the National Gallery, London), 1959; A. Matějček and J. Pesina, *Czech Gothic Painting, 1350–1450*; T. Müller, *Sculpture in the Netherlands, Germany, France and Spain, 1400 to 1500*, 1966; G. von der Osten and H. Vey, *Painting and Sculpture in Germany and the Netherlands, 1500 to 1600*, 1969; A. Stange, *German Painting, XIV–XVI Centuries*, 1950; *German Art, 1400–1800* (catalogue of an exhibition at Manchester), 1961.

France J. Adhémar, *French Drawings of the 16th Century*, 1955; A. Blunt, *Art and Architecture in France, 1500 to 1700*, 1953; M. Davies, *The French School* (catalogue of the National Gallery, London), 1946; L. Dimier, *French Painting in the 16th Century*, 1911; J. Evans, *Art in Medieval France, 987–1498*, 1948; T. Müller, *Sculpture in the Netherlands, Germany, France and Spain, 1400 to 1500*, 1966; L. Réau, *French Painting in the XIVth, XVth and XVIth Centuries*, 1939; G. Ring, *A Century of French Painting, 1400–1500*, 1949.

Spain and Portugal L. Gudiol, *Spanish Painting*, 1941; E. Harris, *Spanish Painting*, 1938; J. Harvey, *The Cathedrals of Spain*, 1957; G. Kubler and M. Soria, *Art and Architecture in Spain and Portugal and their American Dominions, 1500 to 1800*, 1959; J. Lassaigne, *Spanish Painting*, 1952; T. Müller, *Sculpture in the Netherlands, Germany, France and Spain, 1400 to 1500*, 1966; C. R. Post, *A History of Spanish Painting*, 1930–66; B. G. Proske, *Castilian Sculpture, Gothic to Renaissance*, 1951; R. C. Smith, *The Art of Portugal, 1500–1800*, 1968.

England C. H. Collins Baker and M. R. James, *British Painting*, 1933; T. Garner and A. Stratton, *The Domestic Architecture of England during the Tudor Period*, 1911; J. Lees-Milne, *Tudor Renaissance*, 1951; E. Mercer, *English Art, 1553–1625*, 1962; O. Millar, *Tudor, Stuart and Georgian Pictures in the Royal Collection*, 1963; G. Reynolds, *English Portrait Miniatures*, 1952; F. Saxl and R. Wittkower, *British Art and the Mediterranean*, 1948; R. Strong, *Tudor and Jacobean Portraits*, 1969; E. Waterhouse, *Painting in Britain, 1530 to 1790*, rev. ed. 1969; M. Whinney, *Sculpture in Britain, 1530 to 1830*, 1964; C. Winter, *Elizabethan Miniatures*, rev. ed. 1955.

V MONOGRAPHS

Hieronymus Bosch L. Baldass (1960); J. Combe (1946, 1957); W. Fraenger (*The 'Millenium' of H.B.*, 1951); R. H. Wilenski (1953).

Dieric Bouts M. J. Friedländer (*D.B. and Joos van Ghent; Early Netherlandish Painting*, III, 1968).

Pieter Bruegel the Elder A. J. Barnouw (*The Fantasy of P.B.*, 1947); V. Denis (1961); F. Grossmann (1966); J. Lavalleye (*B. and Lucas van Leyden: Complete Engravings, Etchings and Woodcuts*, 1967); L. Münz (*B.: the Drawings*, 1961); L. van Puyvelde (*P.B.: The 'Dulle Griet'*, 1945); C. de Tolnay (*The Drawings of P.B. the Elder*, 1952).

Robert Campin see **Master of Flémalle**

Petrus Christus M. J. Friedländer (*The van Eycks – P.C.; Early Netherlandish Painting*, I, 1967).

Lucas Cranach the Elder P. Descargues (1960); E. Ruhmer (1963).

Gerard David W. H. J. Weale (1895).

Albrecht Dürer M. Brion (1960); K. A. Knappe (*The Complete Woodcuts, Engravings and Etchings of A.D.*, 1965); W. Kurth (*The Complete Woodcuts of A.D.*, intro. C. Dodgson, 1927); E. Panofsky (1943, 1945, 1948); W. Waetzold (tr. R. H. Boothroyd, 1950).

Hans Eworth R. Strong (catalogue of exhibition at Leicester, 1966).

Jan van Eyck L. Baldass (1952); W. M. Conway (1921); P. Coremans and A. Janssens de Bisthoven (*V.E.: 'The Adoration of the Mystic Lamb'*, 1948); M. J. Friedländer (*The v.E. – Petrus Christus; Early Netherlandish Painting*, I, 1967); L. van Puyvelde (*V.E.: 'The Holy Lamb'*, 1947); W. H. J. Weale and M. W. Brockwell (1910).

Jean Fouquet T. Cox (1931); K. Perls (1940).

Geertgen tot sint Jans M. J. Friedländer (*G. and Jerome Bosch; Early Netherlandish Painting*, V, 1969).

Hugo van der Goes M. J. Friedländer (*H. van der G.; Early Netherlandish Painting*, IV, 1969).

Nuño Gonçalves R. dos Santos (1955).

El Greco L. Goldscheider (1938); F. Rutter (1930); E. du G. Trapier (*E.G.'s early Years at Toledo, 1576–86*, 1958); H. E. Wethey (1962).

Mathis Grünewald A. Burkhard (1936); J. K. Huysmans and E. Ruhmer (1958); N. Pevsner and M. Meier (1958); G. Schoenberger (*The Drawings of M. Gothart Nithart, called G.*, 1948).

Nicholas Hilliard E. Auerbach (1961); J. Pope-Hennessy (1949); G. Reynolds (catalogue of exhibition at the Victoria and Albert Museum, London, 1947).

Hans Holbein the Younger A. B. Chamberlain (1913); P. Ganz (1950); K. T. Parker (catalogue of the drawings at Windsor Castle, 1945); R. Strong (*H. and Henry VIII*, 1967); *Works by H. and other Masters* (catalogue of exhibition at the Royal Academy of Arts, London, 1950).

Jaime Huguet B. Rowland (1932).

Lucas van Leyden J. Lavalleye (*Bruegel and L. van L.: Complete Engravings, Etchings and Woodcuts*, 1967).

Limbourg Brothers J. Lognon (*Les Très Riches Heures du Duc de Berry*, preface by M. Meiss, 1969); M. Meiss (*French Painting in the Time of Jean de Berry*, Part III, 1970).

Master of Flémalle (Robert Campin?) M. J. Friedländer (*Rogier van der Weyden and the M. of F.*; *Early Netherlandish Painting*, II, 1968).

Hans Memling W. H. J. Weale (1901).

Luis de Morales E. du G. Trapier (*L. de M. and Leonardesque Influence in Spain*, 1933).

Francisco Ribalta D. F. Darby (1938).

Gil de Siloe H. E. Wethey (1936).

Robert Smythson M. Girouard (1966).

Rogier van der Weyden M. J. Friedländer (*R. van der W. and the Master of Flémalle*; *Early Netherlandish Painting*, II, 1968); W. Ueberwasser (*R. van der W.: Paintings from the Escorial and the Prado Museum*, 1945); W. Vogelsang (*E. van der W., 'Pietà'*, 1949).

Index

Numbers in italic refer to illustrations